Bridget Riley
A Very Very Person

Bridget Riley
A Very Very Person

The Early Years

Paul Moorhouse

Ridinghouse

Contents

Preface

The literature on Bridget Riley's art is extensive. The reviews of her debut solo exhibition in 1962 were the first instalments in a wide-ranging discussion of her achievements that continues to the present. During the intervening six decades, in addition to exhibition reviews the bibliography has been swelled by numerous articles, exhibition catalogues, published interviews, anthologies containing essays by the artist herself and commentaries by art historians, as well as textbooks placing her work in a wider context. A comprehensive catalogue, *The Complete Paintings*, was published in 2018. Nor is the present book the first monograph on Riley. That accolade belongs to Maurice de Sausmarez, whose short but incisive publication *Bridget Riley* appeared in 1970, and contained two illuminating essays, a conversation with the artist and a biographical outline. Collectively, there is no shortage of reference material about Riley's work. Why then, it may be asked, is another book needed?

The short answer is that, despite the proliferation of words about Riley's art, there is a dearth of information about the artist herself. For those seeking biographical details, De Sausmarez's outline of her life and the later notes compiled by Robert Kudielka are helpful sources. That said, the former is now out of print; the latter provides an up-to-date chronology, but, like De Sausmarez's outline, its purpose is to give an overview of life and career events rather than to paint a portrait of the person. It could, of course, be argued that deeper insights into the individual are unnecessary because the work stands entirely on its own. I would dispute that view. While Riley's paintings are certainly abstract and the perceptual experiences that they generate are self-contained, it would be a mistake to assume that their significance is only optical. In the present book my

main concern is to show that Riley's art is rooted in much wider experience, and it elicits responses that transcend the visual. To appreciate her work fully, it needs to be seen in relation to the broader empirical context from which it derives. Indeed, my central theme is that the life and the work are inseparable, and an appreciation of one illuminates the other.

This equation is not one that could be applied to all artists. There are instances when the work of a creative individual is truly autonomous and occupies its own imaginative space. In Riley's case, however, my argument is that, while the work stands alone, it acquires its unique character from concerns and experiences that are deeply personal. In the following pages, I endeavour to show how from her early childhood onwards the artist was affected by her surroundings, absorbed impressions and developed sensitivities in ways that called for expression. Such experiences informed her growth as an artist, shaping the way she saw the world, responded to it and eventually succeeded in creating material equivalents using paint on canvas. Central to her being – and, hence, to her work – are the visual pleasures she has always derived from looking at her environment. The evocation of light, atmosphere and movement is a vital characteristic of Riley's art. My aim is to identify the source of her fascination with these phenomena as being her relationship with landscape. In that respect, her childhood in Cornwall was formative and, I would argue, her work needs to be seen in relation to that aspect of her existence to be fully grasped. For this reason, I dwell on that early part of her life in detail.

A parallel theme of the book is to explore the formation of an artistic personality, and it concentrates on Riley's life and work up to the age of 34. Rather than surveying Riley's work as a whole – a subject covered by other publications, including my own 2003 Tate exhibition catalogue – my focus is on those events that nurtured the growth of a painter. I am principally concerned with questions of why and how creativity comes into being. For that reason, I go beyond Riley's primary relationship with landscape and also describe her relationships with her family and other influential individuals, her time as a student and deep engagement with drawing from life, her struggle to understand the central questions of artistic expression, the personal and artistic crisis that occurred during

her 20s, and her ultimate discovery of a way forward. My sense is that all these aspects of her early years contributed to the extraordinary artist that Riley eventually became. They account, for example, for the underpinning structure in her work (notably the recurrent pattern of repose–disturbance–repose), its emotional depth and its capacity to affect the viewer physically as well as perceptually. While the subject of the book is Bridget Riley, my hope is that some of the issues explored – looking and learning to look, drawing from observation, the search for order and so on – will have relevance to understanding the artistic process more generally.

The genesis of this book was the commission that I received from Karsten Schubert in August 2014. In our early conversations, the publication was originally conceived as a short monograph that would span Riley's entire career, and at the outset I proceeded with that intention. Quite soon, however, it became apparent that the book required a different approach. In addition to the primary research that I began to develop, it was agreed that an important source of previously unavailable information would be the artist herself. Accordingly, I carried out my first interview with her in early September 2014, and this established a pattern that continued until March 2016. During the course of our discussions, I realised that the large amount of biographical information that was emerging would be better presented, in the first instance at least, as a volume covering the early life up to the point when Riley first achieved critical recognition. While reducing the chronological scope of the book in that way, I was also prompted to identify its focus as being an account of the life insofar as it illuminates the work, and that became the rationale for our conversations. At a later point in the proceedings, I fixed on 1965 as being the closing date for the book, this being the moment when Riley attained international status following her success in the exhibition *The Responsive Eye* held at the Museum of Modern Art in New York that year.

I am very grateful to Bridget Riley for the time and attention that she contributed to the preparation of this book. She provided me with access to her archive of documents and family photographs and was an invaluable guide during my visits to the various locations in Cornwall that form an important part of the narrative. She responded to my questions with

painstaking care, and I have endeavoured to present the personal information she gave me with the sensitivity it deserves and the precision required. In describing the experiences and events that were shared with me, I have based my narrative on the information I received, combined with my own research and, in revisiting the distant past, a degree of imaginative re-creation. This includes accounts of conversations and thoughts where I felt that these were helpful in evoking particular moments. In employing that biographical method, I had in mind George D. Painter, the distinguished biographer of Marcel Proust, who observed of his own approach: 'Fortunately the quality of life was already abundant in the sources. I have invented nothing whatever; and even when I give the words of a conversation, or describe the state of the weather or a facial expression at a particular moment, I do so from evidence that seems reliable.'[1]

In bringing the book to fruition I am indebted to Karsten Schubert, who supported and encouraged the process throughout, to Sophie Kullmann, who edited the book with great care and sensitivity, to Mark Thomson for his elegant design, to the numerous individuals who kindly provided additional information, and not least to my wife Rosemary, who carried out a large amount of essential research and helped see it through in so many other ways.

Paul Moorhouse

1 Ancestral landscape

The look, smell and feeling of a cornfield. Bridget Riley's earliest memory is rooted in the intoxicating immediacy of nature. She was two years old. Enticed by the surrounding countryside, she had wandered out of the garden at Stonehouse Farm, the family's home in Knockholt, a village in Kent. An expanse of brilliant yellow had attracted her attention and she sensed its seductive warmth. Accompanied by a small pet cocker spaniel, she began to explore the undergrowth. As she probed further, the two became enveloped.

Seen close up, the complex patterns formed by the entwined plants exercised a deepening fascination, and a dusty fragrance filled the air. The corn towered overhead. Within moments the child and the dog disappeared from view. At some point, Bridget's mother Louise discovered their absence and a state of alarm ensued. Bridget and her pet were eventually found and the crisis passed. However, her parents had received a shock and her father Jack resolved to move the family to a new address, which hopefully would pose fewer temptations. For her part, Bridget was oblivious to the drama she had provoked. Instead, the experience was to become a deep-seated memory. For a moment she had luxuriated in the complete sensory arena she had discovered and briefly inhabited. Even at this early age the appearance of things had proved irresistible and entirely fulfilling. It was a prophetic confirmation of a life that would be spent in thrall to the experience of looking.

Engaging visually with the world has always been Riley's abiding passion and, as this childhood encounter suggests, a major source of that preoccupation and pleasure has been her sustained involvement with landscape. One place in particular has been singularly important. The site

of her formative years, and later a second home and the location of one of her studios, Cornwall has been a constant inspiration. Riley's immersion in the physical fabric of that timeless location has been total: a place to visit, recharge and nourish the senses. It is not difficult to see why this is so. Its exhilarating and occasionally precipitous coastline projects into the Atlantic, forming an exposed promontory where the weather is an active agent, shaping and defining the land. But the same steep cliffs and massive headlands also provide innumerable places of shelter: inlets, bays and beaches of all proportions, from yawning expanses to secret coves of quiet intimacy. In all these sites, and across the land itself that forms the peninsula, the endlessly changing light is responsible for the impression of a place in constant flux, responsive, fugitive and, at some profound level, alive. Being there, walking and looking, becoming attuned to the rhythms and patterns of nature: these are the activities that have nurtured not only an engagement, but also an enduring relationship.

The seeds of Riley's connection with Cornwall were planted long before her birth. In that respect, her maternal grandfather, James William Gladstone, has special importance, for it was he who consolidated the family's foothold in Cornwall. Born in 1859 in Newington Green, Middlesex, the reputation that subsequently grew around him, and which has passed down through the family, is – in Riley's words – that of 'a fascinating character, a lot of character'.[1] Certainly, his life, interests and achievements created the context for those particular childhood conditions that fostered Riley's later artistic development. That said, the close association that James William Gladstone forged with Cornwall was a relatively recent development in the family history. James William's own grandfather (Riley's great-great-grandfather), James Gladstone (1786–1865), had been born in Dunse, Berwickshire. Described as a warehouseman, his marriage to Isabella Nairn (1792–1836) in 1814 took place in Tower Hamlets, London, and on Riley's mother's side of the family the association with London dates from that time. Born in 1825, James Gladstone's son, James Nairn Gladstone (Riley's great-grandfather), lived in Stoke Newington, Islington, and died in Lewisham in 1905. A banker's clerk, he married Martha Beauchamp (1831–?) and they had six children, of

whom James William (Riley's grandfather) was the second. Records show that James William spent his early years living with his family in Islington, and later in Lewisham.

The next phase of James William's life is unclear. As a young man he moved to India where he married the daughter of a civil servant, and the two are thought to have spent their honeymoon in the Himalayas. A relic of that happy time survives in the form of a set of Limoges china, a wedding present that is still in the family's possession. Nothing is known about James William's subsequent occupation, but the period in India drew to a close when his wife contracted tuberculosis and subsequently died. They appear to have returned to England during the final phase of her illness as she is buried in High Wycombe. Now a relatively youthful widower, still in his 20s, James William is said to have been distraught and to have visited her grave frequently. His response was to throw himself into work. According to a later census this seems to have been connected with electrical engineering, but his success in that field suggests a level of achievement and creativity belied by the description 'electrical engineer'.

During the 1880s James William began what would be a fruitful association with America. The last two decades of the nineteenth century saw a massive expansion in the growth of cities in the New World, the boom in industry coinciding with a huge influx of immigrants. The demands made on the infrastructure of main cities such as New York, as well as the vastly increased need for housing, presented unprecedented opportunities for the talented and opportunistic to prosper. Evidently, James William saw the potential and, free of marital ties, he made the transatlantic crossing. This move was fortuitous, for he became associated with Thomas Edison, one of America's leading inventors and businessmen. Having begun his career in Newark, New Jersey, Edison went on to establish a major industrial research laboratory, which he built in Menlo Park, Middlesex County, New Jersey. In 1887 he then purchased 14 acres of land in West Orange, where he constructed a new centre for his activities. A true pioneer, Edison emphasised research and development, an approach that resulted in more than a thousand patents. These included many important innovations, notably: the phonograph; a commercially

viable incandescent lamp; the development of motion-picture cameras; the invention of an early fluoroscope for use in X-ray medical diagnosis; and, not least, the creation of an improved electrical storage battery.

James William was closely involved with Edison's groundbreaking work. By the 1890s, his position was that of manager of the Edison Manufacturing Company. In this capacity, he was based at Edison's Chemical Works at Silver Lake, approximately 3 miles (4.8 km) from the West Orange Laboratory. The site at Silver Lake played an important part in Edison's manufacturing activities and was responsible for producing nickel-alkaline storage batteries and phonograph records, among other products. James William's role was evidently lucrative. A portrait photograph taken in New York around this time shows a well-groomed man in his 30s, wearing a collar with small, stiff wings, a style then fashionable. Sporting a neat moustache and sideburns, he appears both attentive and sensitive. This is Riley's grandfather in his prime, portrayed at the moment when he was making his way in the world. It was also a time of responsibility, sadness and, perhaps, anxiety. In addition to his professional concerns, he missed the family he had left behind. His younger sister Isabella Hannah died in 1890, and throughout these years he continued to provide financial support to his siblings. Nevertheless, he was thrilled by America and conscious of his progress. Now commanding a comfortable income, he was sufficiently well off to make occasional return crossings to England, and during one of his visits to London he attended a party. This event would prove highly significant.

In addition to possessing what seems to have been a creative intelligence, James William was gifted musically. He enjoyed playing the piano and before emigrating to America had already acquired a reputation as an enthusiastic performer of popular music in local pubs and at other gatherings. He was gregarious and his musical talents may have provided a distraction from the personal tragedy that had beset him earlier. Now in London once again, and in the midst of a convivial setting, he noticed a young, attractive woman and was immediately drawn. The question he posed to a friend at that moment has survived: 'who is the little whipper-in?'[2] This choice of words is interesting, being a fox-hunting

term denoting someone who assists the huntsman in handling a pack of hounds. The phrase also has connotations that refer to a supporter or an invaluable assistant. Whatever his meaning, the object of his attention was Eliza Susan Bowman, known as Bessy. Born in 1873 in Bayswater, she was 14 years younger than James William, and was probably living in Croydon around the time of their meeting. Their encounter was the beginning of a relationship that would continue, conducted across the Atlantic, and lead eventually to marriage. During their courtship, James William regularly wrote to Bessy from New Jersey, and may even have despatched the engagement ring that survives as a family heirloom. They were married on 31 October 1899 at Shirley, Surrey, where she was then living, at the church of St John the Evangelist. The church register records Bessy's father as a merchant, and James William's as 'a gentleman'.

Bessy may not have joined James William immediately. A story passed down recalls that he sent a message, 'pack and follow', its terseness suggesting an instruction in a telegram. Eventually the two were reunited in America and set up home in New Jersey. A contemporary photograph shows a well-appointed brick-built residence on three floors standing in its own grounds. It conveys a persuasive impression that its occupants were well-to-do. By 1903, there were two additions to the family: a son, also named James William, born in 1901, and a girl, Bessy Louise, who arrived in 1903. The latter would be Bridget Riley's mother. The 1911 census records both births as taking place in America. Indeed, family lore has it that at Louise's birth her father spread a Union Jack across the floor of the attic situated over the room where the labour was taking place, ensuring she was born under the British flag.

James William was by now successful and established but had ceased to work for Edison. It is known that the older man surrounded himself with talented employees, whose research was attributed to Edison. He drove his staff hard and resentments were bound to surface. James William was one of those who fell out with him. Having split with his employer, in 1903 James William set up his own business, the Battery Supplies Company, with another former Edison employee, Eben G. Dodge. In the same year, he submitted a patent application for an invention that he clearly

wished to identify as his own. This stated that 'I, James W. Gladstone, a subject of the King of Great Britain, and a resident of West Orange, in the State of New Jersey, have invented certain new and useful Improvements in Batteries, of which the following is a specification accompanied by drawings.' In July 1903, Edison took out a lawsuit against his former associate, alleging patent infringement. As reported in *The New York Herald*, James William filed a countersuit against Edison in August 1903, 'to restrain him from using patented processes believed to be essential in perfecting the storage battery method of propelling automobiles.'[3] A settlement was reached in November 1904, and in 1905 the Battery Supplies Company was purchased by Edison and then later dissolved.[4]

The relationship between the two men can only be described as embattled. It is said that James William took out no fewer than 13 lawsuits against the celebrated inventor. Subsequently Riley's grandfather moved to Detroit. In that new location, he may have become associated with the Dodge Brothers Company. Established in Detroit in 1900 by Horace and John Dodge, the company found success manufacturing precision engine and chassis components for the city's rapidly expanding automobile firms. James William is thought to have worked on the so-called 'Dodge engine'. Less an electrical engineer than an inventor in his own right, James William's innovations ensured that, despite the earlier problems with Edison, he now attained personal distinction. A contemporary photograph shows Bessy astride a magnificent mare outside the columned portico of their New Jersey residence. A studio photograph of her husband taken around the same time portrays a very assured and elegantly dressed man, confident of his position.

Despite this material success, and for unknown reasons, the family returned to England and by 1906 was living in Lewisham. Possibly the move was prompted by the death of James William's father, in April 1905. James William's mother, Martha, was still alive, and this may have been a consideration, although she later moved to Boscastle, in north Cornwall, with her daughter Ruth. There may also have been some sense of disillusionment with America and its values following the problems with Edison. He may simply have wanted to bring up the family in England.

Whatever the reason, the couple's next three children, John, Albert and Alice, were all born in Forest Hill. At first, they lived at Grampian Lodge, Westwood Park. In 1909 they then moved again to a property described in *The London Gazette* as a dwelling house and garden. Summerfield, at 74 Honor Oak Road, Forest Hill, in south-east London, was built by Joseph Paxton, designer of the Crystal Palace. As befitting a successful man in touch with modern technology, their new home boasted a telephone, the number of which was '5 London'. In addition to James William, his wife and five children, by 1911 the house also accommodated three servants: a children's nurse, a cook/general assistant and a parlourmaid.

Having reached his 50s, Riley's grandfather was now effectively self-employed and freer to indulge his interests and enthusiasms, which, unfortunately, involved radium. He was fascinated by the work of Marie Curie, who in 1910 had succeeded in isolating the element in its metallic state. James William no doubt shared the wider belief, which initially accompanied Curie's achievements, that radium possessed curative powers and had potential commercial use. As later became apparent, the metal's toxicity posed a hazard to health, and this may have been responsible for the cancer that subsequently developed in his hand and arm.[5] In the meantime, however, he embarked on an aspect of his life that in many ways brought him great fulfilment.

In common with his brothers and sisters, James William participated in the growing fascination with the romantic appeal of Cornwall as a place to visit and explore, an interest that may have been encouraged by his mother's residence in Boscastle. Whether he or his younger brother George led that initiative is not known, but the two men idealised Cornwall, succumbing completely to the allure of its history, culture and natural splendours. George developed a voracious interest in abandoned Cornish cottages, of which, with the decline of the tin and copper mining industry, there were many. He eventually acquired around 20 such properties, though with no intention of occupying any of them. In contrast, James William now sought a place in Cornwall where, in addition to his London home, he could live.

The house he found and bought is within walking distance of some

of the most breathtaking views on the Cornish peninsula. The Old Fish
Cellars, as it was originally known, is situated at Trevose Head, four miles
west of Padstow, and overlooks Mother Ivey's Bay. In close proximity
are Harlyn Bay to the east, and, facing south-west on the other side of
the headland, Booby's Bay, Constantine Bay and Treyarnon Bay. Further
down the same stretch of coastline lies Porthcothan Bay and, beyond that,
Porth Mear, a location that would be central to his future granddaughter's
own life and visual awareness. On a clear day, the view from Trevose Head
extends for 40 miles (64 km) in a north-easterly direction, with Hartland
Point, a high rocky outcrop, clearly visible. To the south lies St Ives and,
some 35 miles (56 km) away, the headland at Pendeen Watch. The coastal
path connecting these places provides a winding route along which chang-
ing sensations of space, distance, scale, colour and light are insistent and
ever-present. From the house itself, Mother Ivey's Bay is revealed as a mar-
vel of contained natural energy. To stand on its sheltered sandy beach is
to be in continuous dialogue with the sea. The rhythmic pattern of water,
reflection, land and sky has in fine weather a regular, hypnotic pulse, and,
at other moments, a thrilling unpredictability.

The Old Fish Cellars, or Mother Ivey Cottage as it became later
known, was a large, impressive house, which still exists, although now as
a holiday let. Originally an industrial building, in the early years of the
twentieth century it comprised two storeys with twin gables. Positioned
close to the edge of a low headland, the soft sand and sea are in close
proximity, underpinning the occupants' sense of connection with nature.
Although the house was generously proportioned, the prospect of needing
to accommodate seven people, as well as other members of the wider
family, encouraged James William to enlarge it by building an extension.
The resulting, asymmetrical structure became a holiday house and even-
tually a second home, which he furnished by indulging another passion,
that of collecting old and antique furniture acquired at auction. At the
outset, the family would escape from London to this idyllic setting at
Easter, summer and Christmas holidays. In those days the journey would
have been a lengthy business, involving travelling by train to Falmouth
and, beyond there, by road. Even so, the roots that were put down in

Cornwall at this time would penetrate deeply. It was during these first holidays at Mother Ivey Cottage that Riley's mother, Louise, forged what would become a lifelong love of the Cornish landscape.

A photograph taken when Louise was aged about four or five, in 1907 or 1908, shows her bright and lively expression. From a young age she absorbed the impressions that formed in response to her new surroundings. Later in life she could recall in detail the tamarisk trees at the top of the lane leading to the house. This was a route along which the family occasionally travelled by pony and trap. There were also early memories of playing down on the beach and among the rock pools, rowing in small boats, and watching her brothers setting lobster pots and then exploring their contents. In time, members of the extended family joined them and made connections with other parts of the area. Louise's uncle George and his girlfriend Grace, whom he later married, travelled down by motorbike and sidecar and were regular visitors. Their children were greatly enamoured with the freedom they found in the landscape and ran barefoot. At some point, George made what would prove to be a singular addition to his growing collection of abandoned Cornish homesteads. Further down the coast, south of Porthcothan, he bought an old cottage near Trevemedar Farm. This would be the site of Bridget Riley's formative childhood years, the place where she lived from 1940 to 1944.

In the meantime, Louise's attachment to Cornwall deepened, albeit tainted by circumstances of a more adverse nature. James William spent increasing amounts of time at Mother Ivey Cottage and eventually it became his main home. This came about partly as a result of his advancing years and also because of failing health. It seems likely that his previous practice of handling radium had a dreadful consequence. Having developed cancer, his right arm had to be amputated. Even afterwards, he felt pain from the missing limb. He required nursing and Louise took on that role, supporting him and ministering to his needs. The time she spent in Cornwall was thus divided between her own attachment to the natural beauty of her surroundings and the caring responsibility she had assumed. In a photograph from the 1920s, she is shown standing alone at Mother Ivey's Bay. Now an attractive young woman, she is looking at some distant

point, wearing a dark dress that contrasts with the backdrop of the nearby surf and rocks. This was a difficult period. At one particularly worrying juncture, James William's condition worsened and he almost died. With treatment he rallied, but on regaining consciousness he asked Louise, 'Why did you call me back? I saw something beautiful....'. This phrase became something of a talisman, often repeated to her own children. For Louise's daughter Bridget, the prospect of 'something beautiful' acquired a special resonance.

Throughout James William's illness, Louise continued to travel between Cornwall and London. It was during one such visit to the family home in Lewisham that, in an echo of her father's first encounter with Bessy, she met her future husband. It was while attending a party that she got to know John Fisher Riley, known as Jack, who would be Bridget Riley's father. Bridget's ancestors on Jack's side originally came from Yorkshire. His grandfather, William Chapman Riley (Bridget's paternal great-grandfather), was born in 1809 and moved from Cottingham to London, where he died at Mile End in 1860. Jack's parents, Edmond John Riley (1858–1928) and Bertha Jennet Newling (1865–1938), had both been born in London. Jack was born in 1901 in Upper Tooting and was the fourth of five children. In addition to three older brothers, Norman, Victor and Philip, he had a younger sister, Bertha Joyce, known as Betty, who would also play an important part in Bridget's upbringing.

By all accounts, Jack's father Edmond (Bridget Riley's paternal grand-father) was a very scrupulous man. Born in 1858, he was close in age to Bridget's maternal grandfather, James William, but his life followed a very different course. At the time of Jack's birth, he was 43 years old, and is described on his son's birth certificate as a 'Civil Servant (War Office)'.[6] He appears to have spent his career in that capacity, including service during the First World War, when between 1914 and 1918 he was responsible for the provision of equipment and supplies to the armed forces. It is said that, in that role, he would occasionally be approached by colleagues and others bearing gifts and inducements, seeking the advantage of preferential treatment. Edmond gave this kind of thing short shrift, and he acquired a reputation for being 'untouchable'.

His sons were, in their different ways, no less exact in their respective chosen courses. Norman, the eldest, was an entomologist and an expert in Lepidoptera. During the First World War he served in France in the Royal Army Service Corps, and subsequently became Keeper of Entomology at the British Museum, a post he held for many years. His younger brother Victor was also a soldier in the war and, as a captain in the Royal Army Service Corps, was posted to the Balkans in 1915. He later rose to the rank of colonel in the Indian Army. Philip, who was older than Jack by only two years, was the last of the four brothers to see military service. He seems to have been greatly affected by his wartime experience and was said to be a rather silent man, communicating very little. He later worked in the London Stock Exchange and was responsible for editing the *Yearbook*, the detailed record of the international market and a central point of reference for business and economic historians. Unlike his three brothers, because of his age Jack was not involved in the war. Falsifying his birth date, as many did, he attempted recruitment, but the deception was uncovered and he was turned down. This was an omission that he appears to have felt deeply and, as we shall see, he was keen to redress it.

Jack attended Dulwich College, and on leaving the school in 1919, aged 18, his sixth form report was somewhat qualified in its estimation of his performance. There are two references to his having done little work, although his house report noted that he had taken his responsibilities as a house prefect much more seriously. The master of the college concluded that he possessed a very quick intellect and with effort would do well. At the time he met Louise, Jack was working in the City for a printing firm. He had started in a junior capacity and had worked his way up, becoming increasingly skilled as a printer as he did so. He had learnt his trade but evidently found the work less than exciting. For her part, Louise was attracted by his easy-going manner and sense of humour. Her nursing responsibilities weighed heavily and Jack had the ability to make her laugh. As the relationship developed, he too began visiting Mother Ivey Cottage, often making the long journey to Cornwall by motorbike.

His occasional presence in Cornwall was a welcome restorative as Louise struggled to cope with her father's declining health. That daunting

experience gave her a maturity far beyond her years, and when James William eventually died, she was deeply affected. Bessy was overwhelmed and it fell to Louise to provide much-needed support and strength.

A simple, private philosophy now asserted itself, as it would in later times of adversity. Essentially this involved making the best of things, never succumbing to self-pity. Throughout that period of suffering, she was sustained by her surroundings, the activity of walking and, above all, the enjoyment of looking. This profound visual engagement was central to her being, the source of her love of life and a passion she readily shared, first with Jack and later with her children. It would form the closest of bonds with her daughters, and for Bridget Riley it would be the inherited foundation of her life's work.

2 A very very person

Bridget Louise Riley was born on 24 April 1931 at her maternal grand-
parents' home, Summerfield in Forest Hill. The birth took place in a
four-poster bed. Louise had inherited her father's interest in antique
furniture, and this was the first item that Bridget's parents had acquired
following their marriage in autumn 1928. After the birth, Louise and Jack
moved to Stonehouse Farm, the site of Bridget's cornfield experience.
No doubt wishing to continue the sense of rural existence Louise had left
behind in Cornwall, they found what had previously been a simple farm
labourer's building. Alongside a liking for fine furniture and well-made
things, from the outset Louise's desire for contact with the land would
exert an ongoing influence. The house in Knockholt stood at the top of
a steep lane, and to reach their destination the couple had to push their
recently acquired car up the final leg of the journey. As we have seen, their
young daughter's outdoor adventure suggests that this location was not
ideal. Although Louise deeply valued their proximity to nature, she was
mindful of her daughter's tender years and caution prevailed. Two further
moves ensued. At first they lived in a flat in Uxbridge, west London.
Subsequently, they purchased The Corner House at Bushey Heath, near
Harrow in Hertfordshire.

Living in these new surroundings, in autumn 1936 Bridget commenced
her primary education at The School in Chiltern Avenue, Bushey, where
she would remain for the next three years. The teaching there was based
on the ideas of Rudolf Steiner, the founder of eurythmy in the early twen-
tieth century. Steiner's philosophy emphasised the importance of move-
ment and gesture. In an educational context, this ethos was presented as a
means of encouraging imaginative, expressive and cognitive development.

Intellectually curious and receptive to advanced ideas generally, Louise embraced Steiner's approach. In part she may have been influenced by contact with those values that developed in Germany during the 1930s relating to the idealisation of the human body. A German au pair they employed was an enthusiastic advocate and some of that interest may have rubbed off. It is also possible that Bridget's mother was pursuing the perceived therapeutic benefits of eurythmy.

By the time she started school, Bridget was already a very difficult child. At an early age she had begun to be uncooperative, refusing to eat and being generally stubborn. The au pair bore the brunt of this behaviour. The young rebel would sit in her high chair and throw her food onto the floor. When this was replaced, the same response would follow, only to be repeated again and again. A strong-willed child, Bridget was, as her grandmother put it, 'a very very person'. There were no half measures. Things were taken to extremes, and on occasion tantrums led to consequences. Refusing flatly to accept food, the child would sometimes faint with self-imposed hunger. The reasons for these actions were, as is often the case with young children, obscure. A contributing factor may have been the attention now being diverted away from Bridget and towards her younger sister, Sally, who had been born in 1934, three years after her predecessor. From an early age Sally experienced difficulty with walking due to problems with the development of the bones in her feet and ankles. As this condition worsened she had to wear splints and was in plaster for prolonged periods. This was a deep concern for her parents, who naturally had to commit themselves to helping and supporting her. Their unease was compounded by the behavioural issues displayed by Bridget.

Determined and obstinate, Bridget did well at school but did not enjoy the learning environment. A promising start drew praise from the head teacher, who commented in her report that Bridget was quick to answer questions and that her replies were intelligent. This assessment was followed by a further, perceptive observation that her new pupil was artistic and had a keen creative sense. Aged five and a half, she had begun to make a mark. A year later, however, the same teacher's views had changed somewhat. She noted that Bridget did not appear to retain facts

well, an observation qualified by recognition that whenever she chose
to pay attention her intelligence was again apparent. Significantly, in her
nature studies she was said to be very interested and observant. This
general pattern of uneven behaviour and motivation continued. Bridget's
report for the spring term of 1938 noted that absences from school had
checked her progress in arithmetic and English; however, there had been
progress in handiwork, in which she was said to show a strong creative
ability, and drawing, which drew praise for effective expression. The same
report contained further contradictory assessments: in speech training
Bridget was too quiet, while in sports she was seen as a very active
participant.

Incorporating Steiner's ideas relating to expressive movement, the
school had an enlightened approach to learning, and Louise's confidence
was undiminished. But Bridget's attendance record suggests that when
confronted with the competing prospects of rote instruction and outdoor
freedom, she was in no doubt as to her preference. The abiding memories
of this early time are those of wonderful visits with her mother and sister
to the local park. There they built a tree house, the first of many. This had
a platform onto which they could climb and enjoy an alternative, elevated
view of things. Houses that moved were also fascinating. Following James
William's death, their grandmother Bessy sold Mother Ivey Cottage and
moved to a property in Bushey Heath, close to where they were living.
In her garden there was a revolving garden house. Inhabiting that space,
the children were enchanted by an enclosed view that could be changed
at will, providing numerous different outlooks. Throughout, Louise was
ever-present, entering into their domain of make-believe and observation.
For her part, she built a large kitchen at the Corner House, a mirror image
of the extension that James William had added to the house in Cornwall.
Together they established a close nexus, fed by a shared delight in occu-
pying private spaces that opened out onto the world.

Bridget's school attendance continued to be erratic, and her report
for the term ending in April 1939, when she was almost eight years old,
was stoical. While her progress was deemed to be satisfactory, it was
felt that she was slowly making up for time lost due to frequent absences

from school. Even so, there had been strong advances in her creative development. Her geography teacher recognised that she possessed a strong imagination, which she used to good effect. Her performances in painting and nature study had also coalesced in a telling way. Regarding the former, there was a resounding note of approval: Bridget was said to have a definite eye for colour, shape and design, and it was noted that her attention to detail was excellent. Similarly, there was no equivocation about her interest in nature; the report commented on Bridget's ability to look closely and perceptively. Evidence of that sensitivity must have been a particular pleasure to her mother, whose influence it surely reflects. Although incipient, Bridget's enjoyment of visual experience was an early indication of the way ahead.

However, events took an unanticipated new direction. An opportunity had arisen for her father Jack to take a more senior position with the printing firm Fisher Clark. The Managing Director of the family-owned business was retiring and a replacement being sought. The job represented a significant advance in terms of the Riley family's own prospects, but would entail moving to Boston, Lincolnshire, where the company was based. Jack decided to apply and was interviewed by Ira Bartlett, whom he now met for the first time. This kindly older man would prove to be an important guiding influence in terms of Bridget's later art education and, generally, a great help to the family. For the moment, he was instrumental in appointing Jack to his new position. The interview went well. Bartlett referred to the need for efficiency and, during a lull in the conversation, Jack made a humorous comment about his interviewer's ashtray, which, he remarked, was filled to overflowing with discarded stubs. Laughter ensued. It suggested acuity of observation combined with a teasing wit. Both were appealing qualities and Jack was invited to take the job.

Louise was less keen, not least because she did not want to leave London. Bushey Heath was congenial, there was access to the city's cultural attractions and relocating would entail interrupting the children's education. A bargain was therefore struck, which involved moving to a larger, imposing home. Holly House, as it was called, had a big garden and

was situated in a sedate neighbourhood near the centre of Boston. Louise compensated for whatever misgivings she felt by furnishing their new home in sumptuous fashion. A recently built school was located conveniently at the end of the road and there were vast expanses of open land nearby. However, Bridget was not enamoured with their new way of life. She hated her school and its unfamiliar formality entailing uniform, satchels and hats. Having commenced at Boston High School in autumn 1939, her absences now increased significantly, due partly to illness. Her end of term report shows that she missed school on no fewer than 85 occasions.[1] Her form mistress concluded that the school was sorry Bridget had been ill and was glad she was now recovering; her additional comment was, however, equivocal. While noting that her pupil's conduct was good, she was concerned that Bridget tended to demand too much individual attention.

If Louise harboured doubts about Boston, characteristically she made the best of it. She indulged her passion for nature by cultivating the garden. There was a small orchard and a vegetable patch to which she committed her attention. Double digging – which involved hard work and a lot of time – now became the order of the day. She grew poppies and lupins and introduced a herbaceous border. Even so, and despite the impressive comforts of their new address, she missed the home they had left behind. She also felt the absence of contact with Cornwall. At first there had been occasional visits to Mother Ivey Cottage, but now that the house had been sold there was no longer anywhere to stay, and holidays petered out. Jack, however, found other diversions. When he was not working, his escape from routine took the form of exercises with the Royal Artillery. Compensating perhaps for the military service experienced by his brothers that had eluded him, he was greatly attracted to the outdoor life offered by such breaks. Louise referred teasingly to this activity as 'playing soldiers'. During these absences there were lonely times. Additional adult company was, however, provided by her mother Bessy, who put the furniture belonging to her house in Bushey Heath in store and came to live with the family in Boston. In general, it was a happy period.

It was, however, to be cut short by the darkening political situation.

Following the declaration of war on Germany on 3 September 1939, Jack volunteered for active service. Louise was furious and felt he was abandoning the family. He took an entirely different view, citing the call of duty. There is no doubt that his brothers' involvement in the First World War had conveyed a deep sense of patriotism. Quite simply, he felt it was the right thing to do. There was also some sense that his decision was motivated, in part at least, by his occasional experience of army life, which he had enjoyed. Louise's growing unease was underpinned by the wider anxiety felt in the country about the threat of invasion. Given the vulnerability of their position on the east coast, facing Holland, this was a concern that she and Jack shared. As a result, they now took what would be a fateful decision. It was agreed that for the duration of the war Louise and the children would relocate to Cornwall. As well as offering a greater sense of security, that alternative location was familiar. They knew the landscape and had contacts there. The question was where to live. A solution was provided by Louise's uncle George, whose portfolio of abandoned Cornish cottages included the empty building at Trevemedar, five miles south-west of Padstow. The property was available and at a small rent. As the accommodation there was known to be limited, and facilities rudimentary, it was decided that Bessy should stay with Louise's younger sister Alice in Shrewsbury, Shropshire. The plan was completed by Jack's suggestion that his younger sister Betty join his wife and the two girls.

Alongside Louise, aunt Betty was the other guiding light in what would be a crucial formative phase in Riley's life. Born in 1908, she was five years younger than Louise. Intelligent and lively, she had studied art at Goldsmiths College, London, and during her 20s had become something of a flapper, complete with bobbed hair and an emancipated outlook on life. Card games – 'a throw around' – were a particular enthusiasm. However, she had not pursued her artistic talents and there was little talk on that subject. Now 31, whatever professional or personal ambitions she had entertained had not come to fruition. In contrast, Louise was more intellectual, and although she lacked a formal art training, her sensitivity to nature and willingness to examine ideas were strong elements of her character. In their respective ways, the two women

were complementary and became good companions. Despite inevitable occasional quarrels, the atmosphere was never tense.

The date of the move to Cornwall is not known with certainty, but it seems likely that it took place in spring 1940. The house in Boston was rented out, and whatever possessions they needed were packed into the family car, a Talbot. Despite being overcrowded, room was found for a fifth passenger, their pet dachshund named Gertrude. The journey involved a drive of more than 350 miles (563 km). Having started early, they got as far as Shepton Mallet, in Somerset, just over half way, before disaster struck. With limited visibility because of the load they were carrying, they had a serious accident and the vehicle was a write-off. Fortunately, there were no injuries. But in order to complete their expedition it was necessary to seek local help. Bundling their cargo into a small replacement car, they were driven the rest of the way, finally arriving at Trevemedar after a very long day.

Effectively marooned, Louise's initial response was one of consternation. They found a small, primitive-looking, slate-roofed building with stone steps leading to the centrally placed front door. Four windows were situated symmetrically, each corresponding to one of the rooms in a two-up, two-down arrangement. Inside, the proportions were cramped. Standing in the sitting room on the left-hand side, Louise could touch the bowed ceiling, which moved under upward pressure. Betty, being slightly shorter, found it just out of reach. The room had a broken window that Louise noted as requiring immediate repair. A fireplace and grate provided the prospect of heat, as there was no electricity. Coal was kept beneath the stairs opposite the front door, although, as they would discover, this was rationed and in winter would need to be supplemented with gathered wood and gorse. At night the light from a candle in any of the rooms was clearly visible in the remaining spaces.

The furniture was sparse. There was a rocking chair to one side of the fireplace, matched by a half-upholstered chair and a horsehair sofa. A grandfather clock added a touch of decoration and also provided storage space. Having long lost its mechanism, its interior now doubled as a shelved cupboard. The kitchen boasted a Valor cooker that depended

on a supply of bottled gas. It comprised a hob and a grill but lacked an oven, which existed separately as a portable unit. There was a sink, but no running water or plumbing of any description. Water would have to be brought from a nearby stream. Once filled, the sink would have to be emptied by hand. Washing would take place in a washstand using a bowl and jugs. In winter an enamel hip bath would be retrieved from its usual place in the garden, where it afforded accommodation for frogs, and pressed into domestic service. A lavatory did not form part of the historic fabric of the building, and arrangements were traditional, involving trips to the cesspit. Betty's bedroom was situated over the sitting room; Louise was on the other side, sharing with the girls, who each had a small bed on either side of their mother. Their future home thus revealed itself. Uncle George's wife, Grace, had visited the day before their arrival. Part of her preparations included a present of a new, handmade lampshade. In the circumstances this kind gesture of welcome had a practical irrelevance that could only raise a smile. The contrast with their previous life could hardly have been greater.

The rudimentary nature of their new accommodation presented a host of immediate challenges. In almost every aspect, the daily routine of rising, washing, eating and obtaining basic necessities needed rethinking. However, as they now found, there were delightful surprises. Tucked away in the corner of the field in which the cottage stood, the stream ran clear and pure. Entrusted with the task of fetching jugs of water, the children became acquainted with the large frog, 'the prince of the terrain', that sat on a rock in the midst of the flow. As they ventured further, the surrounding landscape disclosed an extraordinary beauty. The walk to the church at St Eval, some 3 miles (4.8 km) away, took them along lanes lined with tall hedgerows bent by the wind into eccentric shapes. Hawthorn proliferated, presenting gorgeous splashes of pink and white that dazzled in full sunlight. At the end of the day, deep shadows filled the foliage, transforming its previous appearance. These sights were a joy, prompting Louise to draw the children's attention to the various effects of light, reflection, colour and shape as they went.

Trevemedar is situated near the coast, with the cove at Porth Mear,

as well as Porthcothan Bay and Bedruthan Steps, in close proximity. As they grew familiar with their surroundings, routes from the cottage would lead the new arrivals towards the sound and smell of the sea. Exploring further still, they came upon the edge of the land, defined by these places, each with its own special character. Porth Mear was closest, and the walk there was their first and became the most frequent. A sinuous track leads through rough terrain, gently rising and falling. On a spring day the surrounding grass and bushes are alive with butterflies and buzzing insects, the path throwing off a pleasant warmth. Alongside, a trickle of water gradually gains strength and direction as the land descends and then opens out as it meets the sheltered cove. This enclosed shallow space shelves towards the sea, its grey slate floor glistening and dotted with innumerable rock pools of reflected light. Porth Mear conveys a feeling of intimacy. Contained by the flanking cliffs, it is open but also embraces the visitor, who in some strange way feels at one with its stillness, and yet at the same time is entranced by the spectacle of endless change.

Moving south, the coastal path provides access to Bedruthan Steps. With its gigantic cliffs and vast, jagged rock stacks, the impression is one of exciting grandeur. The sea breaking on the sand is an animating force, providing constant movement and a sense of restless energy. Looking down from the adjacent headland, the eye is seduced by the elusive scale of the place and loses its bearings. Height and distance defy apprehension at Porthcothan Bay, in the opposite direction, where the space is immeasurably flat and wide. The expanse of beach contends with the rolling surf, producing long ragged edges of vivid white spreading into ochre. These sights made a profound impression, not least in being observed with eyes that beheld them afresh. Throughout her adult life, Riley would continue to return to the same sites, finding in them the endless visual pleasure that is the source of her mature work. For Louise they were a deep consolation, a reconnecting with those natural sources that had nourished her in the past. For her children, these early visual experiences in Cornwall were an awakening. They were, as Riley later recalled, 'the first feeling', moments of discovery that now stirred her own interest in nature.

3 Unearthly beauty

As the family settled into their new existence in Cornwall, the misgivings they had felt on arrival were tempered. Although living arrangements remained rudimentary, there was a growing awareness and appreciation of the wider situation. Louise rose to the occasion, making it clear to the children that living at Trevemedar presented a unique opportunity to experience a simpler way of life, without dependence on modern conveniences. They would just adapt, and in any case it was only 'for the duration', as it was called. That affirmative attitude was both reassuring and liberating. While there was no way of predicting the course of events, they were sustained by the hope that the enemy would be defeated, normality restored and eventually they would return to Lincolnshire. In the meantime, they would make the best of it. As things turned out, Bridget would spend the next four years in this location, and during that time they would all be affected by uncertain circumstances. In retrospect, buoyed by her mother and the collective experience they shared, she would draw upon her childhood in Cornwall as a source of profound spiritual nourishment.

At the outset, Jack was stationed in Norfolk where he underwent training. Equipment was in short supply, often to unintentionally comic effect. Officers were instructed to 'cut a short stick and train with that'. Despite these logistical shortcomings, through the period of the so-called phoney war, when there was a lull in operations, he participated fully in the process of turning civilians into soldiers and was able to take leave in order to visit his exiled family on two occasions. Photographs taken during those precious sojourns, when the entire family was together, record happy times, despite the context in which they took place. In some of the snaps Jack is in mufti. Evidently relaxed, as ever his easy sense of

humour lifted everybody's spirits. In others, a more formal note is struck. Wearing uniform, he appears to be getting ready to return to his regiment. Unknown to all, on departing at the end of his second visit, he would not see his family again until after the end of the war.

But that lay in the future. In the meantime, Bridget experienced 'radiant days', and she later described their first summer at Trevemedar as one of 'unearthly beauty'. This was the time when the full splendour of their surroundings made itself apparent, and her freedom to enjoy it was tasted in full. They took their meals out of doors, went on long walks and got to know the places that she would come to love. Each day was different and unique, each contributing to the new rhythm of their lives in which there was a growing awareness of the wonder and solace of looking. Riley later wrote a description of her experiences in Cornwall. In *The Pleasures of Sight* (1984) she recalled, 'what I experienced there formed the basis of my visual life'.[1] The tapestry of sensations that made up her existence at that time interweaves movement, colour, reflected light, shadow, shape, space, pattern, transparency, density, saturation and fragmentation. The following passage is a characteristically vivid account of things seen, savoured and precisely remembered:

> Going up and down valleys and around twisting corners there was a constant interchange of horizon lines, cliff-tops and brows of hills – narrow slivers of colour rhythmically weaving and layering, edge against edge. And sometimes, on turning into a completely different aspect of the landscape, which – especially if the sun was behind – one encountered almost as though the new view was a monumental edifice, so flat and dense did the colour seem.[2]

After leaving the family behind at Trevemedar, Jack returned to duty. The war now entered a different phase. With escalating political tensions in the Far East, in late 1941 Jack was posted to Singapore, Britain's principal military base in that area. Events moved quickly. On 7 December 1941, Japan attacked American and British bases in South-East Asia and the central Pacific, including the notorious onslaught at Pearl Harbor.

As a result, the United States and Britain were among those countries that declared war on a new enemy. This placed Jack for the first time in an active war zone. Louise remained optimistic – outwardly, at least – but this news was hardly welcome. The situation then worsened. On 8 February 1942 the Japanese invaded Singapore. Fighting lasted a week and finally the city surrendered. Over 85,000 Allied troops were taken prisoner, the worst capitulation in British military history. Around 5,000 were killed or wounded. Jack was one of the many reported missing.

Louise, Betty and the children experienced a period of not knowing, during which the sense of isolation deepened. Again, Bridget's mother remained positive. Her personal philosophy, which she was to articulate on many occasions, was that there was a choice to be made: life can be awful with wonderful moments or wonderful with awful moments. It was up to the individual to decide. In the absence of certainty about Jack's fate, she resolved to carry on as best she could, and to make the most of what they had. In later life Riley recognised the strength that this must have required. Delight must be protected from despair, but how to keep the two apart? It was an outlook that would be sorely tested. Part of Louise's approach involved shielding the children as far as possible from the worry that now crept upon them, and also setting an example that would sustain them. In that respect she was, in the main, successful. This could have been a terrible time, and in her private moments it almost certainly was. However, while collectively aware of their predicament, they now faced this anxiety together. As a result, Bridget continued to be inspired by the place in which they lived and rejoiced in the idyllic rhythms of those days.

The walks continued, with the conversation turning always to the treasures of nature that lay about them. Louise's great ability was being able to share her perceptions, infused as they were with the love she felt for things that moved her. Through repetition – visits to familiar places, as well as endless new discoveries – the patterns that underpin the world were revealed. The sea and tides, the light at various times of day, the recurring structures in the landscape: all were absorbed, feasted upon, digested. Bridget was not the only beneficiary of these outdoor experiences. Helped by the exercise and air, Sally, who had initially relied upon

a pushchair to get around, became stronger and started to walk unassisted. As a result, there were frequent visits to the beaches, when clambering over rocks and playing in the sea would fill the days. For Bridget, this was the time when the organ of sight developed an unusual sensitivity and perspicacity. Her teacher's earlier recognition that she possessed a keen perceptual sense now deepened in significance as she gained confidence in her visual experiences and began to look around her in an independent way. Again, her words in *The Pleasures of Sight* are evocative:

Swimming through the oval, saucer-like reflections, dipping and flashing on the sea surface, one traced the colours back to the origins of those reflections. Some came directly from the sky and different coloured clouds, some from the golden greens of the vegetation growing on the cliffs, some from the red-orange of the seaweed on the blues and violets of adjacent rocks, and, all between, the actual hues of the water, according to its various depths and over what it was passing.[3]

The days unfolded, and there was no further news of Jack. The Red Cross notified relatives when there was anything to report, but there was nothing. If ever she harboured doubts, Louise kept them to herself and carried on. Her constant refrain was 'when your father comes home'. She dug the garden, acquired a bicycle, and made trips for provisions to local farms and to Padstow. Throughout, she wrote and posted letters to her missing husband, hoping that somehow they would reach him. Only at night were there moments when her feelings surfaced. Lying in the bed next to Louise, Bridget would occasionally be awakened by the sound of her mother softly weeping.

These were difficult times and Betty was a great support. There were others, too, who offered help. For the first year or so, the question of the children's education had receded. But as their stay in Cornwall showed no sign of coming to an end, the matter now raised itself. At the beginning Betty provided tuition. Louise's responsibilities lay with the running of the house and the supplying of food, and so she tended not to get involved. After a while, Betty and the children joined up with a number

of families living in the vicinity. Louise's sister-in-law, Clare (the wife of Louise's younger brother John), had also moved to Cornwall in 1941 and was living nearby, at Windy Ridge, with her young daughter, Susan. Their cousin became a playmate for Bridget and Sally and was also in need of schooling. Situated on a hill en route to Porthcothan, the bungalow at Windy Ridge became a place for informal lessons.

Taking up their places in the sitting room, Betty presided over a cluster of children positioned behind card tables. The room had high windows that removed outside distractions. There were also children belonging to the families of Royal Air Force personnel, based at the local aerodromes near St Merryn. These expanded a group that attracted a network of women who volunteered their improvised services as teachers. Betty taught algebra. Mrs Mackeldowney, who had spent time in India and Africa, was responsible for geography. Nora Loos, a somewhat colourful and poetic individual who lived with her aged father and had a passion for theatre, recited Shakespeare. She had a captive and enthralled young audience. There was a travelling library, and on occasion Louise would also join in and read from the classics, Emily Brontë's *Wuthering Heights* and Charlotte Brontë's *Jane Eyre* being great favourites.

Eventually the need for a better organised school became apparent and this came to be based at Treyarnon Bay, where Mrs Denman had a house that overlooked the sea. This improvised classroom was about 3 miles (4.8 km) from Trevemedar, and the daily journey there involved a walk along the coast. Bridget and Sally would be accompanied either by Louise or Betty, who took turns in delivering and collecting the children. These excursions also allowed wonderful interactions with nature. During summer time, when mornings were light, breakfast would be taken outside. Surrounded by hyacinths with their suffusing perfume, the group contemplated a view that stretched from the cliff-edge to the distant horizon. In later years Riley would make a connection between the thrilling panorama of rocks and sea she saw on those mornings and Georges Seurat's *Le Bec du Hoc, Grandcamp* (1885), a painting that would thus become replete with personal significance. During the winter months the same outward journey would coincide with the break of dawn. On those

occasions they watched the retreat of night and the gradual spread of light across the sky and sea. These were experiences that ignited a sense of wonder. This coastal walk, from cove to cove, was perhaps the most spellbinding of all. It formed a glittering thread, and along it moved a small but close-knit unit. Walking and looking; the pattern became ingrained. And with the passage of the days, each individual grew acutely receptive to the spectacle around them: the changing face of nature that followed their every step.

As the months passed, anxiety was held at bay but did not abate. A trickle of Red Cross postcards occasionally brought reassurance to others in a similar position, but regarding Jack's whereabouts – and his fate – silence prevailed. A year came and went and, in the circumstances, must have seemed a very long time. Beyond the only notification they had – that he was missing – there was an even bleaker prospect: presumed killed. This was the unspoken fear, the worst possible outcome. In the face of that eventuality, the family went on, immersed in an uncertain way of life that in almost every other aspect was a source of joy. But isolation could breed despondency and was an ever-present prospect. While there was a circle of contacts, these were dispersed, with long distances between people living in the wider area. Some sense of that separation can be gathered from the system of communication that evolved between neighbours. Uncle George also owned Maze House, the cottage situated at Efflins on an adjacent ridge visible from Trevemedar. The occupants would put out a red cloth that meant, 'Can we have the pony and trap, please?' Such contacts were important, for they staved off the sense of being marooned.

Among these neighbours, Mrs Marjorie Kitton became a great source of reassurance and advice. Louise met her at Porthcothan Bay, where she lived with her soldier husband, Colonel Kitton. Older and eminently sensible, Mrs Kitton was an organising force, helping with the local Women's Institute and with Red Cross activities. She took an interest in the Riley family and their predicament. When Louise cycled to Shop, the small, local village where she obtained groceries and other basics, she would always peruse the newspapers on sale there for news regarding

the progress of the war. Mrs Kitton knew this and, in advance of Louise's visits, made it her business to scan the relevant reports, and to remove anything that would potentially be worrying or upsetting. In this way, Louise was protected from developments that could easily have been demoralising. In her military bearing, Mrs Kitton was a force to be reckoned with, a person alert to the need for self-discipline. 'Woman, dear' was her term of address for Louise. Neither did Bridget – 'bold girl' – escape her reproving eye. That force of personality was put to good effect in the potentially distressing situation that now blew up. In view of the length of time that had elapsed, the War Office assumed that Jack had indeed been killed, and that Louise was therefore receiving payment in respect of his service, to which she was no longer entitled. Facing the dire prospect of having to repay this money, a tearful Louise sought the advice of the redoubtable Mrs Kitton. Reinforced by her husband's rank, the riposte she launched was decisive and the authorities backed down.

With no end to the war yet in sight, and concerns about Jack as pressing as ever, Bridget's life in Cornwall was suspended between the idyllic and the ominous. The beauty she sought and found in nature was an end in itself, but, at some deeper level, it may also have become something even more profound and lasting: a consolation in the midst of adversity. With that emotive foundation, visual experience assumed an affective character that would have an abiding significance. Games proliferated. The children built a big swing near the vegetable patch. There were bathing parties at favourite spots, away from adults' watchful eyes. Further afield, there were tree houses at a range of secret locations. Some of their hideaways were built on the ground, beneath tamarisk and hawthorn bushes, and had an earth floor. Places of escape from the grown-ups, the 'huddles', as they were called, were equipped with utensils and other bits and pieces that went missing from the cottage. A reprise of the tree house at Bushey Park, such shelters – eventually there were 13 of them – were constructed from branches and well camouflaged with leaves. They were also private sites for exercising the imagination, the forerunners perhaps of the various studios, dotted at locations in London, Cornwall and France, that Riley would occupy in later life.

The domestic routine of country life continued, and sustained the family. Essential small chores had a purpose and a charm. Fetching water was a pleasure and was appropriately rewarded: 'Thank you Bridget, that's wonderful.' In autumn, the migration of birds was a stirring display, casting great nets of activity, turning and twisting across the sky. These were sights beheld and then stored away in memory, the emblems of an impressionable age. During winter, the children's evening baths were taken in front of the glowing fire. At those times, the wireless played in the background, supplying a cheering source of music and – avidly followed by them all – a constant supply of news about the progress of the war. At bedtime there would be covert reading under the covers. At the centre of it all was Bridget's mother: 'indomitable'. Then, one otherwise ordinary day in autumn 1944, a postcard was delivered that changed everything.

Louise's younger brother Albert was staying in Cornwall and at that moment happened to be paying a visit. Betty was also present. Considering the momentous news that it conveyed, the card itself was perfunctory and formal. In the form of ticked boxes, this Red Cross communication reported that Jack Riley was alive and being held in a Japanese prisoner of war camp. The signature that accompanied these bald facts was the sole point of personal contact, but, as the 13-year-old Bridget noted, it was undoubtedly his. After two and a half years without a word, this wonderful news unleashed those feelings that had for so long been checked. Louise fled into the fields at the back of the house and absorbed the revelation. She was comforted by Albert, who pressed a bottle of brandy – long stored in the grandfather clock for precisely this occasion – into service. Louise was overwhelmed and a sip of brandy did not help, but nothing could erase or enhance the central fact that her husband had survived.

It would later transpire that his escape had been a narrow one. Following the fall of Singapore, the plan was that the captured men were to be marched to a destination in Thailand where the Japanese were building a railway. About to commence that fateful journey, he had succumbed to diphtheria and had been hospitalised. This may have saved his life, for during the march that continued without him a terrible massacre took

the lives of many comrades. His subsequent experiences as a prisoner were no less awful, with ferocious searches, inspections and other cruel treatment common. He recalled that a continuous problem was that of persuading the younger men not to try to escape, there being no place to go. Throughout that time, the letters that Louise had continued to send all reached him, and he believed that they sustained him. But such revelations belonged to the future. For the moment, what mattered most was that he was safe.

4 Leaving Trevemedar

Even as Bridget's life in Cornwall gained in familiarity, the prospect of that time ending loomed. After almost four years without a regular education, Bridget's and Sally's academic progress – such as it was – had become an increasing concern. Louise again consulted Mrs Kitton. The older woman had two daughters who were boarders at St Stephen's College, an Anglican convent school. Based in Folkestone, on the southeast Kent coast, the school had been evacuated to Taplow, Buckinghamshire, at the start of the war. With Mrs Kitton's support, Louise explored the possibility of Bridget and Sally attending. Having to pay fees would have been a problem and Louise sought help from one of her aunts. As that hoped-for support was unforthcoming, the source of funding is something of a mystery. It is possible that the ever-helpful Mrs Kitton may have spoken to the school about the Riley family's predicament, and that the school took a benevolent view and waived their charges.

Bridget's new address could hardly have been more different from the home in Cornwall that she left behind. The school was housed in Taplow Court, a large, stately Victorian house that had been the seat of residence of the Grenfell family since the mid-nineteenth century. After it was inherited by the first Baron Desborough in 1867, it became the hub of the family's prominent social life, and distinguished visitors included Henry Irving, Vita Sackville-West, Edward VII when he was Prince of Wales, H.G. Wells, Patrick Shaw-Stewart, Edith Wharton and Oscar Wilde. Situated within extensive grounds, this formidable mansion comprises four storeys built in red brick in an early Tudor style. The approach to the house is impressive, numerous tall chimney stacks and gables increasing the overall impression of towering height. On arrival, the visitor passes

through a heavy oak door set within a Norman-style arch, and discovers a vast, glazed central hall that ascends to the extreme vertical limits of the building. For a 13-year-old used to a two-up two-down cottage, the experience would have been disorientating.

Indeed, Bridget found her time at Taplow Court destabilising. She was immediately homesick and found it extremely difficult to adjust to her new surroundings. She missed the family atmosphere and everything about her outdoor life in Cornwall, which had become so central to her existence and feelings. However, not everything was intimidating. The teachers now directing her daily life comprised nuns and lay staff. Headed by the Mother Superior of the school, Sister Jean Marian, known as 'Jam', the staff were generally welcoming and sympathetic, and Bridget warmed to them. Complete with wimple and gown, Sister Agnes, who taught mathematics, was a favourite among a cast of congenial characters. The facilities were also remarkably well-appointed and salubrious. There was a fully equipped gymnasium and a tennis court that boasted a gallery. Traces of the building's peacetime character were evident in odd places. In one corner of the court there was a full-size stuffed giraffe, and in the other an equally well-preserved hippopotamus. Further evidence of big-game hunting could be found in the former smoking room, which was lined with photographs and other trophies of exotic expeditions. The surrounding grounds and gardens were expansive and provided beautiful walks.

All in all, St Stephen's was, in its own way, extraordinary. Life there had its gentle rhythms and religious conventions, with grace before meals and evensong at the close of day. Even so – and, perhaps, because this new habitat was so different and surprising – Bridget was uneasy. In Cornwall she had been aware of their isolated position, on the edge of things as it were, and she had been curious about the wider world. Now she had been expelled from her previous surroundings. She arrived at Taplow Court with a pink felt toy cat, made while sitting in one of her secret hideaways near Trevemedar, which provided a link with familiar territory. This mascot spoke of an insecurity that became progressively worse. At first, she participated in the lessons, but then increasingly found it difficult

to concentrate. Although she applied herself, learning and even taking in information became impossible. Her mood changed and there were outbursts of excitable behaviour. At night-time in the dormitory Bridget would lead a mass charge around the room, with 30 girls leaping from bed to bed. Pandemonium ensued. She also began escaping from the building, climbing out of windows in order to make nocturnal visits to the local river. Taplow sits on the east bank of the Thames, facing Maidenhead, and it was a relatively short route from the school across the estate, through the cedars, to the boathouse and jetty. There she would descend into the water, paddling in darkness, while renewing contact with the natural scenery that called her. These were delightful, secret experiences, sometimes undertaken in moonlight, but they were illicit.

Bridget's behaviour became a growing cause of concern. She was held responsible for the frequent outbreaks of chaos in the dormitory. After other girls joined her nocturnal rambles to the river, she began to be seen as a worrying influence and even a source of trouble. The causes of her excitability and inability to conform are perhaps not difficult to identify. The contrast with her previous rural life was marked. Having been a free spirit, in daily contact with her family and the landscape she loved, at Taplow Court she was in an unfamiliar environment and expected to fit in with the school's discipline. She railed against that constraint. There were also various anxieties. The threat of doodlebugs – Adolf Hitler's flying V-1 bombs – was an ever-present apprehension, which weighed on an impressionable mind. Nor was this an idle fear. While Bridget was still at Trevemedar, in February 1943 Louise had received a letter from Mrs Pledger, a family friend in Catford, south-east London. The letter contains a first-hand account of the devastation wrought by a bomb that exploded close to where Mrs Pledger was living. According to that description, the blast blew her out of the house, took the French windows off, and opened a big hole in the roof. Shared with the children, these were frightening revelations. As Bridget was well aware, Taplow was less than 30 miles (48 km) away from London, the main target of German aerial attacks.

The situation regarding her father was also disturbing. Among

Bridget's possessions at St Stephen's there was a collage of photographs relating to life at Trevemedar, many of which depict Jack during the visits he had made four years earlier. Pasted on the same sheet is an announcement that Louise had placed in *The Times*. It reads:

RILEY, CAPT. J.F. (Jack), 1st Indian Hy. A.A. Regt. I.A., missing Singapore, reported P.O.W. – Mrs J. F. Riley, Trevemedar, St. Eval, Wadebridge, N. Cornwall.

This short caption contains, in essence, Bridget's greatest hopes and forebodings at that time. As she now knew, her father was alive. But from that realisation sprang a host of other concerns. With the war still in progress, would he continue to be safe? Three years had passed since she last saw him. After the war was over, an eventuality she never doubted, how would this man have changed? She felt the separation from her mother keenly, and worried about the effect on the family of being reunited with a man who in some ways had become a stranger. This was also someone whom in certain moments she blamed, holding him responsible for the trial they had endured when dreading the worst. She loved her father, longed for his return and feared it.

Three years younger than her sister, Sally was less affected by the disruption in their routine and the uncertainties that continued. But Bridget's behaviour grew more erratic and uncontrollable. The nocturnal expeditions involved hiding from patrolling teachers and prefects who were anxious to ensure that all was well in the dormitory. The young rebel was also troubled by a heightened sense of the darkness that surrounded the school at night, an awareness that had never bothered her in the cottage. Such insecurities seemed to sharpen her perceptions and to make her more watchful, more receptive to an unsettling situation. The school's concerns deepened and their response was to segregate their overexcited and high-spirited pupil. She was given tranquillisers to calm her and a new regime of sleeping alone was introduced. Relocated to the ironing room, Bridget was separated off and placed under the watchful eyes of teachers who slept next door. These arrangements were worse. The ironing room

occupied a part of the building that was used as a sanatorium. The house had been built on the site of an Iron Age hill fort and a seventh-century Anglo-Saxon burial mound is still visible in the garden. The room in which she was now placed overlooked the graveyard. At night this presented a gloomy sight that distressed her further.

At the same time, however, there were causes for optimism. As the war in the Far East continued, the tide of events began to turn. Following Allied offensive operations in Burma in late 1944 and early 1945, there was a progressive advance into territory previously held by the Japanese. These developments were followed avidly by their young observer at Taplow Court. In a letter to her mother dated 4 May [1945], Bridget wrote in celebratory mood. Following the news every night on the wireless, she was well aware of the movement forward that heralded her father's liberation. Reports that prisoner of war camps near Rangoon had already been reached were exciting, and she was now able to hope that good news was imminent. With that in mind, Bridget felt the need to make plans. In the same letter, she referred to the national celebrations due to take place on 8 May. Anticipating that VE Day would mean a half holiday from school, she outlined her intention to travel to London. Accordingly, on the great day itself, Bridget was part of the huge crowd that gathered in Trafalgar Square. She observed the seething mass, the scenes of jubilation, the men and women dancing in the fountains and the tears of joy. Coursing through that throng, one overwhelming emotion rose up above all else – that of relief.

In the same earlier letter to her mother, Bridget correctly surmised that Louise would also have her own plans and would be in the midst of making preparations to leave Trevemedar. She, too, had been galvanised by the news of the advance by British forces towards Rangoon in early May. A letter sent by Ira Bartlett's wife Mabel on 6 May makes clear her realisation that this military success brought closer the prospect of Jack's return. In that message, she expressed elation and keen anticipation that the family would soon be reunited. With that prospect in mind, she looked forward to celebrating as soon as they heard that fighting had ceased, an event that would signal the beginning of the process of repatriating

prisoners of war. Mabel confided that three bottles of Liebfraumilch were ready and waiting, one of these being set aside for Jack's return. There was no doubt that the news changed everything. In common with Bridget, Mabel expected that Louise would be preparing to depart from Cornwall and getting ready to return to Boston.

Indeed, with these quickening developments, Louise closed down the cottage at Trevemedar, leaving behind the place that had been the family's haven for over four years. This involved parting from Betty, who went to live in Sydenham, south-east London. In taking her leave of Cornwall, there must have been an acute sense of a way of life coming to an end. Replacing it, Boston now had to be made ready for Jack's return. In the meantime, Bridget's own separate existence at Taplow Court maintained its uneasy progress. As the letters to her mother intimate, there were occasional flashpoints. One of these involved her French teacher, with whom Bridget lost her temper. The outcome of Mademoiselle Goufflé's perceived failure to explain properly and her pupil's inability to understand, there was a major difference of opinion and tears were shed. Bridget's letter suggests that a main cause of this incident was the frustration felt by the 14-year-old at not being able fully to grasp the object of her attention. The need to comprehend would be an abiding imperative of Riley's maturity.

The atomic bombs dropped on the Japanese cities of Hiroshima and Nagasaki in early August 1945 brought the war in the Far East to its conclusion. On 15 August Japan surrendered, and with that momentous event Jack's eventual return was assured. The exact date when the family was reunited is not known but certainly took place in October 1945. Wearing the grey suit that she kept for special occasions, Louise travelled to London to meet him. During the time he was missing, the children used to play a game that involved performing certain feats of running and jumping in order to secure his safety. Louise always responded to these dares by saying, 'Don't make bargains with God'. Whatever pacts had or had not been struck, Louise and the girls now received the prize for which they had hoped, for so long. The man who now re-entered their lives was not the same as the light-hearted, amusing individual they remembered

sitting on the beaches in Cornwall. The man they beheld was much thinner, greyer and a little graver. But, his appearance and demeanour were otherwise remarkably unchanged. Extraordinarily, he seemed undamaged by his experiences. As would emerge later, he survived the process of incarceration through self-discipline and extreme determination. At his lowest point, when he was incapacitated by diphtheria, he had clung to the conviction, 'I'm coming out of this'. That quality of stubborn endurance, which verged on obstinacy, had been a lifesaver. But his patient stoicism was matched by another great strength. Riley's father said he never worried.

5 First steps

Following the end of the war, St Stephen's was re-established at a new location at Broadstairs, a coastal town on the Isle of Thanet in east Kent, and Bridget and Sally continued there as boarders. However, the war had disrupted their studies and their father's return unsettled Bridget further. Her academic progress became an increasing worry to her teachers. Still prone to overexcitement, Bridget remained under close supervision as this was felt to be the most reliable way of checking her nocturnal excursions. Furthermore, the school persisted in relying on sedation in order to calm their unruly pupil. During the daytime, she sat opposite her teacher in order that she could be observed closely. The abiding impression was that Bridget was 'not good at taking things in'.

During holidays the girls resumed their pre-war existence in Boston and, after Jack's return, the family was reunited. They now reaped the reward of the austerity they had endured. Holly House had been acquired on a mortgage, but throughout the war years was rented out to local RAF people. After the family's return to Boston, that income enabled Jack and Louise to pay off the mortgage. While living at home, Bridget readjusted to her former surroundings and to the experience of again being with her parents and sister. Viewing the house with older eyes, its considerable comforts were apparent to her. In complete contrast to the cottage at Trevemedar, there were fitted carpets, each a rose colour; heavy padded curtains bound with cords; a staircase; a breakfast room and a luxurious bathroom. The rooms also boasted excellent antique furniture, including many fine pieces inherited from Louise's father. Bridget's mother added to that collection with items she acquired from the local rag-and-bone man, but she had a good eye for quality and an ability to recognise the

potential for effective restoration, at which she was adept. She also began to add certain decorative touches and had a penchant for Bernard Leach pots. Holly House became Louise's creation, and it had style.

The sumptuous character of their reinstated home was indulged. But because they had become used to an entirely different way of life in Cornwall, their present accommodation seemed at odds with their recently acquired habits and conventions. In that respect life at Boston had a Jekyll and Hyde character, with comfort vying with a contradictory instinct for simplicity. To Jack's bemusement, Louise, Bridget and Sally retreated, and began sleeping in an outbuilding at the back of the house. Used as a place for drying clothes, this simple shed was open on one side. It offered a view of the garden, and at night admitted the subtle colours, changing light and delicate fragrance of their surroundings. That direct contact with nature was an antidote to the suburban character of the house, striking a chord that evoked their former rural existence. It seems that through living in Cornwall the trio had merged with the rhythms and character of the landscape to an extent that possibly even they underestimated. Louise and her children missed the countryside and yearned for that sensory engagement.

Although the family was reunited, Bridget was disturbed by this profound change. Delighted to be with her father again, she also had to get to know this unfamiliar man. Transplanted from its previous locus, the family unit had altered. Betty had gone and was missed. Cornwall was receding into the past, and, as a result of the difficulties she was experiencing at St Stephen's, Bridget's future seemed uncertain. It was around this time that she took her first steps along the path that would determine her adult life. On the top floor at the back of the house, the room that previously had been a nursery now attracted her attention. She started to use it as a private place to which she would retreat, and it was there that she began to make art. The exact reasons for that important development are unclear. There had been beginnings at St Stephen's when she had started working with a drawing mistress for a couple of hours each week. She had also commenced drawing there, by herself, this activity replacing the academic studies with which she had struggled.

Possibly the enforced isolation of her sleeping arrangements had prompted that alternative interest and means of expression.

In the room at home that she redesignated as a studio, drawing became a developing passion and provided a focus for exploring her interior life. An extension perhaps of the continued night-time retreats into the garden with Louise and Sally, the sensory impressions that populated her visual memory now proliferated and became a source of inspiration for her art. Through making sketches and studies, she indulged her observations. She also gave free rein to her imagination. One of her earliest efforts was a picture depicting the explosion of an atomic bomb. The source of that terrible image was, as she was well aware, a human catastrophe. She understood the arguments for and against its use. At the same time, she linked the event with the return of her father. A monstrous calamity, it had brought the war in the Far East to an abrupt end, and, in so doing, had secured his survival.

Other imaginative inventions followed. She depicted people in caves, influenced by accounts she had heard of Henry Moore's shelter drawings. She also drew from observation, producing views of buildings, windows and gardens. Still lifes and portraits began to take shape. Louise and Sally were her first sitters. To her delight, she discovered a talent for such studies. A deepening engagement with the appearance of her world increasingly governed this private activity, and she was thrilled by being able to replicate the look of things and the features of people. In making that connection she was struck by a feeling of beauty, one she associated simply with the act of creating art, rather than with any elevated artistic ambitions. With practice, this way of working became automatic and even inevitable. Through the creation of images of places and people, she found a process that was completely absorbing. Such early essays were exploratory and revealed little in terms of the difficulties that lay ahead. But in the freedom they afforded, and the consolation provided, there was an intimation of things to come. In retrospect, Riley recalls thinking to herself at that time, 'This is what I would do.'

In pursuing this activity, there were meagre family precedents. Her great-aunt Grace (the wife of Louise's uncle George) had owned a few

flower paintings that had caught Bridget's notice. And, as we have seen, her aunt Betty had evinced an early interest in art but had never taken any further her student involvement. Beyond these blood relations, there were few other examples that had made any impression. In Cornwall, she had been vaguely aware of a local commercial artist named Andy Johnson who lived at Porthcothan Bay. He later made a portrait of Louise, and possibly that stirred a developing interest in making images of people. Among these fragmentary instances, only one memory stands out with any definition. At Taplow Court, the dining room had been housed in a large gallery that contained two large original landscape paintings by Philips Koninck. Traversed by water stains resulting from a previous accident, these magisterial works had impressed the young Riley. At the same time, the damage they bore worried her. Possibly the future painter's earliest encounter with art of any distinction, she had viewed these representations of place with a mixture of fascination and compassion. From this relatively small number of antecedents, Riley's lifelong preoccupation with art would grow.

Her parents welcomed these advances and began actively to encourage their daughter's burgeoning talents. They were glad that Bridget had found something that engaged her fully, a positive way of behaving and thinking that tempered her previous tendency to excitability. They bought her books on art and assisted in turning the former nursery into a place in which she could work. This, her first studio, had a fireplace, two windows admitting a good light, a floor covered in linoleum and, most importantly, an easel. It thus became the site of her first paintings. With growing confidence and a dawning awareness of the nature of the task, Bridget now began to think about how best to develop her ability. The idea of attending art school emerged and became a focus of debate. While her parents were keen to support her, they were concerned about the shortcomings of her education, her future need to earn a living and – as Jack in particular saw it – her marriage prospects. Bridget brushed these issues aside. At this stage the idea of a career repulsed her. The notion of becoming an artist was not even an issue. She simply wanted to learn how to draw and paint.

With admirable pragmatism, they agreed a plan to put her artistic potential to the test. It was suggested that Bridget should amass a portfolio of work that could be properly assessed, and the practicality of attending art school determined. Lacking the appropriate expert connections, Jack asked his employer Ira Bartlett for advice, and the older man proposed sharing Bridget's portfolio with an associate of his who was well placed to give a view. The individual he approached, George Butler, was Director of the art department of the London-based advertising agency J. Walter Thompson. Then 41 years old, Butler had attended Sheffield College of Art and the Central School of Art, London, where his teachers included the Scottish artist A. S. Hartrick. Alongside his professional position at J. Walter Thompson, Butler was an artist in his own right and had held his first solo exhibition at the Redfern Gallery in London in 1927. He also exhibited with the London Group, the New English Art Club and at the Royal Academy of Arts. The subjects of his work included landscapes and drawings of young girls, frequently ballet dancers. In terms of Riley's future development this would be a crucial contact, for Butler recognised the importance and significance of drawing, an activity he once described – with some insight – as the probity of art.

Butler was well connected and, in turn, showed Bridget's youthful drawings to various distinguished colleagues. As a letter dated 20 June 1946 that he sent to Jack reveals, Butler carried out his task conscientiously. By his own account, those he consulted included Charles Cundall, RA, James Fitton, ARA, two Ministry of Education Inspectors and one art school principal. The response Butler provided was perceptive and its detailed advice would guide the next phase of Riley's life. He began by summarising the opinions he had solicited. All were agreed that for a girl of her age the drawings were very interesting and showed evidence of unusual gifts. The consensus was that Bridget was a precocious student who should be given the opportunity to develop her drawing ability, albeit without being given the impression that she was abnormally brilliant. He therefore recommended that she should carry on with her ordinary education until she gained a school certificate, and at the same time should have extra drawing and painting lessons. Butler then turned to

the knotty question of her future art school education. In his view it was preferable that she attend a college in London. His sense was that she would be treated more sympathetically there than in a regional art school, and that studying in the capital would enable her to make supportive contacts with other female students. Drawing attention to the different qualities of the various London art schools, Butler cited Chelsea Poly-technic (as it then was known) and Goldsmiths College as being the most suitable in his estimation. He concluded with an invitation for Bridget to make contact with him when she was ready to make a choice, at which point he would provide up-to-date advice on the final selection of a school.

These were sound observations, and if her father was in any doubt about his daughter's potential this reassured him. His reply to Butler dated 27 June 1946 is illuminating, as it suggests the way things were developing. In his letter, Jack confirmed the importance that Louise and he attached to Butler's encouragement and advice, adding that they had seen her recently at her school and, exercising discretion, had told her some of the opinions they had received through Butler. Jack reported that as a result Bridget was both very excited and keen to move forward, and that she understood the need to work hard not only at her drawing and painting but also for her general education. In addition to the drawing lessons she had been receiving at her school for two hours each week, in the same letter Jack referred to another activity. Apparently Bridget was keeping a private notebook in which she preserved small sketches and ideas for subjects that she felt unable to develop at school but intended to work on in private moments during her holidays. In that secret activity there is an intimation of the frustration Bridget felt at not being able to express herself fully in the drawings she was making at Broadstairs, and already a sense of her impatience to devote herself to art of a more personal nature.

Around this time the prospect of being released from St Stephen's sooner rather than later became a reality. Towards the end of the summer term Louise was invited to come to the school for a meeting with Sister Jean Marian. In what was evidently a difficult conversation, the Mother Superior confided that they could not cope with her visitor's daughter. Their view was that Bridget was not learning very much and, indeed, they

felt unable to do anything further to help. Sister Jean Marian's conclusion was she would be better placed 'somewhere else'. Although there was no disgrace in that advice, the implication sounded a note of alarm. Bridget was 15 years old, but her education was far from complete. If there had been any thought of Bridget continuing her education at the school, such an idea was dashed. Looking ahead, Louise was acutely aware that an emancipated woman – as she was determined her daughter would be – needed some means of making her way in the world. Remedial steps would be required. The problem of finding an alternative school now became pressing and she and Jack began what would be a lengthy search.

Bridget's time at St Stephen's came to a close at the end of the summer term and she returned to Boston for the holidays. For the time being, her education was suspended, and, as Jack had intimated, at last she was able fully to indulge her passion for drawing. Even so, things would not go quite as Bridget hoped. Butler's advice had shown the way. She would go to art school, but – much to her dismay – not straight away. Before that she would need to complete her general education elsewhere.

6 Great promise

Bridget railed against the prospect of having to postpone starting at art college, and did her best to avoid further attendance at secondary school. She was invited by Butler to come to his home at Chipping Norton to discuss her work, which she did. The urgency she felt about beginning her art training was plain to see. Her interviewer was sympathetic and he presented her with a set of oil paints, brushes and canvas pliers.[1] However, the young artist's impatience was to no avail. Butler was kindly but firm and he repeated his advice, impressing upon her the need to catch up before going forward. Her father was similarly convinced and anxious to put Bridget on a solid path. In part he was motivated by the perception that his daughter was not only talented but also headstrong. Keen to place his family's future on a surer footing, his view was that in Bridget's case some discipline would not go amiss. Despite the problems she had experienced at St Stephen's, boarding school remained the preferred option and was seen as a valuable way of encouraging independence. Accordingly, the search for an appropriate new school continued with a mounting sense of urgency. Travelling around by car, Jack and Louise visited several prospective institutions, accompanied by their entirely unconvinced charge. Bridget disliked them all. Eventually their quest led them in September 1946 to Cheltenham Ladies' College in Gloucestershire, a destination that filled the would-be artist with apprehension.

Founded in 1854, this prestigious and somewhat formidable establishment included Dorothea Beale as one of its former headmistresses. A prominent suffragette, Beale was appointed as Head in 1858. She pioneered the school's ethos of providing a fully rounded education for girls, equipping them to take their place alongside men in what was then a less

than equitable society. Jack, Louise, Bridget and Sally were greeted by the school's Principal, the impressive Miss Margaret E. Popham. Prior to this meeting, there had been an earlier interview when the subject of taking both girls as boarders, as well as the predicament posed by Bridget's talents and frustrations, was raised. On that occasion, Bridget's talents were discussed, as was her character, her previous problems and the uncertainty she was still experiencing. Miss Popham took all this in her stride and indeed went out of her way to accommodate an individual who appeared difficult, yet, in her own way, exceptional. Following their discussion the perceptive headmistress wrote with an offer of a place at the school. As Miss Popham's letter intimates, the family's wartime experiences were taken into account. Requesting that the matter remain confidential, she explained her conviction that those who had suffered in the war deserved special consideration, and for that reason the Riley family had been given preference over other applicants. Accordingly, Bridget had been found a place in St Helen's House.

The deciding factor was, however, Bridget's artistic ability. Examples of their daughter's paintings had been shown to Miss Popham and evidently made an impression. In the same letter, she reported her belief that because Bridget was a very sensitive and gifted person there was a consequent need to ensure that she was happy at school. Nor had the aspiring painter's acuity of perception gone unnoticed. Being aware of Bridget's sensitivity to appearances and aesthetic issues, Miss Popham felt obliged to disclose that Miss Barnes, Bridget's future House Mistress, had been blinded in one eye as a child, and for that reason her eyes differed. She mentioned this in anticipation of Bridget noticing it immediately, adding that she would be placed in the care of a deeply spiritual individual, a very experienced woman who was keen on art and drama and able to provide the necessary support. Aware of the particular needs of her prospective pupil, the Principal included in her letter an expression of personal interest, observing that she should like Bridget to keep in touch with her. She concluded with a promise to talk to the senior art mistress about her new student, requesting that Bridget bring the paintings she had seen previously as she wanted to share these with her colleague.

Deposited in the hall of their new school, Bridget and Sally were left in the care of Miss Popham while their parents returned to Boston. Bridget took in her mentor's appearance. Aged 52, Miss Popham had become Principal nine years earlier and was in her professional prime. Smartly dressed, she conveyed an impression of total commitment to her role, which remained, as it had been for her distinguished predecessor, Dorothea Beale, that of producing properly educated and resourceful women. Miss Popham had a modern outlook. The world for which she was preparing her charges was, as she was well aware, a changing place. In the wake of the war, Britain, and indeed all the combatant nations, had been shaken to their foundations. Politically and socially, the landscape had been profoundly altered. The feeling of relief that had accompanied the end of the conflict was now joined by uncertainty about the future.

In their different ways Miss Popham and Bridget shared a sense of the unpredictable nature of things. During the war Bridget used to look at a large map of the world. Focusing on the Far East, she would think, 'Somewhere there is father.' Then she would survey the wider area covered by the British Empire, defined by its large expanses of pink, and there followed the thought, 'and because of all this, that is why he is there.' Now the contours of her world were changing again. As she viewed her new headmistress, her mind turned to her immediate situation and was clouded by dismay. Determined and proper, Miss Popham was likeable but not a woman to be trifled with, and her school appeared to Bridget rather regimented. For her part Bridget was cross with her mother for – as she saw it – letting her down. Louise had promised her she could attend art college but had been overruled by Jack. Once again Bridget was standing in an unfamiliar place. Viewing its corridors and files of girls walking in silence, and not yet possessing uniform of her own, she felt completely unsettled by her predicament.

Despite her initial misgivings, Bridget made a favourable impression. A month into the autumn term, Miss Popham reported to Louise that she thought both her daughters delightful. Putting aside the reports of Bridget's previous difficulties, she found her instead to be a sweet-natured

girl, able to make friends easily and to fit in generally. Bridget's medical report, completed around the same time, records her appearance. Aged 15 years and 6 months, she was petite: a little over 5 feet (approx. 152 cm) tall, weighing eight and a half stone (54 kg). Interestingly, at that time she was wearing glasses, an optical prescription that disappears from her subsequent medical assessments. Academically, too, she won praise for her efforts, but there were the first signs of concern about her level of attainment. At the end of the autumn term her class teacher's report noted that she had found the work in academic subjects somewhat beyond her capacity but had attacked it with courage. On a positive note, there was a sense that if she kept up that attitude and worked with confidence, she would overcome many of her difficulties. Somewhat ominously, however, Miss Barnes added that Bridget did not always take correction well. Indeed, there was a note of qualification in her observation that Bridget was a pleasant member of the house – when things were going smoothly.

Unfortunately, the course of Bridget's subsequent progress was not entirely smooth. Having made an auspicious start in art, a subject to which she had pinned her hopes and ambition, her involvement in that subject now won qualified praise. Her art teacher considered that she had much creative ability but needed to discipline herself in order to master the fundamentals of composition and technique. Her art report for the following term was also somewhat slighting; it noted that Bridget's work was less superficial than previously, but she still needed to concentrate on drawing and composition. For a student who had formed an early confidence in her ability, this criticism must have felt like a setback. Miss Popham's assessment for the spring term 1947 was warm but adopted a rather imperious tone. The Principal noted Bridget's excellent qualities and appreciated her friendliness. However, there was a stern reminder of her pupil's need to learn to read, write and spell if she wished to avoid going out into the world an illiterate person. That note of condescension reflected the struggle Bridget encountered with her studies, but it also sowed the seeds of problems that began to develop.

Although her teachers believed that she fitted in well socially, Bridget felt isolated. Sally was in a different house, a precaution taken by Miss

Popham, who maintained that Bridget and Sally ought not to be together. Bridget also struggled to catch up in subjects in which she was still some way behind. The school boasted a wonderful library, but she was at a loss as to how to use it, no training having been provided. Miss Popham's imperative that she should improve her literacy thus foundered. Bridget disliked the rote of prep and set work that followed supper and longed for the outdoors. Gradually she fell into a pattern of not doing very much and, whenever possible, simply idling in the school's garden. Miss Popham now recognised that her pupil presented a difficulty to which no ready answer was available. As a result of the earlier disruption to her schooling, she was at least three years behind her peers in terms of academic development. Putting the girl in a more junior group in order to make up the ground would be upsetting and was not deemed an option. But being out of step with girls of her own age was creating frustrations both for the teachers and their pupil.

Miss Popham puzzled over this perplexing issue and spoke to Bridget directly. Confronting what seemed to be a situation of academic disarray, it was suggested that she should complete her own timetable and was invited to fill this in to reflect her own wishes and needs. This she duly did, but, to the Principal's consternation, art appeared in all the available slots: morning and afternoon, every day of each week. It was a shot across the bows, intended to make a point, and it produced a predictable, negative response. Having reached something of an impasse, Bridget's studies took a turn for the worse, accompanied by a descent into what her house mistress perceived as wrongdoing. During the summer term of 1947 it was discovered that while spending time in the garden, Bridget, together with two other girls, had been consorting with some local boys. Worse still, Bridget had passed a note to one of the youths and she was identified as the ringleader in this misdemeanour. Punishment was therefore in order.

In an echo of her previous spell of isolation in the ironing room at St Stephen's, the wrongdoer was now despatched to the school sanatorium where she was to spend three weeks in what Riley later described as 'solitary confinement'. As had been the case on the earlier occasion, the perception was that Bridget was too excitable and, having been separated

from the other girls, a period of private reflection would help. As Riley's recollection suggests, it was, however, an extremely disagreeable and stressful experience, which she felt to be more connected with harsh discipline than therapy. It was during this period of incarceration that help appeared in the form of a new art master, Colin Hayes. Then 27 years old, Hayes had attended the Ruskin School of Drawing in Oxford. With the outbreak of war in 1939, like Riley's father he had volunteered for the army. Commissioned in 1940, he served with the Royal Engineers and had been wounded while on active service in the Western Desert. Recently invalided out of his military responsibilities, his first teaching post was as the school's Head of Painting, a role he took up in 1945.

Hayes was a protégé of Kenneth Clark, the former Director of the National Gallery, London, and at that time the recently appointed Slade Professor of Fine Art at Oxford University. Clark's daughter was a pupil at the school and he had been instrumental in convincing Miss Popham to employ the brilliant younger man. Little persuasion was necessary as the Principal greatly admired her new recruit. It transpired, however, that Hayes's time at Cheltenham Ladies' College was relatively short: he went on to join an influential teaching staff at the Royal College of Art, London, in 1949. But in terms of Riley's artistic development this was a fortuitous encounter and Hayes's teaching was hugely beneficial. Central to his approach was the principle that in order fully to comprehend a subject it was necessary to draw it. With the eye and the intellect working in harness, Hayes encouraged self-criticism and an avoidance of easy solutions. Through active visual engagement with an observed motif, the artist acquired a thorough understanding. Hayes would impart these valuable insights to his eager apprentice.

First, he began by relieving her unhappy situation in the sanatorium. Hayes was aware of Bridget's punishment and was sympathetic to her predicament. Accordingly, he arranged for paints to be sent to the isolated pupil. Nearby there was an escarpment that presented a view of some trees. Bridget recognised this as offering a beautiful subject and she obtained permission to go out of doors to paint the motif. Hayes visited Bridget during her incarceration, saw her paintings and encouraged her.

With growing confidence, more paintings followed and Hayes continued to provide a supply of materials. Through that positive re-engagement with art, she regained strength and a renewed sense of purpose. With hindsight, Riley felt that Hayes 'saved' her. In the face of adversity and confronting complete confusion about her future direction, Bridget found a new will to go forward as a result of her young teacher's support.

In the meantime, however, there was a highly charged interview between Miss Popham and Bridget's appalled parents. When they heard that their daughter had not only been segregated but also confined to the sanatorium, they immediately confronted the Principal to demand an explanation. Miss Popham's position was that in consorting with local boys Bridget had committed a serious misdemeanour and it was necessary to make an example of her. Louise was amazed and angry that the school would treat any girl, let alone one known to be over-sensitive, in this extreme way for a paltry offence. Normally a cooler head, Jack was no less inflamed and later told his daughter: 'Miss Popham could have damaged you for life, Bridget.' The situation escalated with Louise threatening to expose the school's actions. The matter was concluded when Bridget's solitary confinement came to an end, but the episode had been bruising for both sides. Miss Popham had taken what she regarded as appropriate steps. Jack and Louise saw this as a failure to diagnose and properly address the problem of Bridget's arrested education: a delicate issue that had placed her out of step with girls of a similar age. As a result, the problem deepened. Now that Bridget's preoccupation with art had revived, her antipathy to her wider studies was strengthened. This meant that the conundrum of how to deal with her was as perplexing as ever.

A standoff ensued, with neither side certain about how to move forward, but eventually a compromise was reached. It began with a truce of sorts. Bridget's report for the term suggests that, following her suspension, she made an effort both with her work and to comply. Previously, her class teacher had noted that she still found academic subjects very difficult. Now it was observed that Bridget had shown keen interest in class and had made progress, though still had difficulty expressing herself in her written work. Before the period of internment, Miss Barnes

had complained that her pupil was too easily defeated by difficulties and remained resentful of correction. With Bridget once again part of her house, Miss Barnes expressed the view that she had learned the folly of allowing herself to be led into wrongdoing and, since her return, was more compliant. Notwithstanding the exchange with Bridget's parents, Miss Popham was no less confident of the efficacy of punishment. She reported her pleasure that Bridget had realised her mistakes, had become quiet, steady and sensible, and for that reason had regained the Principal's trust.

Following that tacit approval, during the autumn term of 1947 Bridget secured the concession she had been seeking. Recognising perhaps that its pupil continued to struggle academically, the school now adopted a different course. Instead of studying English literature, English history, French and geography, Bridget was placed in the Citizenship class. Comprising divinity, English, history, economics, social history, anatomy and physiology, this alternative mode of instruction was aimed at girls who were not taking specialised subjects to examination level. Rather, the Citizenship course aspired to equip them with a grounding in the functions of society. Bridget seems immediately to have prospered. Her class teacher noted that she had enjoyed a good term, had lost her fear of the more academic subjects, and had begun to do well in them. Even the somewhat stern Miss Popham conceded that there had been real development. But this improvement concealed a deeper advancement. Concurrent with taking up Citizenship, Bridget was permitted to engage with art much more fully. Her previous idea of studying art to the exclusion of all other subjects was not resurrected, but there was a substantial move in that direction. From now on, at least half her timetable was devoted to the subject she had coveted.

Most importantly, this aspect of her education was entrusted to Colin Hayes. With these changes, Bridget embarked on a happier time. She began working with an enlightened teacher who contributed substantially to her growth as an artist. With his air of quiet authority, Hayes taught his promising pupil the rudiments of painting. He showed her how to lay out

a palette of colours, demonstrated the practice of mixing different hues and explained the methods of preparing a surface using rabbit-skin glue. Bridget greeted these insights with a profound sense of relief, reassured that this was someone who really knew what he was doing. Central to her tuition was the encouragement to draw. As Bridget now realised, Hayes's approach was uncompromising. There were no shortcuts and no reliance on stock responses. Making a drawing involved long looking, careful scrutiny, the precise analysis of tonal values and the construction of an equivalent pictorial structure. The grounding she now received in tonal drawing was, in terms of Riley's subsequent development, of fundamental importance. It was an approach that would serve her well, rooted as it was in observation, evaluation and equivalence. As Hayes's example intimated, a drawing proceeded from the motif, but had to make sense as an end in itself.

Working with this unflamboyant but dedicated young man, Bridget gradually acquired a growing seriousness of purpose and attitude. That emerging maturity not only underpinned her approach to art but also benefited her wider studies. She was happier because, fundamentally, she knew what she needed to do, and was now receiving the instruction she desperately desired. In addition to self-portraits and portrait drawings of other girls, she made watercolour studies of trees. Occasionally Hayes's own mentor, Kenneth Clark, visited and saw her efforts. Although she was unaware of her visitor's importance, the praise she received from Clark was an additional source of confidence. Hayes's report for the first term of his tuition reveals as much about the teacher as it does the pupil. Focusing on drawing, he noted her strong sense of constructive form, which he felt showed great promise. However, by way of caution, Hayes recommended that while concentrating on closely observed drawing she must avoid a tendency to fall back on clichés; in particular, he felt it important that she avoided acquiring an easy but limited facility. He concluded that on her present form she was certainly justified in her decision to undertake a proper art training, and cited her paintings, which showed understanding of tone and colour, as supporting that resolution. All in all, Hayes

acknowledged a student with intelligence and original ideas.

The principle of achieving understanding through close observation of the subject was a vital aspect of Hayes's approach, as is evident in his own work. His paintings are characterised by an economy of means rooted in careful scrutiny, but also in the idea that he formed of his subject matter. Never illustrative, his work possesses an understated pictorial integrity arising from the clear conception of the motif that each image conveys. Hayes's ability to evoke light and atmosphere through the sensitive organisation of colour is particularly distinctive. As his student developed, the ethos of careful observation was communicated effectively and took root. In spring 1948 Hayes could report that her work was developing an intelligent understanding. In particular, she had made a great advance in drawing from life, had become more objective and scholarly, and was dropping her mannerisms. By the end of summer 1948, almost a year into her tuition with Hayes, her teacher's praise was glowing. Describing her work as excellent, he saw the evidence of unquestionable talent and paid tribute to considerable technical improvement. Her understanding of painting and tonality was now noted as a strength. While recognising that she was sometimes unwilling to persevere with a work which did not satisfy her, Hayes's sage advice was that she should persevere even at the apparent risk of spoiling it. In his overall estimation, Bridget had now developed an attitude to aesthetic problems.

The opportunity of discussing the wider context of art with Hayes was as important to Bridget as the formal instruction he provided. Among the many artists he admired, Rembrandt van Rijn and Pierre-Auguste Renoir were prominent and he later published studies on both. Among the modern influences on his own work, Hayes's idols were Pierre Bonnard and Henri Matisse. As these enthusiasms demonstrated, while a solid grounding in the practice of drawing and painting was in his view essential, art history also formed an essential part of any artist's make-up. Accordingly, Hayes was keen to expand his young acolyte's awareness of the great masters of the past. Thus, in his final report on her progress, written at the end of the autumn term in 1948, he observed that her work

was going well and that she showed a real understanding of tonal painting. There was again some concern about a tendency to mannerism, but this was something he felt could be cured through the study of paintings by masters. Somewhat earlier, thanks to Hayes, Bridget had her first encounter with modern art when, as part of a school outing, the two visited the Tate Gallery to see *Vincent Van Gogh: An Exhibition of Paintings and Drawings*. Held between December 1947 and January 1948, the exhibition was a comprehensive survey comprising almost 200 works. For Bridget it was a key moment.

Prior to that visit she had become familiar with Van Gogh's work in reproduction. Her parents had provided her with art books that included, in addition to the Dutch master, volumes devoted to Paul Gauguin and Edgar Degas. She also knew a little about Impressionism and, adjacent to that awareness, Walter Sickert's paintings had come to her attention. As this disparate group suggests, in common with her generation, her knowledge of modern art was distinctly unstructured and limited to the few publications then available. Now able to encounter Van Gogh's work directly, she was electrified by the artist's energetic handling of paint and radiant use of colour. The conspicuous presence of plein-air subject matter also struck a personal chord and she was impressed, in particular, by the painter's treatment of clouds. The spiral movement of Van Gogh's 'amazing skies' evoked memories of Cornwall and had a tangible immediacy. Such imagery quickly found its way into her own work and, in response, she painted a study of swirling clouds over rooftops that was reminiscent of Van Gogh but based on her own observations.

The open character of skies in movement would be summoned, at various moments, in Riley's mature abstract work. For example, the colour stripe paintings that she commenced in 1967 are composed entirely of abstract elements, but the arresting quality of shifting, diffused light that they advance is based on Riley's observations of nature. For the moment, however, her involvement with that subject remained rooted in description. Significantly, Van Gogh's palette was a revelation. Having absorbed Hayes's lessons about tonal painting, she now perceived the radical

significance of colour relationships. Indeed, the gulf that existed between Van Gogh, whom she recognised as a master of colour, and Sickert, whose tonal painting was for Hayes a guiding star, was plain to her.

Even so, such insights – while inspiring – were bewildering, and colour would remain a long-standing challenge that, as yet, she could only aspire to conquer. In the meantime, tonal analysis remained the focus of her work. Indeed, as Hayes's report for autumn 1948 attests, he felt it was important that his student should not only study good originals but also that she would profit from seeing the work of other and more advanced students. To that end, as part of her future development Hayes took her to the life class at the local art school in Cheltenham. There, for the first time, she saw a nude female model. By this point Hayes was clearly preparing his apprentice for art school, and this excursion was intended to ensure that there were no surprises. If her tutor anticipated a response, he was disappointed. The 17-year-old greeted the sight with complete equanimity. As a child on Cornwall's deserted beaches, swimming naked in the sea was a joyous activity and was entirely natural. Even then she had formed an awareness of others' bodies, not least while observing her mother's graceful poise and movement. If at that time Bridget had ever been self-conscious, Louise had extinguished such childhood shyness with a wry 'what's so different about you?' As a result, simplicity and dignity were linked, and nudity connected with emancipation. In the life class, Bridget regarded the proceedings with a practised eye, and although she did not participate fully, she made a little drawing. It was a beginning.

With the close of the autumn term in 1948, Bridget's time at Cheltenham Ladies' College came to an end. While her passage there had had its turbulent moments, finally an armistice was reached. Her class teacher noted that she had worked consistently well at her art and acknowledged that there was the promise of achievement – when her outlook was more mature. Miss Barnes conceded sadness that she was leaving the school. Ever proper, Miss Popham observed that Bridget had experienced a term of good development, adding that she hoped she would keep in touch. Given his previous praise, Colin Hayes's assessment

was surprisingly restrained. Somewhat laconically, he observed simply that Bridget had been concentrating on drawing and painting recently. Perhaps this intimated that he felt his pupil had gone as far as she could in her present situation and was now ready for the next step. If so, that view was surely correct.

7 The fledgling

Bridget's aspiration to receive a proper art school training was undimmed by the three years she had spent completing her general education. As she saw it, this interlude had been a deferral, albeit one that had been enormously beneficial through the tuition she had received from Colin Hayes. Now the question of which art college to attend loomed larger than ever, and the matter of obtaining a place acquired a growing sense of urgency. Once again living in Boston with her parents, she continued to work in the studio she had set up at the top of the house. Without a mentor to provide guidance, her sense of direction required a new impetus. It was around this time that she made the acquaintance of Dr Booth, whose influence would be highly significant.

The local residents were sociable and formed something of a friendly community that shared news and common knowledge. Dr Booth was a cultivated Jewish gentleman, a practising doctor, whose house was diagonally opposite the Riley family's home. He had heard of Bridget's artistic ambitions and, having taken an interest in her talents, invited her to join in with one of the cultural evenings he occasionally organised. These soirées sometimes took the form of musical gatherings, in which Louise had an interest. Living in Boston, she missed the intellectual attractions she had previously enjoyed in London and welcomed participation in the circle that formed around Dr Booth. Bridget was less convinced. No longer a schoolgirl, she was nevertheless desperately self-conscious and shy. However, when it transpired that the evening would involve life drawing and the opportunity to meet people who had art connections, she relented.

Dr Booth chose his guests well. One of the principal attendees was his

cousin, Clifford Frith. Born in London in 1924, he was the grandson
of the Victorian artist and Royal Academician William Powell Frith,
celebrated for *The Derby Day* (1856–58) and other enormously popular
paintings of nineteenth-century life. Then 45 years old, Frith had
followed in his illustrious predecessor's footsteps. Having trained at
Camberwell School of Arts and Crafts, and subsequently at St Martin's
School of Art under Roland Pitchforth and Victor Pasmore, he had
served during the recent conflict as an official war artist. A skilled
draughtsman and painter, his subjects included portraiture and, like
his grandfather, scenes of common life. He also taught art. At the time
of his meeting with Bridget, he was teaching at Goldsmiths College,
which had only just reopened, having been gutted by bombing during
the war. Frith was accompanied by Gerald Kitchin, who was a student
at Goldsmiths. This sensitive and gentle young man would form a close
friendship with Bridget. Then in his 20s, he had recently taken up a place
at the college, having been a conscientious objector and a Bevin boy,
working as a coal miner during the latter part of the war. Now he became
the subject of one of Bridget's first painted portraits made from life.

 With Frith acting as tutor for the evening, Kitchin sat as a model for
the assembled group. Bridget approached the task as Hayes had shown
her, looking closely, analysing her impressions, then reproducing her
observations faithfully and according to the idea she formed of her sub-
ject. Seated on a chair, Gerald was wearing a grey-green jacket, a tie and
dark blue trousers. Bridget noted the subtle tonal relations presented by
this understated subject and focused on the connection between the
figure and the background. Worked in oils on Daler board, the compo-
sition was executed relatively quickly and straightforwardly. Finding
the process easy, by the close of the session she had produced a small,
harmonious painting whose interplay of gentle, greyed colours was an
underpinning visual theme. The painting anticipates Riley's later pre-
occupation, during the 1960s, with abstract grey shapes in close tonal
relationships. But that lay far in the future. For the moment, she was
pleased with her efforts, and it won the admiration of her tutor and
her model.

When the session concluded, both men accompanied her back to Holly House. Not possessing a key, she rang the bell. The door was opened, and stepping into the hall she found Louise and Jack waiting, keen to know how the gathering had gone. Frith enthusiastically reported a success. Furthermore, so impressed was he with the evidence of Bridget's ability that he recommended that she should receive an art school training and suggested Goldsmiths. This was music to their daughter's ears, but there were certain conditions. She would have to put together a portfolio of work that would form the basis of her application. Also, she would need to produce a painting that would really demonstrate her abilities. To achieve that, Frith proposed that Bridget attend a week-long out-of-town residential summer school he was convening, which would provide tuition and guidance. That proposal immediately triggered the young artist's diffidence and, horrified by the prospect, she demurred.

The moment was, in some ways, a defining one. The opportunity she had been seeking now arose, but the prospect of leaving the nursery she had converted into a studio was intimidating. The fledgling hesitated, as it were, on the edge of the nest. Her father was not discouraging but also held back. He could see that his daughter had talent and determination but was not convinced that a career in art would equip her for life. In that respect, he was typical of wider attitudes shared by his generation, not least in relation to the role of women. Somewhat orthodox in outlook, he believed that a woman's position in society was bound up with being materially secure. For that reason, she had to be able to present herself as an eligible marriage partner. Being an artist was not only financially precarious but also implied a self-contained existence. Such a course seemed parlous for a woman at that time. Louise took a different view. Aware of her daughter's commitment to art, she sensed that being able to do what she so strongly desired was essential to Bridget's well-being and future happiness. For her part, Bridget was in no doubt about what she wanted, and the professional status of an artist did not figure in her thinking. The practicalities of earning a living were for her not a consideration. As Louise correctly perceived, it was the activity of making art that was all important. Even so, the idea of striking out on her own – even for a

short time – was alarming.

Louise provided the push. It was clear that if Bridget was serious about going on to art school then spending time away from home in order to make art was the essential next step. With her mother's encouragement, in spring 1949 she attended the course convened by Frith. Gerald also took part, and during that time Bridget concentrated on producing work for her portfolio. In addition to drawing, she made some painted studies of plants that were sprouting new shoots. This aspect of her botanical subject seems apposite, connecting with her own situation at that moment. Given Bridget's shyness, her attendance had required a considerable personal effort, but it proved beneficial, forming her first independent involvement in an art course. Even so, it was only a beginning. Frith did not under-estimate the difficulty of her longer-term goal: that of securing a place at Goldsmiths. Ex-servicemen whose ambition to go to art school had been interrupted by the war had priority, and the 18-year-old would be in competition with these older and more mature students. For that reason, it was important that she made a favourable impression, and therefore needed something that would provide conspicuous evidence of ability. Frith therefore now upped the stakes and set her the task of painting a copy of an Old Master.

Although she had yet to visit the National Gallery, she had several books for reference that contained reproductions. Her idea of selecting a painting belonging to that collection also had particular significance: the role of the Gallery during the war had been inspirational and she was well aware of the morale-boosting concerts given there by Myra Hess from 1939 onwards. When the first concert took place on 10 October that year, the queue to hear her stretched around Trafalgar Square. Kenneth Clark, the Gallery's Director, later observed of the concert, 'The moment when she played the opening bars of Beethoven's *Appassionata* will always remain for me one of the great experiences of my life.'[1] He added, 'It was an assurance that all our sufferings were not in vain. I think the whole audience felt this, for I have never known people to listen so earnestly nor applaud with such a rush of pent-up emotion and gratitude.'[2] Bridget knew that the Gallery had provided much-needed reassurance during that

protracted crisis, and at this present moment of personal uncertainty it seemed again to offer hope. With its array of wonderful paintings in mind, she considered which of its treasures might make a suitable subject. She settled on a portrait that ranks as one of the genre's most compelling early manifestations, a work of formidable technical achievement and subtle expression: *Portrait of a Man* by Jan van Eyck.

Painted in 1433, Van Eyck presents the sitter in three-quarters view. The work is somewhat enigmatic, and some have speculated, without confirmation, that the painting may be a self-portrait. Notable for its precise description of chin stubble, the soft fur of the collar and the slightly bloodshot eye, it combines a searching attention to detail and texture with a firm structural solidity. The result is a portrait that, in psychological terms, reveals relatively little about the impassive-looking individual who forms its subject. There are few clues to his identity and character. However, seen as a whole the painting conveys a keen sense of a living being observed in proximity. The resulting figure fills the modest image-area and has considerable presence. This is due, not least, to the formal aspects of the composition in which the contrast between light and shadow, the relation of flesh, fur and fabric, and the impressive expanse of red formed by the sitter's headgear are lively sources of visual interest. It was perhaps these characteristics that appealed most strongly, presenting – as they do – an image that can be savoured as an evocation of something seen, but also one that has an integral pictorial identity. Drawing on her tuition with Hayes, Riley was fascinated by the equation of description with a form of representation that has an independent visual logic and strength.

Through studying the painting in reproduction Bridget had a clear grasp of its pictorial structure. Working from a postcard, she set about creating her copy. She noted the inclination of the face turned slightly away from the viewer, the invisible line that passes vertically through the head just left of centre and the large mass formed by the turban in the top third of the composition. Her response is arresting. It expands the original to larger proportions and adjusts the position of the sitter's features so that the eye nearest the picture plane occupies the exact

midpoint between its vertical edges. The turban is also somewhat modified and the drapery is treated more broadly so that in some respects it resembles a greatly enlarged brushstroke, such is the evident enjoyment in the movement of red on black. In Van Eyck's version, the painted inscription partly in Greek letters in the top of the frame means 'As I can'. It was a suitable talisman for the work of its young emulator, whose hopes were now attached to the impression that her copy was calculated to achieve.

8 To Goldsmiths

Bridget was pleased with her copy of the Van Eyck. Clifford Frith concurred that the painting should be included in the portfolio that she submitted as part of her application to Goldsmiths, and it was decided that he would present her work for consideration by the school. Bridget's efforts served her well. Despite the anticipated stiff competition from older, ex-service men and women, some of whom were in their 30s, the 18-year-old managed to obtain a place. Accordingly, in autumn 1949 Bridget finally commenced the full-time art education she had so ardently pursued.

Situated in New Cross, south-east London, Goldsmiths had been part of the University of London since 1904, but when Bridget started her studies its reputation as a leading art school lay in the future, following later expansion in the 1960s. The institution that she joined was somewhat overshadowed by the older schools, notably the Royal College of Art, the Slade School of Fine Art, the Central School of Arts and Crafts, and St Martin's School of Art. By contrast, Goldsmiths was perceived as one of the newer and fresher art schools. But Bridget was largely unaware of, and unconcerned by, the issue of reputation. Her aunt Betty had been a former student, George Butler had recommended the school, and Frith was teaching there and had been instrumental in securing her a place. Gerald Kitchin, whose portrait she had painted and with whom she discerned an affinity, was already studying at Goldsmiths. Proceeding from different sources, these various paths had met, so there may have been some sense of rightness about her eventual destination. Whatever Goldsmiths stood for, and irrespective of the route she had taken, Bridget's feeling on arrival was one of acceptance. This is where she wanted to be.

That feeling was accompanied, not least, by a sense of gratitude. Coming almost straight from school, Bridget immediately found herself among an older cast of fellow students, many of whom were returning to civilian life following active war service. Those with whom she had contact included Albert Irvin, who was then 27 years old and a former navigator in the RAF, and his girlfriend Betty Nicholson. Some of Bridget's younger contemporaries were Mary Quant, her future husband Alexander Plunket Greene and John Norris Wood. Not least among that circle was Kitchin, with whom she now began to form a close, affectionate attachment. The common atmosphere was overwhelmingly one of relief. Everyone – Bridget included – still shared a delight that the war was over. No one was unaware that freedom had been won and that the outcome of the war could have been very different, and none took their present situation for granted. It seemed to Bridget that previous anxieties had now receded. The war years and its uncertainties and austerities were in the past. Although the world was still recovering from the recent horrors and indeed was not without new concerns, the future appeared brighter. Her mood was one of excited expectation. The prospect of embarking on a life with art as its focus felt positive and celebratory, almost a luxury. Later she recalled, 'I wanted joy'.

While attending Goldsmiths Bridget lived with aunt Betty and her brother Philip in their home at Sydenham Hill. Now an adult, she nevertheless remained in some ways very immature. Acute shyness continued to be inhibiting and her confidence was weakened by self-consciousness about the way she spoke. Her 'educated voice', which she hated, was not a problem at Cheltenham Ladies' College, but in her new surroundings she felt it presented a disadvantage, possibly because it did not accord with the more down-to-earth cultural atmosphere. At this time, her political outlook was very left-wing, and in this she was influenced by Gerald's beliefs. Her appearance, too, was also slightly out of step with the wider look. Then, as now, art students favoured a studied informality, and at that time the fashion for women tended towards cardigans, scarves worn around the neck, men's shirts and corduroy trousers. Reflecting her mother's preferences, Bridget wore tea dresses. One of her favourites was

made by Louise and had an eye-catching pattern comprising black diamonds on yellow. A petite figure, she was both much younger than many of the other students and appeared so, and felt her relative lack of experience keenly. Socially, her quietness was awkward. Living at Sydenham Hill, she missed the contact with her immediate family and this conspired to exacerbate her nervousness. From her bedroom window, in the distance she could see the spires of 25 Christopher Wren churches, a sight that somehow accentuated the unfamiliarity and remoteness of her present position. At times the daunting prospect of the day ahead meant she was unable to face breakfast.

Her situation was exciting but unsettling. During those early days, and throughout the next three years, Gerald was her close companion and with him she formed her first relationship. Sensitive and imaginative in temperament, he looked after the highly strung new recruit, his ready smile and lively sense of humour providing reassurance when most needed. Bridget respected his ability and, while she had some confidence in her own work, she felt that he was a better painter. Being slightly older, he was more worldly and introduced her to student life. He began by saving a place for her in the canteen and they took meals together. The two eventually became regulars for shared lunches at the Green Gate, a little café opposite the college, where a couple of courses could be had for two shillings and sixpence. Through Gerald, she also acquired a familiarity with the Bunch of Grapes, the local pub frequented by older students, in preference to the more popular Marquis of Granby. In the company of her steadfast ally, Bridget gradually grew accustomed to a different way of life. In other respects, however, she began to doubt the validity of the education she was receiving.

At that time, Goldsmiths offered few qualifications other than its four-year National Diploma in Design (NDD), a training that entailed courses in drawing, anatomy, perspective, architecture and figure composition. In addition to Frith, the teaching staff included Sam Rabin, who taught life drawing; Carel Weight and Ivor Roberts-Jones, who were tutors in composition and had been former students at the college; Maurice de Sausmarez, who taught on the painting course; as well as

Leonard Appelbee, Graham Sutherland and Kenneth Martin. The Principal was Clive Gardiner, an intellectual and rather patrician figure, who nevertheless contributed towards the college's gravitation away from its previous academic restrictions and towards an ethos that embraced more modern tendencies. Bridget began her studies by receiving tuition from Frith, who had championed her cause. Although she believed her work to be good, she was also aware of its weaknesses and looked to her teacher for guidance. In particular, she consulted Frith about issues relating to tonality, with which, under Colin Hayes, she had formed a preoccupation. To her dismay, she found that the advice she sought was unforthcoming and gradually sensed an absence in the older man's own awareness.

Having at last reached her long sought-after destination, Bridget became increasingly concerned by an apparently intractable problem. She had come to Goldsmiths to build on the commitment to looking that she felt so keenly, and to develop the means of responding to visual experience in pictorial terms. However, she felt that none of the tuition she was receiving was relevant to that end or helpful in achieving it. In addition to Frith's classes, she had enrolled in courses on illustration, composition, still-life painting, sculpture and etching. By the end of the first term, she seriously doubted whether any of these were of use at all. None addressed the fundamental question of learning to look that she sensed was essential. An unsettling cloud of vagueness and indeterminacy now descended upon her expectations and confounded all sense of purpose and direction. The practice and tradition of painting felt more remote than ever, her copy of the Van Eyck almost a relic of aspirations that now seemed baseless. Leonardo da Vinci's famous dictum, 'He who can copy can create', rang hollow in these circumstances, with creativity and the vehicle for attaining it fast receding. With growing unease, she cast around for other models and, for a short while, worked in the manner of Edward Burra as a way of trying to learn to paint. This, too, led to a dead end. She quickly found that the older artist's approach did not suit her: stylistic mannerisms proliferated without any foundation or substance with which she could identify. A term had almost passed, and

at the end of that time she had succeeded only in discovering a central, looming problem: how to begin? There was no obvious solution and a sense of panic ensued.

The crisis reached its peak one evening towards the end of 1949, while she was waiting for a train at Peckham Rye station. Riley later described her state of mind on that occasion:

> It was dark and wet and I was trying to decide what to do. I was coming to the end of my first term at Goldsmiths School of Art and was feeling upset and frustrated. I had arrived anxious to make a start, to find a firm basis for the work that I hoped lay ahead. It seemed that I was unable to get to grips with some of the real problems of painting, which I felt sure existed but I could not even begin to identify.[1]

Confusion assailed her. She was desperate to make progress on her chosen course, and to address and master those questions and challenges that were an essential part of her artistic journey, but there seemed to be no way forward. She knew she was stuck and, in despair, now confronted her options. She could persevere with the current regime of receiving bits and pieces of training and acquiring scraps of information. However, that way had already proved hopeless and she dismissed it as hardly worth considering. The alternative was to give up. After so long trying to get to art school that prospect was unthinkable, and besides what would she do otherwise? Her commitment to making art was as strong as ever and there was nothing else that would satisfy her. But how to break in, to gain admittance to that citadel of knowledge and experience that was occupied by the artists she revered?

She dwelt on that conundrum and as she did so realised that the question was so fundamental it required an answer that would go to the root of the problem. Somehow, she would have to start again, begin at the beginning. So, what was the genesis of art? The answer was elementary: visual experience – looking. She must therefore learn to look. That much was certain. And what was the means of honing that essential ability? She pondered this critical point; in turning it over in her mind, slowly

the answer materialised. Drawing. It was a realisation that yielded an elemental conclusion. She had to learn to draw – proceeding from the rudiments and putting everything else aside – as only this would form the basis she sought for looking. Drawing would provide the firm foundation on which everything else stood. Her course now seemed both inevitable and imperative. She would focus on drawing, exclusively and intensively, and nothing else would suffice. Armed with that insight the impending disaster was abated and, feeling calmed, she caught the next train home. It was, she recalled, 'the first independent, serious decision that I made about my work'.[2]

She immediately set about pursuing this new direction. Among the teachers she had encountered at Goldsmiths, one in particular had impressed her and stood out from the rest. Sam Rabin was then 46 years old and an arresting presence. Born in Manchester and the son of Russian Jewish immigrants, he had shown an early talent for drawing and at age 11 had won a scholarship to Manchester Municipal School of Art, the youngest ever pupil to achieve that distinction. There he was taught drawing by the French Impressionist painter Adolphe Valette, whose method of teaching by demonstration was then unusual in British art schools. In 1921 Rabin graduated to the Slade, where he received tuition from another master draughtsman, Henry Tonks, and he subsequently spent time in Paris, where he was in contact with the French sculptor Charles Despiau, a former pupil of Auguste Rodin. As a result, Rabin's early artistic career was as a sculptor. Working under his original name, Sam Rabinovitch, between 1928 and 1930 he undertook a number of public commissions, including the carved figure *West Wind* for the Underground Electric Railways Company of London Ltd at its headquarters at 55 Broadway. However, finding that he was unable to earn a living as a sculptor, Rabin subsequently took up a successful alternative career as a wrestler. A quietly spoken, sensitive man, he was nevertheless tall and powerfully built, and had won a bronze medal at the 1928 Amsterdam Olympics for freestyle wrestling. He turned professional in 1932 and appeared under the names 'Rabin the Cat' and 'Sam Radnor the Hebrew Jew'. Rabin was also an accomplished singer with an attractive baritone voice, and during the

1940s he forged a professional operatic stage career. Finally, he had turned to teaching. Like Riley, Rabin was new to Goldsmiths, having commenced there around the same time that she joined, and it was to this singular figure that she now gravitated.

First, however, there had to be certain changes. She sought out Clive Gardiner and, in an echo of her earlier meeting with Miss Popham, told him that she wanted to change her timetable in order to accommodate her main interests and needs. Abandoning all her other courses, henceforward she would attend Rabin's drawing classes only. This announcement met with disapproval. Although it formed part of the curriculum, drawing was seen by some as inimical to artistic originality and, for that reason, there was a feeling that it should not be over-indulged. Also, a training in drawing to the exclusion of other disciplines was unlikely to be profitable. Gardiner remonstrated, 'How are you going to live?' To that, Bridget had no ready answer, nor did she feel she needed one. Having identified the way she wished to go, she was confident that – irrespective of its material implications – drawing was the essential next step and anything else was irrelevant. Having previously attended a couple of classes with Rabin, she now became a regular.

9 Looking and drawing

Rabin's drawing sessions were well attended. There were never fewer than seven or eight students and his classes usually attracted as many as 25 at any time. Armed with drawing boards the pupils assembled around the living subject, and Rabin would begin by carefully positioning the model. He would then leave the room. Confronting the figure, each observer made an attempt to record their observations. After an interval Rabin would reappear and attend to each student's work in turn, moving methodically around the class.

His first question was always the same: 'what is the model doing?' From the outset it was a way of focusing the process of looking, a way of observing rooted in analysis. Before proceeding, it was important to acknowledge the pose, a realisation that paved the way for understanding. Frequently the model would be standing, this stance being the gateway to an apprehension of issues relating to balance, the distribution of weight and the role of gravity. Rabin stressed the primary role of analytical obser-vation, of assessing the visual information presented, but this was accom-panied by the imperative to make sense of the physical experience implied. He would remind his apprentices that they were drawing someone like themselves, a figure with a body comprising arms, legs, a spine; each of these anatomical parts was subject to the familiar sensation of mass being acted upon by the invisible pull of earth. Memory and an awareness of one's own body illuminated the process of observation, forming some-thing to which it was possible to relate, a visual event *felt* as well as seen. In that way, empathy was the foundation of Rabin's teaching, a vital bridge of perception connecting the seer and the seen. By identifying with the subject, a response to its underlying character was enabled.

Alerted to the subject in that way, the students were redirected in their efforts. But as Bridget now grasped, the first objective was not to create a work of art. Rather, Rabin's guidance was intended primarily as an exercise in sharpening and deepening visual experience. There was never any intimation that drawing was ever more than a prerequisite for looking. In common with her fellow classmates, she drew: at first simply, and then, with increasing attentiveness, there was a growing sense of discovery. Through paying attention, careful analysis and a patient effort to record the fund of observation, gradually there evolved a movement towards insight, a trajectory whose goal was learning to see. Only with that purpose in mind could the parallel aim of representing experience find its own resolution, with looking and drawing becoming mutually supportive and inseparable. In that respect, as Rabin made clear, drawing was the vehicle for looking: not only the means but also the *probity* of sight. Thus, a grasp of structure was essential. Reflecting his own background as a sculptor, it was necessary to analyse the physical constitution of the observed model, to understand the relation and unity of its parts, and then to find an equivalent, ordered means of expression in two dimensions. Nor was this a question of documentation or illustration. A record of appearance was not enough. Abstracted from its source and conveyed through marks on paper, the drawing had to transcend mere resemblance. It must make sense on its own terms and be a coherent thing in itself, expressing its subject with credibility and independent authority. In the absence of the model, a drawing had to have an autonomous existence, defined by a self-contained character.

With hindsight, Riley recognised that Rabin's teaching gave her the beginning she had so ardently sought and had despaired of finding. Being taught something of value generated a great sense of relief, and she embraced this way forward wholeheartedly. Having abandoned all her other classes, she now immersed herself completely in drawing from life. From the moment she commenced her exclusive study with Rabin, until finally leaving Goldsmiths almost two and a half years later in 1952, her regime comprised drawing every day. Beginning with a morning session, the students would take a break for tea while the model rested. Then the

procedure would resume, each subsequent sitting lasting about 40 minutes, punctuated by regular intervals, continuing until evening. Gradually the constant rhythm of this practice began to yield a discipline, a maturing process that Bridget found addictive. The students measured each other's progress and became friendly rivals for Rabin's praise and attention. There was a growing sense of discovery, rooted in the realisation that seeing provided a platform for awareness and knowledge. Her teacher's principle 'the more you see the more you know' became a mantra. His dictum 'through drawing you get closer' also took hold. Throughout, Rabin was, in Bridget's words, 'a rock', and in addition to his weekday classes she began to attend his Saturday morning sessions held at his private studio in Swiss Cottage.

Rabin's method was based on demonstration. Continuing the ethos of his own teacher Adolphe Valette, he eschewed lengthy verbal explanations, preferring instead to guide his students by example. Bridget realised that his care in setting the model's pose reflected his desire to generate particular problems relating to the dispersal of weight and the connections between different anatomical parts. For that reason, this initial stage was never perfunctory. It involved moving the sitter into various positions that were calculated to challenge the observer, leading to an understanding of the way the body worked. In correcting his students' responses, he avoided drawing directly on their efforts but, rather, provided solutions in his own hand alongside their work, using pencil, biro or crayon. As they progressed, his demonstrations would be paced according to each student's individual needs and the stage they had reached. His own first lines were invariably structural. Rabin actively discouraged details. Rather than precise renderings of hand and feet, he instead encouraged acquiring a sense of the whole, in which the individual elements were unified. Although not presented as such, his approach to drawing was essentially classical. Having established the fundamentals, the figure would be built up, working from the middle outwards. In this respect, Rabin echoed a way of working passed down from Renaissance draughtsmen to later masters such as Peter Paul Rubens and Paul Cézanne. The form would be gradually filled out: structure and outline first, then proceeding to the

modelling of volume and mass.

As his young student now grasped, an appreciation of tone was vital to the rendering of form. In depicting the figure, irrespective of the pose adopted, the drawing evolved in terms of light and dark and the relation of those essentially abstract components. The amount of black that was added was an ongoing negotiation with the observed model and – critically – with the whiteness of the paper that received those marks. Thus, Rabin generated a deepening awareness of pictorial abstraction: a vital ordering principle. Drawing the live model required scrutiny, but also an intelligent, felt response in the means of representing it. The creation of an image was not simply a replica rooted in resemblance, but, rather, in being committed to a two-dimensional context, involved the formation of a sign, a fully digested pictorial equivalent that made sense on *its* terms. Rabin insisted on this constantly, so that the principle became almost a refrain. A drawing was an entity that had to explain itself and possess an intrinsic identity, logic and integrity. This lesson was fundamental to life drawing. But with regard to the development of Riley's later work, the importance of this dawning awareness – of the autonomy and *equivalent* status of an artistic visual statement – cannot be overestimated. It marks the beginning of a way of thinking, a conviction that a visual statement must have its own explicable character and be able to hold the attention of the beholder through declaring an independent presence.

Thus, as Bridget's work evolved, it engaged fully with the rigours of observation while proceeding beyond appearance. Her drawing penetrated through to the underlying structure of her subject matter and involved the creation of a coherent visual counterpart. Evident in the many drawings that survive from this fertile period, there is a progressive deepening of her understanding of the principle of abstraction, which is entirely connected with her growing grasp of tonal drawing. The nude model is shown standing, lying down, kneeling, seated, facing the observer and turned away. Alongside this investigation of the living figure's different attitudes and postures, there is an ongoing interrogation of its relationship with the surrounding context. Whether depicting a background, a

bed, a dais, a chair or the situation of these elements within their surroundings, the use of tone to create form and pictorial space is a developing concern and represents a real advance in her thinking. Contour is suggested but not overstated. Through an enclosing line or a flurry of marks, the surface of the paper is either denied or asserted, sometimes presented as a solid structure or, alternatively, as a receding void. The potential of abstract shapes to intimate mass and space is a major theme of Riley's mature work; again, that later preoccupation finds its antecedents in these early student drawings.

With Rabin's guidance, Bridget's immersion in tonal abstraction was both intensive and highly structured. Two related drawings of the model lying down reveal the imperative to explore persistently each visual situation, seeking always to build on what has been learned and to find a more condensed, essential response. In the first drawing, the description of the figure and her surroundings is relatively literal, each being rendered with precisely denoted areas of light and shade. The second drawing goes further. Here, the mass of the reclining model is evoked entirely in terms of a white, delineated shape in which all detail has been subsumed. This extreme reductiveness is vividly apparent in her drawing of a standing nude that has been divided into distinct, highly differentiated tonal areas. The upper torso and head are rendered as an abstracted shape contained by darker areas, the legs simply adumbrated within a zone of shadow. Being pushed constantly to find the essence of the observed subject, the student would be frequently reminded, 'sustain your vision'. In other words, do not digress but, rather, work towards forming and holding an idea that encapsulates the whole. Thus, she would first identify the lightest part of the field of vision and go on to construct the image progressively in terms of complementary tonal relationships. As her teacher emphasised, this was a particular discipline in which habits of looking had to be overcome. Throughout, the objective was to analyse the thing seen and then to organise the response. After a day of drawing based on long poses, the students would frequently finish with a five-minute session: a final test, as it were, of the ability to look, assimilate, respond.

Rabin's belief in teaching by example was absolute. When Bridget later

asked him whether he thought a certain other teacher was any good, he would reply, 'Does he demonstrate?' Rabin had benefited from this aspect of Valette's tuition and, later, he had been a star pupil of Henry Tonks. Through being shown, Rabin had acquired his own command of drawing. But Rabin also knew the value of inspiring his pupils by studying the work of other, earlier master draughtsmen. Faithful to those traditional values that nourished his own work and teaching methods, Rabin put forward Renaissance draughtsmanship as an ideal to which to aspire. The Italian School was replete with superlative exemplars, with Annibale Carracci, Raphael, Guido Reni, Titian, Paolo Veronese and Leonardo providing luminous points of reference. The Dutch and Flemish Schools were equally venerated. Rabin held up Anthony van Dyck, Rubens and, not least, Rembrandt, as masters beyond compare.

Rabin introduced his students to the collections at the British Museum, and it was during such visits, and subsequent ones made independently by Bridget, that Rembrandt made a particular impression. His etchings of the Crucifixion were paradigms of tonality, ineffable manifestations of the capacity of black and white to express a profound range of experience and emotion. She later observed, 'I was introduced to the Prints and Drawings Room at the British Museum and made many visits. It was thrilling and inspiring to see at first hand the drawings by the great Renaissance masters and to realise how many of their insights were still, five centuries later, critical to my own endeavour.'[1]

Armed with these examples, Bridget's work prospered. Her drawing proceeded beyond description and acquired a subtle, freer plasticity of expression. In addition to greater economy, her mark-making summarised the essential facts with an arresting vigour and sureness. Entire passages of anatomical detail were adumbrated with a few strokes of charcoal, while others – a complete torso or even the whole figure – were suggested by a contained area of bare white. Such drawings mark the emergence of a new, confident awareness of the life model and its relation to the setting, and an ability to distil these essential facts into a concise but expressive image.

Gradually Bridget became a regular visitor to the British Museum, where she would study the oeuvres of earlier artists and acquire books

containing reproductions of Old Master drawings. She also developed an admiration for more modern masters, such as Honoré Daumier, whose command of light and dark was thrilling. That exposure was fundamentally important. As a result, she gained an increasing familiarity with images and ways of working that she felt were germane to her own concerns. However, she did not draw from those models and indeed still did not think of her own work as art in itself. That conceit was too elevated and would simply have been embarrassing. Rather, her response to the artists she admired was that of a follower or apprentice. She revered the draughtsmanship of a previous age and found strength and inspiration in its achievements. But emulation was not her goal. She saw her study of their art as informing the process in which she was engaged: as preparation for what still lay ahead. The exact nature of that future undertaking remained in many respects unclear, but there were growing intimations.

By now Gerald had become a treasured companion, and any loneliness she had felt on arrival abated. He continued to look after her, and, with growing confidence and a sense that she was making progress, she began to enjoy the experience of student life and to regard this as a happy period. The two spent increasing amounts of time in each other's company. During the holidays Gerald had begun to find work teaching and he also visited the cottage at Trevemedar. Bridget and her family had resumed contact with that special place during the occasional holidays they took there. Given the shortage of space, he did not accompany them and instead made separate visits on his own. But his involvement with a location that had played so significant a part in his friend's life suggests their closeness. During term time, Bridget and Gerald shared a studio near Goldsmiths. Dr Booth owned a house on Lewisham Way that was rented out to a number of fellow students, and at the bottom of the garden there was a small building that provided an improvised space for painting. At weekends and some evenings, the two worked in this studio. It was there that Bridget took her initial steps towards an activity in which she was a novice. Painting was a challenge that she had put aside at Goldsmiths, and, in Gerald's company, she now explored a way of working that presented many mysteries.

Not least among these was the whole question of 'modern art'. This was a form of expression of which Bridget was aware, but any attempt to relate this to her own experience proved utterly bewildering. Rooted in life drawing and the example of the Old Masters, her outlook at that time reached its limits when confronted with the work of modern painters such as Henri Matisse, Pablo Picasso and Bonnard. Her knowledge of these artists was based on the few books then beginning to appear, but their distinctive approaches had barely begun to achieve visibility in a country largely shielded from – and resistant to – such developments. In 1949, the then President of the Royal Academy, Alfred Munnings, had derided 'so-called Modern art' in a speech given at that venerable institution's Annual Dinner. In his view, such foreign influences were pernicious, a form of 'affected juggling'.[2] Munnings's views reflected a deep-seated conservatism but also a wider incomprehension about art that seemed inimical to tradition. Bridget did not share that view, and indeed, based on the little exposure to such work that was then possible, she was intrigued by such developments. However, much as she might have sensed the significance of the work of an artist such as Matisse, the thought processes behind that radical form of abstraction were incomprehensible. Aware, too, of Piet Mondrian's art – through a reproduction she had seen of his celebrated painting *Broadway Boogie Woogie* (1942–43) – the path that led to abstract painting was completely obscure.

Even so, such alternatives to the course she was then following with Rabin were enticing. Although unfathomable, these modern masters seemed part of an adventure upon whose nature she could only speculate. Unlike Edward Burra, whose work she had not found satisfactory, Matisse and others seemed engaged with something that transcended questions of style. She sensed a line of thought, even though it lay beyond intelligibility. It was a cast of mind that had led somewhere; while she did not know its destination, at some deeper level there was a glimmer of excitement at the prospect – possibly – of following. She was aware of Kenneth Martin's presence at Goldsmiths, and his association with Constructivism was a connection with these recherché issues. He held court in the corridors at Goldsmiths and attracted a certain following. However, Martin

himself did not interest her and she felt his ideas were never expressed with the clarity she needed. Unconvinced, she kept her distance.

Instead, she discussed these questions with Gerald, who had a somewhat greater awareness of emerging trends and artistic developments abroad. Together they visited exhibitions and through her friend she came to share an enthusiasm for certain modern painters whose work seemed more approachable. Among these, Edvard Munch's art became an early interest, although she found its expressive, psychologically charged character less compelling than his colours, which fascinated her. Such tentative beginnings fed into her own experiments in painting, which she pursued in the relative privacy of the studio at Lewisham Way. Something of Munch's approach to abstraction can also be seen in the drawings that Bridget made independently in Rabin's class, in which a bolder, more radical simplification of form is apparent. In several of the portraits that she now completed, some using members of her family as models, the features attain a degree of abstraction that echoes the Norwegian master. That said, she felt that Munch's lines, though strong, were something of a barrier in the way they were employed to contain complete shapes. By contrast, Rabin's lines eschewed contour and were essentially structural. 'Put down a line', he would declare, 'it may not be right, but you can alter it.' This process of working encouraged the use of line to discover and suggest, rather than to declare. It seemed truer to her instincts.

However, for the moment, painting remained a matter for the future, and modern art an enigma to be unlocked later. In the meantime, she continued under the guidance of her wise teacher, with tonal drawing a continuing preoccupation. A constant presence in Rabin's class, she felt he was pleased by her faithful attendance and that he was gratified by their special rapport. She now never wandered about but always took up a favoured position in relation to the model. Rabin began to introduce more advanced challenges, to which she rose. Having posed the model, he would instruct the students to enter the class, heads down, without observing their subject. Taking up their places, they were then permitted to look directly at the sitter. The exercise as presented by Rabin was to 'draw what you see in that first instant – that is what your drawing should

be'. As Bridget divined, this was an important lesson in reproducing an impression. In contrast to recording a learned series of observations, the imperative was to preserve the fresh vitality of a first glimpse in which the essentials of the observed subject are taken in. Although the model would be scrutinised subsequently, the preserved memory of that initial sighting would be a guide, providing the motif to be pursued and finally captured. Approaching the subject in this way was a testimony to the capacity of the eye of a trained observer to penetrate the hidden order of things. Involving putting aside accumulated knowledge of the thing seen and returning to the pure revelation yielded in a moment of insight, it was an early intimation of Riley's later engagement with Impressionism: a way of seeing rooted in being able to sustain the penetration of a glance.

Rabin was sensitive to Bridget's acuity and potential. One spring morning towards the end of her time at Goldsmiths, she spoke with her teacher in a spot near the college that she sometimes visited with Gerald. The place where they paused was delightful, a woodland area bedecked at that moment with bluebells. Rabin took in the scene and then confided to his promising student, 'that is not for you'. For her part, Bridget knew he spoke the truth. Her way forward could only take shape from dedication, commitment and, above all, discipline. A key aspect of Rabin's example had been to impart a profound belief that whatever is done must be done well. A superficial involvement would never be enough and already she loathed the idea of half measures. This was an ethos she had inherited from Louise, and in Rabin's class it had received – in the context of art – its crucial affirmation. She would not be misled by appearances and would strive for that which lay deeper and beyond her present reach. As she now knew, this would not be achieved without a struggle.

Eventually Rabin said to Bridget, 'I can teach you no more.' By way of explanation, he added, 'You never now do a bad drawing.' She had been his pupil for almost three years and under his guidance had found the promise of a direction. Having imposed on herself the necessity of starting at the very beginning of her chosen path, through Rabin's teaching she had acquired the resources that would sustain her in the journey ahead. Drawing was now her companion, a means of looking and comprehending

that enabled a deeper insight into the world and nourished a sense of relation with it. In that respect, Rabin had not only conveyed a skill but had imparted a philosophy. However, it was self-evident that this way of thinking was not simply an end in itself but was rooted, fundamentally, in the experience of being alive. As such it called for practical application. In that realisation, there was the first glimmer of what being an artist might entail. Armed with an outlook that surveys the world and responds with a sense of wonder and enquiry, the artist must engage meaningfully with that experience and, from that involvement, find the materials and the rationale for work. With that insight came an understanding of a fresh responsibility and, with it, the need to go forward. Rabin advised her: 'Now you must show us what sort of artist you are.' The implication was clear. As she was well aware, beyond drawing lay an involvement with colour. But Rabin knew his strengths and also the limits of his own reach. His entire being was steeped in drawing. Bridget's awareness that the path ahead would mean parting from her mentor was, inevitably, accompanied by a great sadness. For, as both realised, accomplishing that next step necessitated immersion in a new challenge: painting.

10 The bargain not kept

With her sights now set on studying painting, Bridget's ambition turned
to securing a place at the Royal College of Art (RCA). As she was well
aware, achieving that objective was no small undertaking. Having elimin-
ated her attendance at almost all the other courses at Goldsmiths in
favour of drawing, she left that institution without qualifications. More-
over, her experience of painting was limited. Although she had continued
to explore this activity with Gerald at weekends and during holidays
in the studio they shared at Lewisham Way, she was still in many ways
a beginner. Their common enthusiasm for Munch continued to excite
a sense of experiment and adventure, and through working together
Gerald kept pace with her efforts and interests. They discussed the work
of other European modern masters who were then gaining visibility in
reproduction among a British audience, notably Picasso, Matisse, Bonnard
and Mondrian. She was also familiar with the indigenous modernist
approaches as evinced by Victor Pasmore, John Piper, Paul Nash, Henry
Moore and Ben Nicholson through the books given to her by her mother.
The *Penguin Modern Painters* series provided tantalising – if bewildering
– glimpses of these artists' different styles. There were also contrasting
figures, such as Stanley Spencer, who was then attracting a growing
constituency of admirers. As this disparate range of awareness suggests,
her understanding of modern painting – in common with her peers –
remained fragmentary and even confused. Her desire to attend the RCA
was thus founded both on a lack of experience and on limited knowledge.
These deficits were matched only by her eagerness to learn.

Despite such shortcomings she nevertheless derived confidence from
everything that had been achieved previously with Rabin. She believed

that in drawing, if in little else, she possessed a solid base, and reasoned that attending the RCA would give her a comparable foundation in the discipline of painting. She had a wealth of drawings that demonstrated her ability and from which she drew strength. There were also colour studies from nature and pictures depicting people in cafés that provided further evidence of talent. With the prospect of moving on from Goldsmiths in sight, she had recently turned to working outdoors. She was fascinated by the bright fluorescent lights in the shops and eating places around Victoria station, and these sites had supplied a rich source of new, lively motifs. She had made numerous drawings of people sitting at home watching television, subjects that had been observed through windows. These images had a contemporary feeling that she no doubt hoped would be of interest. She now felt that she was ready to learn about painting and all those related matters that appeared mysterious and yet essential to her goals. Entrusting her eligibility to this array of achievement, she consequently approached the potential move with enormous enthusiasm.

Both Bridget and Gerald applied to the RCA and she was granted an interview. Much to her surprise and delight, among the panel of unfamiliar faces that she confronted was one that she recognised. Having moved on from Cheltenham Ladies' College, Colin Hayes now returned her gaze, albeit with a subtle intimation that any sense of the previous connection between them would not be helpful to her cause. She immediately understood the thinking behind his apparent show of indifference and played along. The Rector was Robin Darwin, the Professor of Painting Rodrigo Moynihan. The college's other staff included John Minton, Carel Weight, Ruskin Spear, Rodney Burn, Barnett Freedman, James Fitton and Roger de Grey. As Bridget recognised, this was 'a very different kind of camp', one that would have regarded Rabin and his teaching methods, rooted as they were in classical thinking, as old guard. She did not take sides in the antagonism between the traditional and modern contingents that was then developing and had no strong feelings either way. At that crucial moment of her assessment, she simply wanted a way into painting. Nevertheless, she knew how her previous training would be perceived, and in presenting her drawings she submitted to the potentially inimical

forces arranged around her. As they examined her efforts, she surveyed a body of men containing one tacit ally. It was a testing moment and her future hung in the balance. Success would be a huge encouragement and would ensure she could complete her studies. Failure would mean having straight away to earn a living as an artist, a prospect for which she felt herself unready. Despite the odds, and to her great relief, she was awarded a place.

Gerald was not so fortunate. Having hoped that they would go forward together, his ambitions were overtaken by problems at home. For some time, he had been living with his father and helping to care for his sister, who suffered from multiple sclerosis. When his father also became ill, Gerald had to commit himself even more fully and to address a looming financial responsibility. He therefore changed his plans and took up a place on a teacher-training course. It was an early disappointment in what had promised to be a wonderful new phase. Bridget's affection for Gerald had deepened during their time together at Goldsmiths and now their paths would separate. Although they remained in contact, the bond between them was never as close. After starting at the RCA, she moved out of her lodgings at Sydenham Hill with Betty and Philip and rented a bedsit in Foulis Terrace, off Fulham Road in South Kensington. The room was empty, and almost the first items she introduced were a large painting easel and a mirror, thus establishing its primary credentials as a studio. Furniture followed and gradually Bridget settled into her surroundings. However, her day-to-day existence as a student at Kensington Gore was initially lonely. Still acutely shy, she failed to make new friends and felt Gerald's absence keenly. Inevitably tears were shed when her sense of separation and solitude became overwhelming.

It was a relief, therefore, when she was joined by a flatmate, Sue, whom she had met earlier at Rabin's weekend drawing classes. Although she no longer attended his classes at Goldsmiths, after starting at the RCA Bridget continued for a while to receive occasional tuition from Rabin. Sue had been one of his pupils and was herself now a teacher of life drawing. That mutual connection was the basis of the friendship that developed both with Sue and her boyfriend, 'Mac', an aspiring painter

whom she supported. Sue moved into an adjacent space within the bedsit, which was separated from Bridget's studio-cum-living area by double doors. Their relationship would be a great help and comfort during the following three years, being both a link with the immediate past and a reassuring source of human contact when Bridget's hopes failed to materialise.

Despite her feelings of being alone in strange surroundings, she was optimistic and had high expectations. The term started on 1 September 1952. Although eager to begin learning to paint, at the outset she stayed on familiar ground and attended life-drawing classes. Having found her bearings, she then moved on to life painting. One of her first experiences of that new way of working entailed a three-week pose. On the first day, there was a jostle among the students to secure the best positions. In this she was successful and took up an advantageous place with her back to the window, the light falling onto her canvas. The model stood on her right, and Bridget was gratified to recognise an individual she had drawn on numerous occasions in Rabin's classes. Looking around, she observed a range of unfamiliar students, one of whom was a young man, Frank Auerbach, standing on her left-hand side. As they commenced work, she gradually became aware of her neighbour's characteristic movements: 'Frank worked by walking to and fro more than several yards to his easel and back, and the path became a kind of metronome through which the work gradually accrued on his canvas. He beat it into place. I had an off-shore position and had my own area of concentration, although I didn't move about so much.'[1]

The two 21-year-old students, whose subsequent careers would pursue startlingly contrasting trajectories, at that moment fell into a kind of harmony. Both worked on their respective paintings, each absorbed in the challenge of the task. By the end of the first week they were the only students left in the room, the others having departed. Frank's approach differed, and eventually would diverge entirely, from Bridget's practice, but in the shared intensity of their engagement with the activity, in Frank she recognised a kindred spirit. Though they would later be cast in radically contrasting moulds, that complete involvement would define

both artists' subsequent commit-ment to painting. In retrospect, Riley recalled that this early experience of painting was the most concrete step she had taken. That positive advance was, however, to be short-lived.

Bridget found herself among a large group of around 50 students. These came from various backgrounds and included, as had been the case at Goldsmiths, older individuals who had served during the war. As a result, there was a wide range of experience, different interests and varying levels of maturity. The college's way of dealing with this melting pot was to divide the students into small groups that were each assigned a tutor. Bridget was one of those allocated to Robert Buhler, who had joined the teaching staff in 1948. She now became aware of some of her other contemporaries. Richard Smith attracted her attention as a rather exotic creature, 'a rare bird' who had managed to travel to the USA using his government allowance of £35 to spend a summer familiarising himself with American culture. He returned wearing a pair of sneakers that caused a stir. Such glamorous items were symbols of the relaxed, hedonistic materialism on the other side of the Atlantic to which post-war Britain looked with envy. Smith had evidently absorbed something of the scale and ambition of that country's artistic scene, too, for he now filled a large studio space at the college with expansive canvases. These were startling intimations of alternative approaches to painting. To Bridget and her fellow students, they appeared radical and new.

At the other end of the spectrum she also sensed the presence of Peter Blake, who joined the college in 1953. Although he had been admitted three years earlier, he had to complete his obligatory national service before taking up his place. The RAF had imbued Blake with confidence, and in that respect, although younger than Bridget, he appeared more mature. His corner in the studio was, she recalled, 'an event, in that what one saw there was constantly being added to by tiny, unexpected and yet familiar nuggets'. Blake's fascination with popular entertainment – side-shows, fairgrounds, the circus and comics – was already finding a place in his art. Three years older than Bridget, John Bratby was the most confi-dent of all, a brash assertiveness evident both in the paintings he was making and in his manner. Bridget observed him 'arriving in the corridor

where we queued for cups of tea with his clothes and glasses properly bespattered with paint. He always jumped the queue and always asked for extra sugar.' The antics and eccentric behaviour of the irrepressible Bruce Lacey added a dash of Surrealism to the mix, completing the impression that independence was both expected and encouraged.

This, however, was not what Bridget was seeking. At Goldsmiths, she had blossomed under Rabin's careful, patient guidance. His teaching had been both informed and disciplined. A working method founded on practical principles had been imparted and absorbed. She now wanted – and needed – something similar in relation to painting, and in that respect she found the tuition at the RCA lacking. She later summarised her tutors' ethos in the following way:

> The College philosophy was stated to me by one member of staff as: 'It's going to be very tough outside, so you might as well have it tough in here.' So we were left to work it out for ourselves. We were abandoned, when what we needed (and hoped for) was help towards independence rather than having independence thrust down our throats. We could ask questions, but the trouble is that you don't necessarily know when you have a problem and students can be either too proud or diffident to ask for help. Advanced teaching ought to help a student to discover his or her problems. We were anxious to find out as much as we could but this was ignored – a certain fundamental bargain was not kept. There was an overpowering sense of a vacuum in the College.[2]

Left to her own devices, Bridget struggled. She cast around for help and found none. To her mounting frustration, her tutors provided no criticism or feedback and, worst of all, no tuition. She was disappointed that Colin Hayes, who could have been an ally, stayed apart. Although he remained a friend, she sensed that he thought that giving her any kind of privileged attention could be damaging. Among her tutors, John Minton was a sympathetic figure and popular at the college. Witty and sophisticated, he alone recognised the problems that beset her. She had come

to the RCA hoping to find someone able to teach her about painting. Minton gave reassurance but, in common with his colleagues, little in the way of information or advice. Her frustration now turned to pain. Returning to the studio one day, she found a group of three tutors looking at the paintings produced by Frank Auerbach and herself. They appeared absorbed in Frank's work but walked away when they realised she had entered the room. Bridget saw this as a stinging rejection. Aware of her limitations, she was nevertheless confident about the painting she had made. The short shrift it received seemed to signal something beyond indifference.

Bridget was very discouraged. From that moment she ceased to do any drawing or painting from life at the college and her attendance started to fall away. She continued to go into the building but tended to drift around, looking for something to do. This was a dispiriting and lonely phase. For consolation she would visit the nearby Victoria and Albert Museum and look at the collection of paintings by John Constable. This at least was inspiration, but her hopes of achieving anything appeared to be fading. Gradually she became bolder about staying away. Aware that her absence would be noticed and anxious to avoid the dangers posed by this, she recruited her sister Sally to go into the college and to sign the attendance record on her behalf. Three years behind Bridget, Sally had by now left Cheltenham Ladies' College, having achieved her School Certificate. Her parents wanted her to go to university but she declined, opting instead to get on with earning a living. To that end, after completing her education she obtained a place at a secretarial training college. Subsequently she went on to work at Pemberton's, a London-based advertising agency. Her availability to provide a forged signature enabled Bridget's non-attendance to be concealed. No longer going into college, she effectively went missing. Instead, she focused on painting at Foulis Terrace. There she was free to find her own way, liberated from the gaze – whether indifferent or hostile – of her tutors.

Supporting that practical, studio-based activity, her aim was to learn for herself by looking at the work of those artists who interested her. In addition to the Victoria and Albert Museum to study Constable, she

frequented the National Gallery and the Tate Gallery and looked hard at
a range of modern painting. The Impressionists and Post-Impressionists
were a rich source of interest. Georges Seurat attracted her attention;
Bonnard, too, intrigued her. But among a range of exemplars, her main
focus fixed on Matisse. She concentrated on his distinctive approach to
help her understand the use of colour in painting. The more she looked,
the more she realised that Matisse's art was not a question of style but,
rather, a line of thought. His vision of the world was not simply connected
with issues of pictorial representation but went deeper than that. The
French master had, it seemed to her, explored and developed his visual
experiences in a highly singular manner, and in so doing had arrived some-
where. As yet, that destination eluded her. Matisse's thinking was fascin-
ating but incomprehensible. Going far beyond literal description, his
deployment of colour was thrilling. A mode of painting that presented an
adventure, it invited a journey fraught with surprises and risks. In contrast
to the tuition she had sought and failed to receive, more than anything it
offered a way forward. She knew only that she wished to follow.

As a result, she now commenced a painting of her own in which
Matisse's example is clear. Made at Foulis Terrace, it depicts a table on
which a bowl of fruit is positioned, its reflection mysteriously resembling
a fish. Beyond, and through an open window, can be seen the skeletal
outline of a tree. These shapes are echoed in a mirror to the left of the
composition. This reflects a plant placed in front and also another tree
framed by a window. The foreground is occupied by a patterned carpet,
a family heirloom provided by Louise. All these elements were based on
observation and to that extent the painting is a description. However,
the way that the scene has been represented demonstrates a significant
advance. The window has been abstracted so as to eliminate its frame.
In consequence the area of white exterior light joins up with the illumin-
ated rectangle falling across the carpet. The effect is to create a vertical
zone that divides the painting into three parts. With that move, the
painting is invested with an underlying tripartite structure that underpins
its representational elements. In terms of its use of abstracted shapes,
high key colour and exotic patterning, Matisse is the painting's presiding

spirit. But structuring the painting in this geometric style is distinctive. The eye proceeds from left to right through three zones of different compression. This device contains in embryo the approach that would characterise Riley's earliest abstract paintings made after 1961, not least in *Movement in Squares*. Although a youthful essay, the work is a fascinating foretaste of things to come.

Concurrent with the paintings made at Foulis Terrace, other changes of a more personal nature were also afoot. Throughout Bridget's earlier attendance at Goldsmiths, whenever she returned home to Boston the old pattern of sleeping outside in the drying shed had been maintained. Her desire for contact with nature remained as strong as ever, and if anything had deepened while she had been living in Sydenham Hill. This nocturnal habit had also been continued by Louise, whose restlessness with the family's suburban existence and longing for the countryside had grown. As town life became increasingly irksome to Bridget's mother, the visits to Cornwall had become more necessary and her desire to relocate to alternative, rural surroundings imperative. Jack had indulged his wife's and daughters' unconventional sleeping arrangements with a degree of bemusement. But as their need for a place in the country became more pressing, his anxiety to ensure the family's happiness meant that the need for change could no longer be ignored. In consequence there had been frequent excursions to the countryside to find another home. Around the time that Bridget started at the RCA, they discovered a surprising new location that would figure significantly in all their lives.

11 Paradise and disaster

In 1952 Bridget's parents left Boston and moved to Molecey's Mill in West Deeping, Lincolnshire. The place that they purchased was dilapidated but, to their eyes, replete with character and potential. Built in the late eighteenth century, it comprised two buildings: a granary dating from 1773 adjoined by a large, three-storey water mill that had come into active use around the same time. Thus combined, the entire complex stood alongside the Stamford Canal, which when it was completed in 1670 had become the longest locked canal in England. Indeed, one of the original twelve locks was located by the mill. The facade of the main house had received subsequent additions in the nineteenth century and boasted an impressive portico, complete with Doric columns. At the front, Molecey, as they called their new home, looked on to a stretch of the canal and, beyond that, the road to Stamford. An ornate footbridge crossed over the canal and provided access. With its slate roof and expansive limestone walls, Molecey was historic in feeling, sedate in character and partly ramshackle in appearance. This place would occupy Bridget's dreams for many years to come.

At the rear, the house connected directly with the mill stream and retained a block containing the original undershot waterwheel, still in working condition, with its grinding wheels, stones and shaft. In its heyday, the canal had been a busy commercial waterway. Around 6.8 miles (11 km) in length, it linked Market Deeping to Stamford, and was part of the waterway system that connected Stamford with The Wash and its seaborne commerce. At its height it formed a lively conduit for the transport of flour, malt, coal, timber and limestone. With the advance of the railways, trade along the canal declined and by 1850 the waterway had

become derelict and polluted. It remained in a sorry state until improvements were made by the local council in the 1930s. Even so, the property that Jack and Louise now occupied was, to say the least, primitive in amenities. It possessed one light bulb and one tap, the plumbing was basic and the need for modernising obvious. However, its charm was inescap-able. There were several outhouses, including an ancient dovecot, and a cellar built parallel to the canal, from which it was separated by a wall. Nevertheless, being lined with blue clay the canal was watertight and the cellar bone dry. Molecey's run-down condition was alarming to its previous occupants, an elderly couple. But for its new owners the house was just the kind of place that they had been seeking, its semi-dereliction possessing a fascinating, almost otherworldly, charm. Sally later recalled the house being 'a fairy land – as if one had walked through a magic door'.[1]

In its favour, Molecey was – in terms of location – a visually entrancing jewel. Enveloped by its rural setting, and surrounded by vast expanses of sky and land, its proximity to nature was entirely redeeming, indeed irresistible. Molecey's situation on the canal meant that water was a dominating and very varied presence. At the front, the canal was still and overgrown with water lilies. At the back, the stream was in constant movement, providing an animated surface of reflected light. Located on a narrow strip of land between these two fluid trajectories, the house seemed at one with the adjacent water. From inside, the various views provided by its numerous rooms were graced by an inexhaustible spectacle of colour in motion, the ceilings illuminated by a wash of dancing reflections. The effect was hypnotic and cast a spell over its inhabitants. At different times of each day there would always be something new and visually mesmerising about its luminous tableaux. Frequently the family would sit together, sharing these experiences. Outside, too, there was much to discover. The ground around the house led in one direction to a walled garden, which Louise enthusiastically planted and cultivated, filling it with chromatic energy and life. Complementing that container of natural growth, the stillness of the water provided an expansive mirror. The two merged seamlessly, the real and the virtual joined together.

Elusive and engaging, this ambiguous prospect was but one of Molecey's many delights, each a feast for the eye.

The charms of the new home were for Bridget a much-needed balm. With mounting frustration at the RCA, her absences had become longer and more frequent. She knew this to be dangerous and as time passed grew to feel she was courting disaster for when the end of year assessment finally came. Even so, she stayed away, and spent increasingly longer at Molecey. The allure of the place was compelling. Being with the family salved her loneliness and it fed her need to commune with nature. Most of all, in contrast to the lack of any inspiration in her place of study, it provided a rich source of subjects for her work. Living there for periods of three or four days, she responded with numerous drawings of her surroundings. The house and the landscape became her motifs, committed at first as tonal drawings and then, with deepening engagement, as adventures in colour. The canal, banks, garden, sky and clouds – and all these elements combined in reflection – were a fertile fund for the works on paper that now flowed. In one way she felt that such essays were the products of a continuing confusion. But she pressed on, committed to the potential she sensed in this magical place for learning and experiment.

Her guides at this time were Matisse, Bonnard and Claude Monet. With the example of these masters in mind, her exploration of colour, abstracted shape and mark-making proceeded apace. Responsive to the predominance of water around her, some of the drawings were 'all reflection'. Others probed the rich fusion of form and texture produced by the interrelation of architecture and nature. Drawing on her previous knowledge gained from Sam Rabin, she blocked in these landscape subjects, creating bands of colour and connected shapes that had a progressively independent character. With a growing confidence in abstracting from observation, gradually her work attained a surer autonomy. She produced images that increasingly stood on their own terms, possessing a self-contained, pictorial coherence. Flattened, lengthening shapes came into being. This newfound activity was pursued for its own sake and indeed was a consolation. She discovered that she no longer missed the education she had sought and had failed to receive at the RCA. Through-

out, Rabin's advice resonated: 'Put down what you see.' Whenever she was in doubt his words were a constant corrective: 'What you see is what your drawing should show.' In this way she focused on the imperative of recording what is seen, as opposed to what is known – or assumed – about an observed subject. As these works make evident, that process involved sustained visual interrogation, analysing her experiences in order to generate a cogent graphic equivalent. Looking – combined with the force of questioning – was her watchword.

Although visual analysis was paramount, at the same time she approached her landscape subjects – as Rabin had shown her – mindful of the need to preserve the freshness of an initial impression. The revelation received in the first glimpse had to be retained and then reinforced by subsequent scrutiny. This meant that the resulting image was not simply a slavish description of the thing seen, but, rather, an essential spontaneous visual response underpinned by later verification. That apparent paradox now gained in significance when applied in a plein-air context. The salient features of the entire scene had to be grasped at the outset and then abstracted from their source so as to be re-created as an equivalent, autonomous image. The relation of observation and representation was underpinned by distillation and encapsulation. Space and the different elements within it were arranged in order to bring about an alternative, two-dimensional unity. The principle of abstracting from her sensations and using that information to build a new, unified structure became clearer. She began to appreciate that, through this method of working, fresh insights were possible, generating new ways of understanding the world and her relation to it. This was looking in the service of knowledge, although at this stage she would not have articulated the process in those terms. In retrospect she claimed, 'I didn't know what I was doing.' Even so, the work she made at this time suggests that, at an intuitive level, she grasped it. In terms of her mature paintings, when the process of organising her sensations in purely abstract terms became paramount, Bridget's experiences at Molecey laid the foundations.

Making regular visits to Molecey and deriving strength from the landscape-based work she did there, Bridget got through a period of three

years that in all other respects she found stultifying. In common with Jack, Louise and Sally, she grew to love the new family home and to value her time there greatly. Her friends Sue and Mac were occasional visitors. As well as working, she also participated in the general enthusiasm for renovating and improving the property and its grounds. Gradually a pattern emerged, with Jack driving to his workplace in Boston and, while he was away, Louise managing the home. Bridget's escapes to the comforts of the country alternated with living at Foulis Terrace, where she carried on with her painting, focusing on studies of figures and interiors. Both these aspects of her work were connected by a central imperative to find an underlying pictorial structure. Feeding that development, she continued to explore a process of progressive abstraction in terms of tone, colour and form. Each of these elements was asserted in its own right, as well as being descriptive. Throughout, she was alert to 'seeing the shapes they make'. Thus, while she struggled and felt an ongoing deep frustration, there was nevertheless a continuing advance in her work and, in the company of her family at Molecey, a great happiness.

However, none of the work she did in either place was shared with her tutors at the RCA. Sally continued to sign the attendance record to provide a cover for her sister's absence, and whenever Bridget made an appearance it was usually with extreme reluctance. Generally, she tried to avoid situations in which she would have to suffer the criticism of tutors such as Carel Weight, Ruskin Spear and, especially, Robert Buhler, with whom she felt little affinity. John Minton continued to be the most sympathetic and there were intimations of warmth. On those few occasions when they met, he would sometimes refer to the elusive student as 'Tiny B': a rare crumb of affection. But even he could be a confusing presence. At one of the parties he occasionally held for the students he asked her, 'Do you really want this life?' While she contemplated that question he added, 'You will have to be a lesbian'. The implication was that, for a woman, life as an artist was an obstacle to marriage and domesticity. She liked Minton, but such observations were not encouraging. Quietly, she remained undeterred, if anything becoming still more determined.

Even so, as time went on and the prospect of assessment loomed, the pressure of potential failure became more insistent. The position in which she found herself in her final year seemed a long way from Goldsmiths, where her abiding sense had been one of fulfilment and achievement. Inevitably her absence from the RCA had been noted, and now she feared the unhappy outcome of the conspicuous distance she had placed between herself and her teachers. She did not want to be rejected, and the thought of that outcome made her both unhappy and nervous. With increasing concern, she sought ways of strengthening her submission for the Diploma exhibition. She applied herself with renewed energy to a thesis that she was required to prepare, the subject of which was Persian art. Her study of colour and form was, in that historical context, absorbing. In addition, she turned to generating work – other than the figures and landscapes completed at Foulis Terrace and Molecey – that she could present to her tutors. She had some earlier figure paintings from before her estrangement from the painting class, and she now focused on creating portraits in order to enliven her portfolio. While at Goldsmiths she had made drawings of Louise, Betty and a range of models. Returning to that way of working, Bridget now produced several outstanding studies using red and sepia crayon on paper. These include a very assured head study of Louise looking down and, in a second drawing, asleep. The images display an evident command of tone in their precise but flexible use of line, and there is an assured maturity about their expressive intimation of character. Not simply technically sophisticated, they manifest a profound empathy with their subject.

With the end of her course at the RCA in sight and her final Diploma assessment pending, Bridget's anxiety became intense. The evening before the results were posted at the college, the family assembled in London in order to give her support. Earlier that day, Jack and Louise had driven down from Molecey and they were joined by Sally. They all then went out together for a meal. At the end of a convivial occasion, the plan was for Louise and Sally to stay with Bridget at Foulis Terrace, while Jack returned to Lincolnshire. This would be a long drive, his second journey that day, but he said that he had to return home as their pet dog was shut up in the

house and he was keen to give the animal a break. The evening traffic was expected to be light, so a difficult drive was not anticipated, and he estimated he would be back before midnight. Having seen him off, the women retired for the night. They were awoken in the early hours of the following morning by the sound of the telephone ringing. At first they ignored this interruption, but when it continued Sally eventually took the call. She noted that the time was 2.30am.

Later she would recall the ensuing conversation precisely.[2] A voice at the other end of the line said, 'Are you Sally Riley?' There was something about the question that chilled her. The caller continued, 'I am sorry to tell you that your father is badly hurt. We do not think he will survive the night.' Sally was stunned but answered evenly, 'You don't know my father.' Having taken in the details that ensued, Sally returned to her mother and sister. Louise sensed danger and immediately asked, 'What has happened?' She reported that Jack had been involved in a terrible road accident, had been critically injured and was in hospital. The sudden revelation of that catastrophe was a stunning blow, and Louise began shaking from head to toe. It transpired that Jack had fallen asleep at the wheel of the car, and the vehicle had veered into the path of an oncoming lorry. In the resulting collision he had been flung through the roof and onto the back of the wagon, before rolling down an embankment. Jack's car was a write-off, but the truck was relatively unscathed and its driver unhurt. The truck driver had therefore immediately rung for an ambulance, which had taken Jack to the accident and emergency unit at nearby Hitchin. Without hesitation, Louise and Bridget set off to reach the stricken man, leaving Sally to follow as soon as she could.

The two women arrived in Hitchin later that morning and went straight to the hospital. The unconscious patient they found there had suffered huge damage and was barely recognisable. Jack's face was extremely disfigured and covered in stitches, and one of his arms was badly broken. Various drips led directly to his shattered body. Bridget's first thought was that this was not her father. However, amid the wreckage of his injuries, her gaze fell upon one of his hands, which she knew, unmistakably, to be his. It was obvious that Jack was in a terrible state

and the doctors pronounced his injuries to be life-threatening. Despite that dire diagnosis, they nevertheless held out a slim hope and were anxious to operate. Their advice was that saving his arm was unlikely to be possible and amputation would be the best course. Louise immediately resisted that idea. The extent of another serious trauma then became apparent. Regaining consciousness, he was initially unable to speak. When he eventually managed to form some words he told his visitors, 'You are upside down.' His sight had been inverted, and with evident understatement he added, 'Be very quiet please because my head is hurting a lot.' Worse revelations followed. His neck was severely mutilated and, because the related muscles had been destroyed, he could not swallow. This was a frightening realisation. For even if he overcame his other injuries, the prospect of not being able to eat was appalling.

Louise was paralysed by the anxiety that now gripped them. She saw that Jack was engaged in a battle for survival. The only consolation was that the hospital was well-equipped to support whatever options existed. Having developed during the Second World War in response to the need to care for injured soldiers, it specialised in facial trauma and had first-rate facilities and expertise. It was a morsel of comfort that Jack's accident had happened in relative proximity to such a place. Louise and Bridget were eventually joined by Sally, and the three passed that first day with mounting apprehension. Returning the following day, they found Jack's condition still critical but stable. Whatever qualities had sustained him as a prisoner now seemed again to be rallying. In an echo of that earlier period of prolonged uncertainty, Louise saw that the test ahead was one of endurance. In order to be as close to the fight as possible, Bridget and Louise took a room in a local boarding house and settled into a pattern of daily visits. Sally had to report for work but continued to come to the hospital as often as she could. Thus began a long wait, during which their collective fates would be decided.

Throughout this time, Jack was conscious but sleeping. Days went by when he continued to be fed by drip. The medical staff ministered to his injuries and remained optimistic. His arm was set in plaster and, wherever possible, the other wounds were left undressed in order to maximise the

healing process. His eyesight corrected itself. After almost three weeks, the patient's condition was stable and he was fully awake, but his inability to take any solid food posed a profound threat. The doctors confided that sustenance could not be administered by tube indefinitely, and the irreversible destruction of his ability to eat was a deeply worrying problem. The implication was obvious: if a man cannot swallow then how can he live? Reaching this impasse was as distressing as the initial shock, and on the eighteenth day of the crisis Louise left her husband's bedside in order to pray. As they all realised, even that was problematic. In the circumstances, the question was what to pray for?

Although none would admit it, time was running out. Jack's determination was plain to see and there had been continuous efforts to encourage him to eat. But this had proved completely unsuccessful because, as they all saw, they confronted a physical impossibility. He was simply unable to take in solid food and whatever was placed in his mouth remained there: tantalisingly close and yet beyond his capacity to accept it. However, he persisted. While Louise was away, Sally remained with her father, who now said to her, 'Pass me that little bit of biscuit.' She did as she was told and – not for the first time – placed a tiny fragment on the tip of his tongue. Jack closed his mouth and some seconds passed. Turning finally to his daughter, he then spoke again: 'It's gone – I'll have another bit.' In that moment, it seemed that a corner had been turned. Passing him additional pieces, each went the way of the first. Unpredictably, the dryness of the biscuit finally enabled him to find some new, unfamiliar response in his mouth and throat that led to a swallowing action. When Louise returned from her prayers, Jack greeted her with the observation, 'I've eaten a biscuit.'

Beginning with this reversal of a seemingly intractable predicament, the crisis began to abate. Although he remained in hospital for a further three weeks, gradually Bridget's father recovered – or, rather, re-created – the ability to swallow. Encouraged by that advance, he joked about the champagne with which he would celebrate. Eventually Jack was well enough to return to Molecey to recuperate, accompanied by Louise and – now that she had finished at the Royal College of Art – Bridget.

Somewhat earlier, Sally had enquired about the outcome of her sister's Diploma examination and learned that she had passed. That result, which previously had prompted enormous worry, no longer seemed of any interest. The near-death experience that had confronted them all had been a stark reminder of the fragility of everything and it had cast Bridget's personal concerns in a different light. She never returned to the college and the qualification went uncollected. Leaving the RCA in the summer of 1955 finally brought about the end of a chapter, a prolonged period of disappointment and frustration that had been sealed by her father's accident, and she returned to Molecey to commence a new phase of her life. However, as she discovered, her problems were only just starting.

12 Crisis

Bridget joined her mother in the long process of nursing Jack back to health, and she immediately threw herself into that new situation. As she quickly discovered, this required providing constant care. Focused on recovery, Jack was a determined patient and in some ways a demanding one. Despite his injuries, he was impatient to return to work and not content to be idle. Early on in the process of convalescence he began seeking help with a range of tasks. 'I would like to write a letter' became a frequent request. Sally also helped, but her job at Pemberton's meant that she could be at Molecey for only part of the time. For that reason, the burden of responsibility fell to Louise and Bridget. This was preoccupying, but even so the ex-student was glad to be useful and able to help. No longer concerned by the prospective outcome of her course, she had time to reflect on her situation, and looking after her father was something of a relief. It provided a welcome sense of purpose, one that she augmented by assisting with alterations and improvements to the house. Such practical involvement offered a sense of security and well-being. As a result, and despite her father's predicament, Molecey continued to be a great consolation.

Gradually, however, the disappointment she had encountered at the RCA increasingly weighed upon her. Recalling the risks she had taken, there was a growing sense of relief in having avoided a formal pronouncement of rejection. She learned later that Frank Auerbach had been instrumental in helping her elude the outcome she had dreaded. Having become something of a favourite with the teaching staff, he had defended her, arguing that 'You can't sack her.' The time they had spent together, although short, had engendered a mutual and enduring respect. The

disgrace of failure had been circumvented, but there was an abiding awareness that success had escaped her. She had been unable to gain the insights into painting that she had sought, and, because of that, she still lacked direction for her work. These considerations made her feel at a complete loss, and as time passed she experienced a deepening depression.

She reflected on the previous reverses she had suffered and, in particular, recalled Robert Buhler's remark when looking at her work, 'you're only young'. It had seemed odd at the time. Now it appeared to form part of a pattern of discouragement and criticism, as if throughout her time at the RCA her tutors had wanted her to desist. Previously the remark had added to a growing sense of disaffection, but she had not brooded over it. At Molecey she began to see such comments as slights. Looking back, she perceived that from around the middle of her time at the college the frustration she had felt had concealed an escalating despair. That feeling now became tangible. In her present situation she was fully committed to caring for her father, a position that was both physically and psychologically demanding. At the same time, she found herself dwelling on the perceived failure of the last three years and confronting the lack of any clear way forward. Increasingly oppressive, eventually these thoughts became intolerable.

The ensuing crisis came without warning, but its impact was debilitating. Overwhelmed by a sense of general unhappiness and anxiety, everything about her life seemed destabilised. The uncertainty about her father's fate during the war years had risen up again following his accident. Now that he appeared to be recovering, the constant pressure of care made itself felt. Combined with worry about her own future, this finally brought about a breakdown in her own health. Bridget collapsed and, unable to carry on living at Molecey, was admitted to the psychiatric unit at Middlesex Hospital. The ensuing episode is something of a blank. It was short in duration, somewhat confused and left little trace. From Middlesex Hospital she quickly transferred to a residential care unit in Muswell Hill, north London, where she continued to recuperate. Opened in 1928, the leafy site comprised three adjacent Victorian villas on Woodside Avenue, near Highgate Wood. The facilities included

accommodation for 50 patients and provided for the treatment of nervous disorders. Bridget found herself sharing a room with three others, one of whom was a young mother. Unable to cope with her own domestic predicament, the woman had succumbed to exhaustion and had been placed in a deep therapeutic sleep. Bridget saw her neighbour's spent condition and thinness, both of which resulted from a situation that had simply slipped beyond her control. Fed intravenously, the woman slept and, as the days passed, gradually began to regain her strength. Bridget observed the process and felt herself lucky not to be in what seemed a far worse predicament. She resolved to leave as soon as possible.

During this time, she was supported in her recovery by an excellent doctor. Trained in Jungian psychology, this capable practitioner was known to Bridget simply as 'Hector'. He proved to be an invaluable, sympathetic and perceptive guide. She was given to understand that the problems she was encountering were entirely reasonable and rational. Hector explained that when an individual's creative energies are thwarted or blocked, they are unable to adapt and grow. The resulting disharmony between unconscious experience and its realisation in conscious life leads to illness. Confronted with that schism, anyone would come up against the situation in which she now found herself. Rather than resulting from some personal weakness, there were sound reasons for her response to the events she had faced. Moreover, she was encouraged to see that these were issues that could be dealt with. These were reassuring insights. Assimilating them required an effort of objectivity, but gradually Bridget found in her mentor's advice a source of strength and a way forward. A state of equanimity had been upset by a profound disturbance and could be restored. That pattern had a logic and, most importantly, the capacity for practical application. It was something to work with – almost a map for life – and Bridget told her doctor that she did not belong in her present surroundings.

Throughout the following weeks she remained in contact with her Jungian adviser, and for a while after being discharged she continued to seek his help at his private London consulting room in Queensdale Road, Holland Park. The breakdown had been undermining and confusing,

but there were positive aspects. On a personal level, lessons had been learned. Seeking reasons for her illness, her family had been told that in psychological terms Bridget had never left the family. Bridget was encouraged to see that the pattern of her distress evidently had deeper roots. Age, experience and gender were all bound up with an individual's response to life events, and the way they reacted had a rational base. In her case, closeness to the family was a great consolation and support, but at the same time some distance was needed. Proximity to others could inhibit growth. This was a valuable realisation.

Perhaps most important of all, the sequence Bridget had experienced at first hand – a state of repose upset by disturbance, leading back to repose – seemed not only personal but also to have some positive universal meaning. In its own way it was a blueprint for being, a process that everyone could recognise. It was also a working discipline, and one that eventually strengthened her grip on doing what she wanted to do. During the early 1960s, when she began to find a way forward in her work, the pattern of repose, disturbance, repose would become a structuring principle for her black-and-white paintings, underpinning the perceptual experiences that they generate. In *Movement in Squares* (1961), for example, a regular sequence of shapes is progressively disrupted, leads to optical disturbance and then stability is restored. But that practical application of the insight she had received lay in the future. For the moment, the sequence of psychological states provided much-needed consolation. Her adviser told her, 'Take no notice – get on with your work.' This was a vital imperative, even though the nature of that activity remained elusive.

Once underway, her recovery proceeded apace. In November 1955, Sally wrote to her mother expressing delight that Bridget was making big strides forward, noting a difference in her sister's letters, which now appeared coordinated, optimistic and hopeful. The letter had been sent from Italy where Sally was now spending some time travelling, eventually finding work as an au pair. As part of that renewed optimism, Bridget had begun to consider her next step and was seeking a job. Mindful of the need for something relatively undemanding, Louise found her an opening in a glassware shop in London. Located opposite Marylebone

Road, the business specialised in supplying fine *objets d'art* to museums and collectors around the world. She was taken on and, in addition to providing general assistance, the new recruit graduated to arranging the window displays. A letter written by Gerald Kitchin around this time shows that, although the two were no longer in regular contact, they remained close. As ever, Gerald was a source of support. Observing that the idea of her working in an antiques shop sounded interesting, he advised her not to try to make hard and fast rules about the part that painting would play in her future. In his view, the best course was simply to see how things went at first, not worry about how long she had been in hospital, to follow the advice of the doctors, and generally to rest and get well. Intriguingly, he concluded with congratulations that she had done some painting.

Kitchin's reference to painting is interesting and shows that her work had not stopped entirely, but in terms of what she was actually able to achieve possibly overstates the case. In fact, from 1956 to 1958 Bridget accomplished relatively little painting, partly because of the recent experience from which she was emerging, and also because she was unsure of how to proceed. While employed in the glassware shop she lived in a local hostel. She was still renting Foulis Terrace, but, as yet still not feeling fully responsible for herself, she needed a simple routine that she could follow. During that period of recovery, and unable to make progress with her work, she did not spend time in her studio. When she eventually felt able to go back to her lodgings, her output there would continue to be limited. She painted a number of canvases influenced by the late works of Matisse and made some studies in oil crayon that emulated Bonnard. Both these artists remained her guiding spirits. Bonnard in particular fascinated her and she attempted to make a copy of a still life by the French master. This, however, did not satisfy her. Attempting to trace his line of thought she found that she could not learn anything from his example. Overall, this was a long period of ongoing uncertainty during which she sought to harness her returning strength to find a personal direction. But without guidance, and left to her own devices, the path forward eluded her. Throughout, the question of how to find a way into painting was an

enduring preoccupation.

Around this time there occurred in London an event that entered her creative thinking and resonated profoundly within the British art world. From 5 January to 12 February 1956, the Tate Gallery hosted an important large exhibition, *Modern Art in the United States*, which comprised a selection of paintings, drawings and sculpture from the collection of the Museum of Modern Art, New York. Organised in six parts, it began with a section titled 'Older Generation of Moderns' covering the twentieth century before 1945. The central body of the show was structured thematically with parts devoted to the 'Realist Tradition', 'Romantic Painting', 'Modern "Primitives"' and 'Sculpture'. Significantly, this magisterial survey concluded with the work of 17 younger painters exhibited as exponents of 'Contemporary Abstract Art'. The line-up included William Baziotes, Arshile Gorky, Philip Guston, Franz Kline, Willem de Kooning, Robert Motherwell, Jackson Pollock, Mark Rothko, Clyfford Still and Mark Tobey among other leading figures associated with Abstract Expressionism. Although she was already familiar with Mondrian's work in reproduction, this arresting conclusion to the exhibition was her first true encounter with abstract painting.

The accompanying catalogue made significant claims for paintings that, to an unsuspecting British audience, appeared both unconventional and, for some, incomprehensible. Holger Cahill, former acting Director of MoMA, put his finger on the characteristic that most defined the new American painting: its imposing size. He wrote that these artists 'work in large scale which gives the spectator a sense of envelopment as if he were "in the middle of the picture". That impression was not lost on Bridget. She registered that the work was 'big', but in other respects she remained relatively unconvinced. Nor was she persuaded by the accompanying rhetoric. Equating the medium and activity of painting with the artist's primary experience, Cahill emphasised the radical nature of the work in terms of its subject matter and its means of expression:

> One might say that they have gone back to beginnings, to 'the first division of chaos at the origin of painting', searching out the meanings

of the parent medium, its darkness and luminosity, weight and body, transparence and opacity, its smoothness and roughness, its cling and flow, the rhythms of the hand that moves over the canvas and the accidents of passage cultivated for their own sake, sometimes to the point of automatism. The subject matter has become the medium, and the way it is handled ... it is what comes out of the artist's experience in producing the work.'[1]

Bridget had heard about the work emanating from America, and word of mouth had suggested that the exhibition was important. For that reason, she had gone to see it. But whatever hopes she had entertained of finding an alternative path were disappointed. While for others the Americans' work carried the force of revelation, for Bridget it was already 'something that had been around'. Uncompromising though it appeared, this way of painting seemed to follow earlier manifestations with which she was already familiar. She felt that Mondrian had crossed the line somewhat earlier, having dispensed with recognisable subject matter. Although the Americans now extended that approach with their audacious and spontaneous application of the medium, she saw this as part of a wider movement that was currently underway. Compounding that impression, she also sensed that, despite its expanded scale and energetic handling, there was something about abstract expressionist painting 'that wasn't very thorough'.

The first manifestation of the New York School painters in Britain generated much debate within the ranks of those who saw the show and heard about it. There were supporters and detractors, as well as those who were baffled. At the centre of the arguments that ensued was a concept: the *freedom* of personal expression. Bridget picked up on that but remained unconvinced. In her view, this was not a sound premise and, worse still, was not a particularly interesting idea. She felt that the claims advanced by its advocates were not well made, and, having now seen these paintings in the flesh, her overriding sense was 'that they did not have the dimensions that I expected from great paintings'. The notion of free expression, while attractive in principle, in other ways seemed to her

almost childish. Held up against the disciplines in which she had been schooled, and in relation to those traditions that she respected, there was an inescapable conclusion: 'I doubted it.'

As a result of the routine she had begun to establish, gradually Bridget regained strength and experienced a growing confidence. Feeling she could take on more, she answered an advertisement and applied for a job teaching children at a Roman Catholic convent day school in Harrow, to the north-west of London. During the course of the interview, the Mother Superior formed the entirely false impression that the candidate's Irish-sounding surname suggested an appropriate religious background. In assuming that Bridget was a Catholic, she overlooked her earlier education when she had attended a Church of England convent school. This may have helped, for more to the point was the inescapable fact that the young woman in question had no training whatsoever for the anticipated role. Despite that deficiency, a rapport was established and Bridget was appointed as the school's new art teacher. A lack of teaching experience was, however, a worrying disadvantage, and for that reason she sought advice from Gerald Kitchin, who by now had completed his teaching course and was actively employed in the profession. Indeed, as one of his letters intimates, he was becoming something of a veteran. Tongue firmly in cheek, he recounted how he had supplied his pupils with modelling clay while threatening terrible reprisals if a mess ensued. Evidently Bridget was undeterred by such reports and Kitchin's teaching experience may even have inspired her to try her hand in a similar capacity. Whatever her motivation, she now embarked on what eventually became a period of almost two years' teaching, which lasted until 1958.

The age range covered by the school was 11 to 17-year-olds, and, armed with impromptu guidelines from her friend, Bridget set about managing large classes of up to 40 pupils. Although they did not belong to a poor neighbourhood, many of her pupils turned up at school without having had breakfast. Also, the art facilities were rudimentary and limited to pencils and writing paper. However, having taken Kitchin's direction to get properly equipped and organised, she obtained a variety of better paper and a supply of charcoal and powder paints. Thus primed for the

task ahead, the new art mistress began with simple drawing exercises. There were sessions devoted to 'consequences', a variation on the Surrealists' exquisite corpse method, which was derived from a parlour game. The pupils would each draw on a folded sheet of paper, passing their partly concealed contribution to a neighbour who would add to the evolving drawing without being able to see the image as a whole. When finally revealed, the entire composite drawing would provoke surprise and great mirth. Initially, maintaining order was a struggle and the sessions were exhausting. Working three days a week she divided her time between Foulis Terrace, where she was again living and to which she returned at the end of the day, and Molecey, where she escaped at weekends. The effort required by her new employment meant that sometimes she would fall asleep on the train journeys back to both. Bridget soon discovered that discipline was the key to holding attention and she proceeded to more demanding activities.

Popular activities were complemented by a growing seriousness. Although not ready for the rigours of life drawing or perspective, the children were encouraged to draw each other. In an echo of her own earlier work at Molecey their teacher guided them to find the shapes in the subjects they depicted. Although she was inexperienced in the classroom, Bridget's thorough grounding in Sam Rabin's methods stood her in good stead. She would exhort her pupils to explore their visual experiences by asking, 'what was the last thing you saw?' In that way, observation – her old ally – became a staple element of her lessons. With growing confidence, she progressively engaged her pupils and the classes became less of a battle. Reflecting her personal interests and passions, colour mixing was avidly pursued. Producing and relating numerous shades of the same colour was an exercise propelled by the fascination it inspired. Referring to each pupil's blank sheet of paper, she urged them to 'go to the edges' and 'fill it up'. With the success of these activities, Bridget began to enjoy the new context in which she found herself.

Gradually, art history also entered their discussions. Although no expert, Bridget began working her way through the major movements

in modern art. This was an exercise conducted in a spirit of exploration as much as explanation, with teacher and pupils trying things out together. It was in this context that her first skirmishes with Pointillism were essayed. While the analytical processes associated with Georges Seurat would later be a fundamental element in her thinking, she now discovered that combining dots of different primary colours did not necessarily provide the anticipated sensations of a related secondary colour. The theory did not support the practice. This was a foretaste of the complexities to come, which Bridget's mature work would address. Exercises in colour and form followed, with Paul Gauguin and Cubism held up as models for emulation. Concurrent with these teaching sessions, at Foulis Terrace she made occasional paintings inspired by Paul Signac, Matisse and Bonnard, whose thinking she continued to attempt to fathom. Bridget's instinct for these exemplars was true, but at this stage was not backed up with the authority of understanding. Such deficiencies were, however, overlooked by her young charges. Whatever the classes lacked in art-historical veracity was amply compensated by the atmosphere of enthusiastic engagement that prevailed. While Bridget continued to struggle with the question of how to progress her own work, it seemed that for the moment she had found a safe haven.

13 Recovery

Bridget's progress as a teacher was recognised by her colleagues and, even after it became clear that the young art mistress did not share the school's religious persuasion, the Mother Superior became a trusted friend. Taking Bridget aside, she pointed out that, while the lack of a formal teaching qualification was not a concern in itself, its financial disadvantages were plain. Without professional credentials Bridget was working for £17 per week. With the appropriate certificate her salary would rise to £25. Furthermore, properly qualified she could look forward to developing a career in teaching. Whether or not that was Bridget's ambition was debatable, but being able to earn a reasonable living had an allure. There was also another incentive. Both women were anxious to avoid difficulties with the education authorities who were scrutinising the school's academic curriculum. There was some concern that Bridget's unconventional teaching methods would not pass muster. Consequently, the Mother Superior and her apprentice teacher now began an informal programme of after-hours tuition aimed at preparing Bridget to obtain the necessary qualifications.

While her involvement with teaching appeared to be deepening, there were timely reminders of her long-standing and increasingly deferred preoccupation: the need to progress her painting. During one memorable summer, she had the opportunity to visit the South of France for the first time. In common with the school's young games mistress, Bridget's teaching role was mostly practical and there was no marking to carry out during staff break times. As a result, the two had become friends. Accompanied by her colleague's mother, the three set off for Nice, a place whose close association with Matisse made it a particularly attractive destination for

at least one member of the group. After the earlier periods of anxiety and illness, this trip was a welcome balm. Bridget luxuriated in the intense colours she had sensed in the reproductions of Matisse's work she had seen and in the paintings she had experienced in London. The place seemed replete with sensuous delight. She swam at night in the sea, enjoying being enveloped by something she could not see. But mainly it was her visible surroundings with their saturated colours that reawakened her earlier feelings for French painting. She relished the chromatic riot of the fruit and vegetable markets, the sky, sea and the warm radiance of the Mediterranean light. The apex of these revelations was visiting the Matisse Chapel at Vence, where the master's ideal consummation of light and colour made an indelible impression.

Throughout the period of Bridget's breakdown and her return to health, her father Jack had continued to recuperate from what had seemed insuperable injuries. Although his lower half was left relatively unscathed by the car accident, the extent of the damage to his upper body was such that nobody expected him to recover completely. For that reason, while convalescing at Molecey he received a number of visits from the two sons of the owner of Fisher Clark. They were keen to follow his progress and concerned to make plans for the future management of the firm. The expectation was that it would take a year at least for Jack to regain his health. That being the case, in their estimation the business could not wait. They concluded that in his place they would take over the running of the company. Although not entirely unforeseen this was a blow, not least because returning to work remained the determined patient's main objective. In that respect, subsequent events would prove him right. To the amazement of all, Bridget's father eventually made a remarkable, if protracted, recovery. Although he never fully regained the ability to swallow properly, he found an alternative, functional way of eating and drinking based on the reflex action he developed. His shattered arm, too, was restored to use: shorter than previously but entirely usable, so that he was again able to drive. With the restoration of his health and strength in sight, he was again in search of a job.

In that regard, the family's solicitor Fred Graham-Moore proved

a great help. After the loss of Jack's position at Fisher Clark, the lawyer secured him a pension for life. He also found him an important role working with the French company Rizla, then the leading manufacturer of rolling paper for cigarettes. Jack's position would involve setting up and running a new factory in Wembley. The downside to this exciting opportunity was that working in London would entail leaving Molecey in order to relocate to the capital. The house in Lincolnshire was, as Riley later recalled, her 'defence': a place of dreams to which she could retreat, both physically and in her imagination. Selling it, as would now be necessary, meant 'no more defence'. This was hardly a welcome prospect. Even so, it was Bridget who found their new home.

While visiting a friend, a girl who had been her predecessor in the Marylebone Road glassware shop, Bridget happened to be walking along Royal Crescent in Holland Park. Designed in 1839, the impressive stucco-fronted crescent had been inspired by its counterpart in Bath and comprised tall, spacious houses on five levels arranged in two graceful, curved terraces. Architecturally distinguished, the site had later deteriorated in parts and been converted into apartments, not least during the war when various properties had been used to accommodate relocated families. Even so, the expansive crescent was still imposing, and the communal, landscaped garden in front retained an undeniable charm. The large house that now caught her attention was in a parlous state but boasted a 'For Sale' sign outside. She immediately telephoned her parents, who viewed the house the following day. Previously used as a letting house, like its forerunner in Lincolnshire it combined character, generous proportions and the potential for radical improvement. They were immediately convinced and set in train arrangements for selling Molecey and moving to London. Royal Crescent would become their future home, and at a later date it would become the site of Bridget's main studio.

In the meantime, there were other opportunities to escape from the routine of teaching and commuting between Foulis Terrace and Molecey. Encouraged by their parents, Bridget and Sally embarked on a three-week tour of Scotland. Taking the family car, a Morris Minor, they proceeded up the west coast, driving by day and sleeping in the vehicle at night.

Passing through the northern Highlands, they explored the epic landscape with its awe-inspiring mountain ranges, coastline and islands, its picturesque lochs, glens, waterfalls and beaches. Although different in character from Cornwall, the vast expanses that enveloped them awakened memories of their liberated childhood when living at Trevemedar. Driving, walking and, most of all, looking became a daily rhythm that instilled a renewed sense of wonder in the presence of nature. As had been the case previously, the rituals of eating and washing were indulged with a carefree and entirely pragmatic abandon. Food was cooked in a tin box heated by a methylated spirit burner, and ablutions took place in whatever water was available. A bracing cold immersion at the start of each day meant that the opposite sensation followed swiftly, with a feeling of warmth compensating the recipient for hours afterwards. As had been the case on so many earlier occasions, that immediate, direct contact with outdoor life was a stimulus to visual awareness and Bridget responded with drawings that she made on the spot. Although she remained uncertain about how to advance her painting, such experiences were a confirmation of her commitment and a call to arms.

Their progress northwards took them to Clashnessie Bay. There they found a rocky inlet enclosing a sandy beach, a high waterfall animating the spectacle of ever-changing colour and reflected light. Warmed by the Gulf Stream, the bowl-shaped bay forms a container for sky, sea and earth, and it triggered memories of Porth Mear with its similarly intimate character. The beauty of the place enticed them to linger and they sought a place to bed down. Although they were unable to find accommodation at a local farmhouse, the availability of its barn presented an ideal nook. Provided with blankets and pillows by the owners of the farm – whose only injunction was a ban on smoking – the sisters spent two days and nights in this idyllic location. As with their nocturnal lodge in Boston, at night the sounds and fragrances of their surroundings were a delightful extension of their daytime experiences. Their stay in that spot was a highpoint of a trip that took them across the northern part of Scotland and down its east coast, an expedition that ran its course only when, during a telephone conversation, their parents called time on the use of the

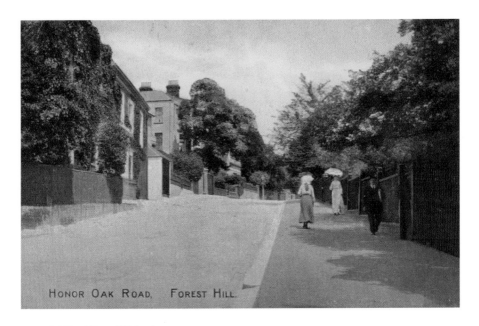

Honor Oak Road, Forest Hill, London
Postcard photograph by Charles Martin, c.1906
Bridget Riley was born in 1931 at Summerfield,
74 Honor Oak Road, her grandfather's home from 1909

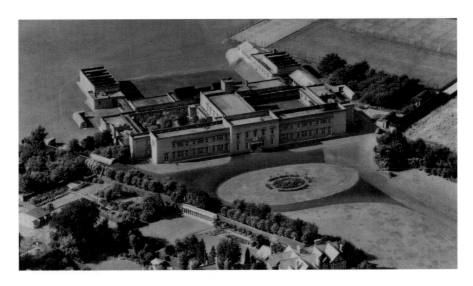

Boston High School, Lincolnshire, which Bridget
attended from 1939

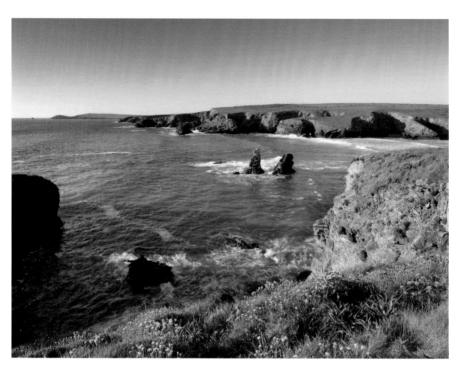

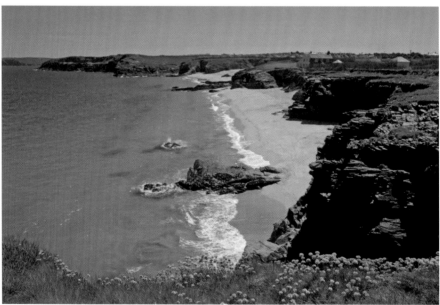

above: Porthcothan Bay and Trevose Head, Cornwall
below: Mother Ivey's Bay, Cornwall, the location of the
Old Fish Cellars

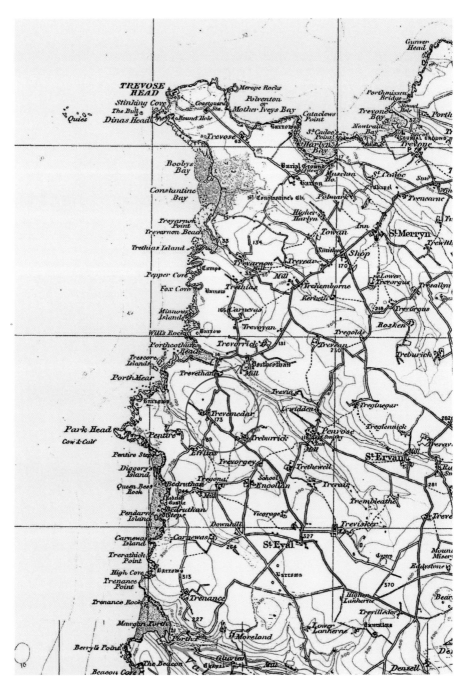

OS map of Porthcothan, Cornwall (1919), showing the
location of Trevemedar

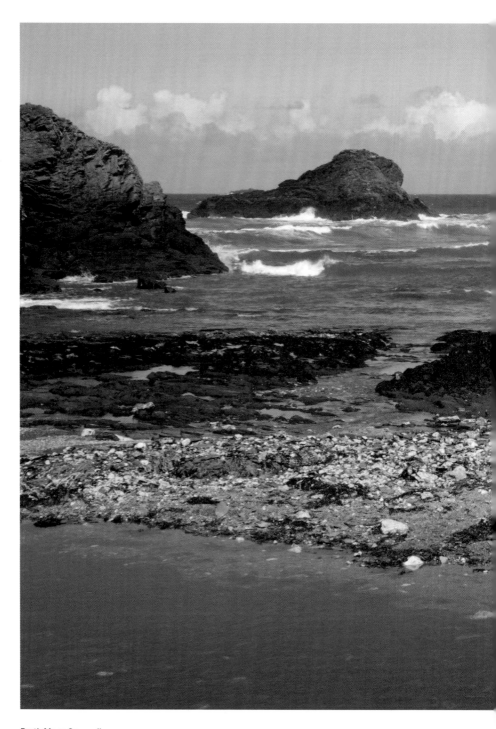

Porth Mear, Cornwall

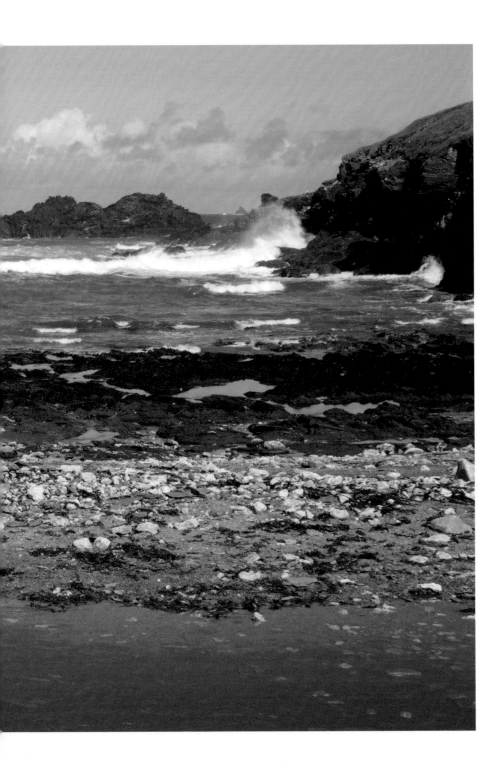

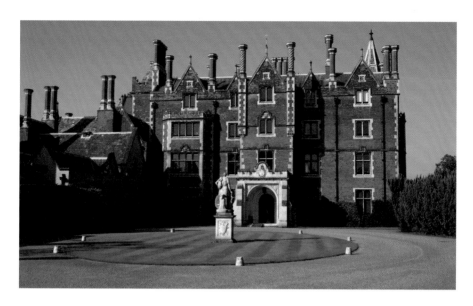

Taplow Court, Berkshire, the wartime location of
St Stephen's College

St Stephen's College, Broadstairs, Kent, after the war

VE Day celebrations in Trafalgar Square, London,
8 May 1945, which Bridget attended

Cheltenham Ladies' College, Gloucestershire,
which Bridget attended from 1946 to 1948

Margaret E. Popham (centre), Principal of Cheltenham
Ladies' College, with members of her staff

George Butler, Director of the art department at the
London-based advertising agency J. Walter Thompson
from 1932 to 1962

The *Penguin Modern Painters* series was an early
source of information about modern art for Bridget

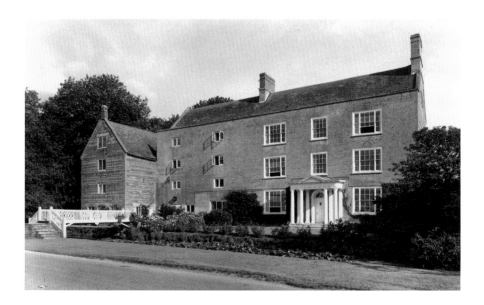

above: Molecey's Mill and granary, West Deeping,
Lincolnshire
below: Molecey's Mill waterwheel

John Deakin, portrait of the artist Frank Auerbach,
a fellow student of Riley's at the Royal College of Art,
London, 1950s

Paintings Sculpture and Prints

Modern Art
in the United States

A selection from the collections of
the Museum of Modern Art, New York

Modern Art in the United States exhibition catalogue,
Tate Gallery, London, 1956

142

The New American Painting

Arranged by The Museum of Modern Art, New York
and The Arts Council of Great Britain

The New American Painting exhibition catalogue,
Tate Gallery, London, 1959

Installation view of the *Jackson Pollock 1912–1956*
exhibition at the Whitechapel Gallery, London, 1958

Royal Crescent, Holland Park, London,
in the early 1960s

Maurice de Sausmarez, passport photograph,
c.1960

John Deakin, portrait of gallerist Victor Musgrave
at Gallery One, London, mid-1950s

148

Ida Kar, portrait of David Sylvester, who wrote an
appreciative review of Riley's first exhibition, c.1960

149

Tony Evans, Bridget Riley in her Warwick Road studio,
London, early 1960s

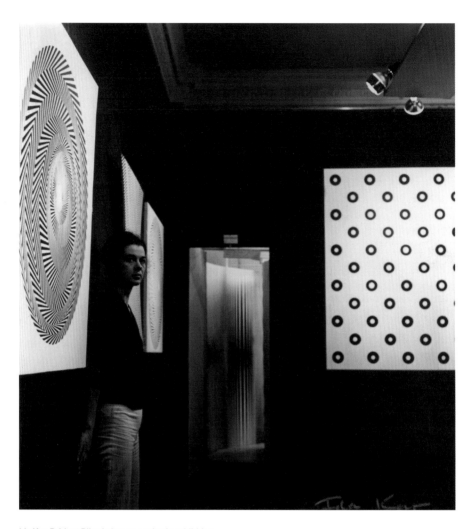

Ida Kar, Bridget Riley in her second solo exhibition
at Gallery One, London, vintage bromide print, 1963
National Portrait Gallery

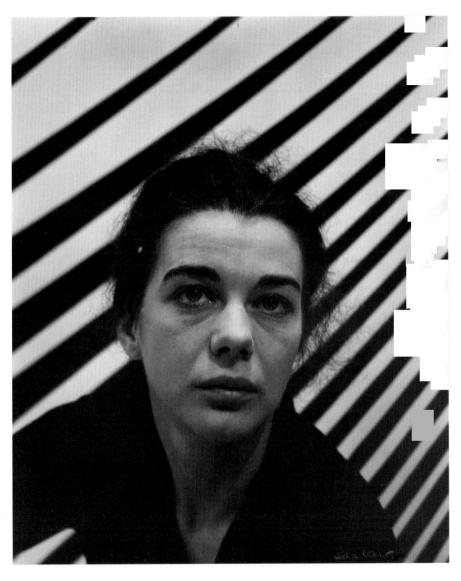

Ida Kar, Bridget Riley, vintage bromide
print, 1963
National Portrait Gallery

following pages: Bridget Riley inside *Continuum*
Contact sheet by Ida Kar, 1963
National Portrait Gallery

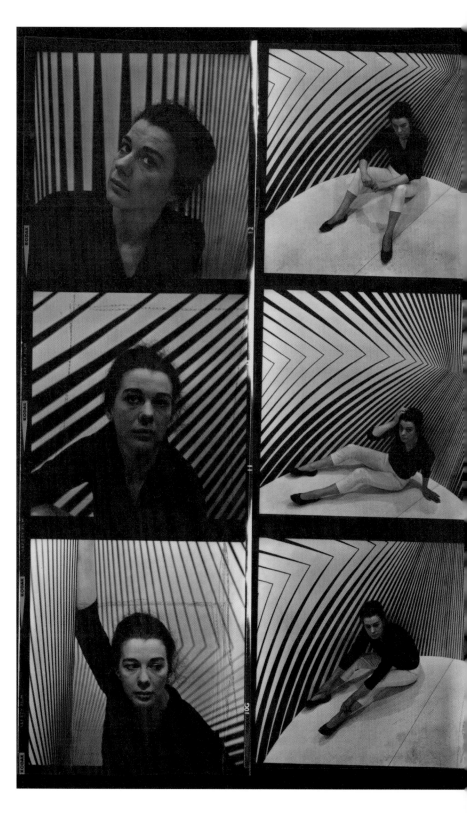

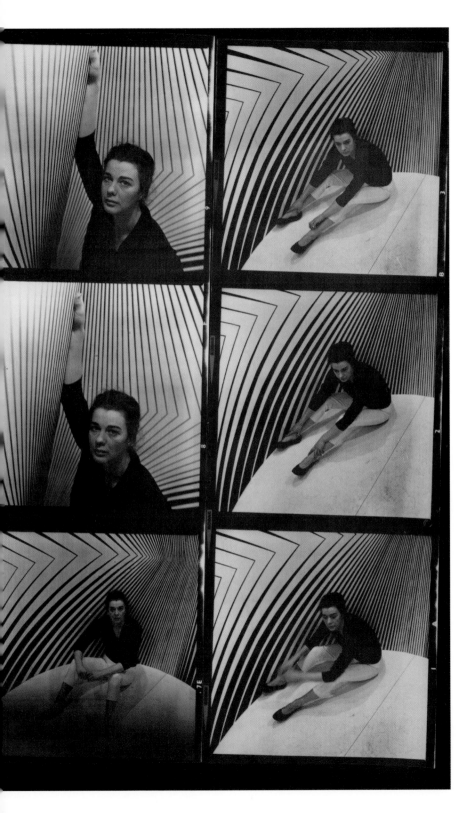

The New Generation: 1964 exhibition at Whitechapel Gallery,
London, 1964. Riley's inclusion confirmed her position as
a rising star. She is shown here with (left to right) artists
Michael Vaughan and Patrick Procktor, Whitechapel Gallery
director Bryan Robertson and artist Paul Huxley

Installation view of *The Responsive Eye*
exhibition at the Museum of Modern Art,
New York, 1965. *Hesitate* (1964) is hanging
on the wall at right of centre

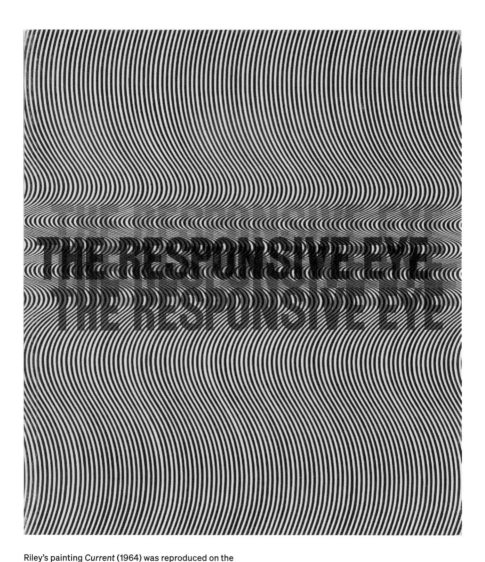

Riley's painting *Current* (1964) was reproduced on the
cover of *The Responsive Eye* exhibition catalogue,
Museum of Modern Art, New York, 1965

Morris Minor. The holiday had been a thrilling reminder of a previous life and, for Bridget, a comfort now that the 'defence' provided by Molecey was drawing to a close. With their life in Lincolnshire concluding, other consolations would be needed.

Living in London, she continued to ponder the knotty question of whether or not to continue as a teacher. Her travels to France and Scotland had been liberating, and possibly this influenced her thinking. Much as she enjoyed her role in the classroom, and even though she appreciated the efforts of the Mother Superior in trying to advance her professional development, she began to realise that settling into teaching was not what she wanted to do. She knew that something resembling contentment beckoned and had to be avoided. Bridget consulted her father, who once again thought of approaching George Butler. When she had previously needed guidance about her future artistic career Butler had provided sage advice, and it was possible that once more he could help. As Director of J. Walter Thompson, he had influence too. Advertising was a very different occupation from teaching but, being a visual medium, was not an unattractive prospect for Bridget. Her experience with children had given her the confidence that she could work with other people, and she reasoned that this was true irrespective of their age. Also, while exploring colour with her pupils, the joy of mixing and applying pigment had reinvigorated her own passion for these activities. That creative world had revealed itself and contact with it needed to be preserved. Based on the lessons she had learned as a teacher, she formed a kind of strategy: to respond to situations as they arose while retaining a longer plan of action. She now put that strategy into practice.

Accordingly, in late 1958 Bridget wrote to Butler and received a reply inviting her to come for an interview at the agency's office in Berkeley Square, Mayfair. J. Walter Thompson was a prestigious organisation. Established in 1878, it was one of the first advertising agencies in America and the first in that country to expand internationally with the opening of its London office in 1899. Its reputation was based on a distinctive ethos that pioneered the use of writers and artists to create bespoke advertising. That approach went far beyond standard advertising practice and spanned

the creation of individually tailored copy, layout, package design and trademark development. If Bridget had been aware of the extent of that expertise it may have given her some pause for thought, for she possessed no relevant knowledge whatsoever. Nor did she recognise the full significance of Butler's previous influence on her artistic aspirations. Although she had sought the older man's help and had met him, she had never seen the authoritative letter he had sent her father in 1945. Butler was equally insouciant and avoided any reference to her work, her previous plans and his earlier interview with a talented but impatient schoolgirl. Both parties now eyed each other, their past meeting something of an elephant in the room. However, Butler was content simply to observe, to let her be. From that encounter Bridget emerged with an offer of future employment and her days as a teacher came to an end.

On her first day at J. Walter Thompson, the new recruit was placed in the starting room and given a basic task involving the cutting up of images for use in design. To her consternation, she discovered that, despite its apparent simplicity, she had no obvious talent for this work. When subsequently she progressed to typography and layout, her lack of experience was similarly painfully apparent. Inevitably mistakes ensued and these did little to bolster her confidence. Fortunately, her colleagues were both sympathetic and supportive, and attempts were made to find work that would use her skills to better effect. Assigned to a young but more experienced colleague for guidance, she was given the task of designing a tea packet. This was a project to which she responded enthusiastically, and, having worked up her ideas, she presented her finished proposal for approval. The conversation that then took place poured cold water on whatever aspirations and expectations the participants may have harboured.

Bridget's design employed a striking range of colours, including, among others, a vibrant yellow. In no uncertain terms she was given to understand that, though arresting, such colours were not appropriate to a tea packet. The lesson of that exchange was that, in an advertising context, creativity had to be adjusted to requirements. The implications of that insight now became bitterly apparent. In her view there would be no discovery, no finding out and, above all, conformism. Disheartened,

Bridget immediately confronted Butler in his office. In floods of tears she told him that the whole idea of her working in advertising was 'terrible, a huge mistake', and for good measure she added, 'I can't do this, it is no good at all.' It was not an ideal beginning. Eventually Butler's protégée found a more suitable niche. She was assigned responsibility for producing preliminary drawings for design situations requiring photography. Being able to draw played to her strengths, was within her reach, and she was relieved at last to be competent in an aspect of her work. However, she was disappointed to find that she did not enjoy the activity. Producing images on demand stifled her instinct for exploration and expression, and once again a feeling of frustration began to grow.

That sense may have been exacerbated by a growing awareness of new artistic developments in London in which the ideas of experiment, innovation and discovery were gaining pace. Since the 1940s, the concept of 'modern art' had been gradually gaining currency in Britain. At Goldsmiths and the Royal College of Art, Bridget had become increasingly familiar with the principal manifestations of European modernism, while remaining – in common with most of her peers – largely unclear about its more detailed chronological development. In their different ways, Matisse, Bonnard, Van Gogh, Mondrian, Munch, Seurat and Monet were her luminous points of reference; but, as yet, both for Bridget and a wider British audience, the overarching narrative was confused and largely shrouded in mystery. The increasing visibility of exhibitions of modern art in London suggested the presence of a story still unfolding. Following important post-war exhibitions devoted to Matisse and Picasso at the Victoria and Albert Museum, Paul Klee at the National Gallery, and Paul Cézanne, Georges Braque and Georges Rouault at the Tate Gallery, there was a growing network of London-based venues featuring more avant-garde developments. Among these the Whitechapel Gallery was one of the most important. Founded in 1901, it had been an early outpost for modern art, and under its farsighted director, Bryan Robertson, who was appointed in 1952, it provided an international focus for recent artistic developments. In November 1958, the Whitechapel showcased the work of Jackson Pollock, one of the leading abstract expressionist painters

whom Bridget had seen almost three years earlier in the survey of
American art shown at the Tate Gallery.

Bridget visited the exhibition and, having felt previously that Pollock
was not a prominent element within the wider group, she was now able
to focus on his work in isolation. As part of an artistic movement charac-
terised by the expression of subjective experience realised on a heroic scale,
since his death in 1956 Pollock had quickly emerged as one of its most
celebrated figures. In particular, his much discussed 'drip' paintings, made
between 1947 and 1950, secured widespread attention. They seemed to
encapsulate the premium placed by the new American painting on liber-
ated painterly activity in which materials and process are immediate
vehicles for recording the artist's presence, energy and impulsive move-
ments. The later poured paintings were no less insistent in their explora-
tion of the interplay of image and abstractness, and in terms of application
they evinced an ethos of raw and spontaneous attack. Collectively, his
work became for many the uncompromising outcome of an ego-
preoccupied vision, an artistic state of mind that Pollock himself is said
to have defined. According to Pollock's wife, the artist Lee Krasner, in
response to Hans Hofmann's question as to whether he worked from
nature, Pollock replied, 'I am nature.'[1]

That revelation belongs to a later interview with Pollock's widow,
so Pollock's words – with their resonant repositioning of the artist at the
centre of things – had not yet entered the lexicon of his fabled reputation.
Even so, in viewing the American's paintings Bridget could not be unaware
of their motivation and ambition. She was familiar with the claims being
made for the courage of their endeavour, the risks taken and the whole-
hearted commitment of the artist's entire immersive involvement. In
particular, she studied the mural-sized painting *Autumn Rhythm: Number
30* (1950), one of the artist's key works, in which Pollock's advance towards
formlessness reached its compelling apotheosis. This magisterial painting
had an irresistible presence and was undeniably impressive. Walking
around the exhibition, Bridget contemplated the direction taken by an
artist probing the limits of painting and she absorbed the lessons advanced
by being able to survey his achievement as a whole. The experience was

an imperative to reconsider the very nature of painting itself, and as such it had a powerful impact. She also recognised the intensity and purity of Pollock's purpose and these were characteristics that she respected. At the same time, however, the qualifications that had accompanied her previous encounter with Pollock's work in the context of the other New York School painters now rose up again.

The freedom from traditional constraints had a primary frisson but, beyond that, she sensed the worrying destination of a dead end. Familiar with the misfortune of Pollock's untimely death aged only 44, she perceived a deeper tragedy that haunted the work itself. In Pollock's art she saw the evidence of an undevelopable way of working, a path taken that, having reached its destination, left nowhere else to go. For this visitor, it was there that the real tragedy lay, one that seemed almost to recall ancient Greek theatre. For all its impressiveness, the exhibition evoked an elevated individual whose failings had sowed the seeds of his own downfall. He had created a way of working that ultimately left no way out. Pollock's work was received by many others as a revelation, a beginning that swept away old habits and modes of thought. For Bridget the experience was double-edged. Abstract painting and the principle of autonomy had received a powerful affirmation and that now took root. The idea that a painting could be a thing in itself began to take shape. Equally, the dangers inherent in abandoning tradition had been laid bare. In putting aside the imitation of the natural world, painting had to do more than draw instinctively upon the well of liberated expression. It had to be disciplined in order to contain within itself the capacity for development and renewal. Her curiosity had been aroused, but she had also absorbed a valuable warning.

The Whitechapel exhibition was soon followed by *The New American Painting* at the Tate Gallery. From February to March 1959, Millbank became a destination for a curious and often bewildered audience, and also those who were keen to build on the previous encounter with Abstract Expressionism provided by the earlier survey of twentieth-century American art. In this new incarnation, the New York School painters now took centre stage. Organised by the Museum of Modern Art, New York,

the exhibition opened in Basel in April 1958 and toured in Europe, being shown at venues in Milan, Berlin, Brussels, Paris and, finally, London. The 17 painters included were each represented by four or five works, so that as a whole the selection amounted to a panoramic overview of the movement. Pollock was again in evidence, as were Sam Francis, Arshile Gorky, Adolph Gottlieb, Philip Guston, Grace Hartigan, Franz Kline, Willem de Kooning, Robert Motherwell, Barnett Newman, Mark Rothko and Clyfford Still, among others.

While presenting a group of artists that shared similar values, the organisers were evidently anxious to avoid any implication of conformity to a style. In the accompanying catalogue Alfred H. Barr, MoMA's Director of Museum Collections, observed, 'None speaks for the others any more than he paints for the others. In principle their individualism is as uncompromising as that of the religion of Kierkegaard whom they honor.'[2] Barr added: 'In short these painters, as a matter of principle, do nothing deliberately in their work to make "communication" easy.'[3] Wishing to pursue the interest generated by her exposure to Pollock's work, and seeking a deeper familiarity with the wider body of related activity, Bridget visited the exhibition. The painters' adoption of heroic scale and their projection of liberated confidence were tangible, and Barr was an articulate advocate, arguing that 'The paintings themselves have a sensuous, emotional, aesthetic and at times mystical power which can be overwhelming.'[4] Ambitious in conception and realisation, the exhibition set out to make a compelling case, and for many it provided confirmation that the latest manifestation of modern art was its irresistible apex. However, Bridget was unconvinced. Presented in these greater numbers, it confirmed rather than confounded the impressions she had previously formed.

She felt that, without the precision of control, not only did the claims made for liberation appear unsound but, worse than that, its manifestations were not particularly interesting. Nor did she trust an approach that too often looked like a reliance on felicitous accident. She remained true to her own ethos. Drawing provided a basis for finding out and for constructing a response. Without that framework, she felt that painting

166

fell short of the greatness she associated with its historic antecedents. Uncompromising, radical and assertive, Abstract Expressionism certainly made itself felt. She also registered that the idea of abstract painting had been furthered and that this was something to which to respond. Indeed, in a later interview published in *The Times* in April 1965, she observed that the exhibition 'left an indelible mark on me'. However, in other ways its influence was qualified. As Bridget later came to realise, the look and style of a way of working can be formed quickly and readily imitated. Her instinct was that the probity of art is its deep-rootedness. However revolutionary it appears, it must arise from a profound connection with tradition. Having revolutionised the course of twentieth-century music, Igor Stravinsky made that point precisely when he observed, 'a real tradition is not the relic of a past that is irretrievably gone; it is a living force that animates and informs the present. In this sense the paradox which banteringly maintains that everything which is not tradition is plagiarism, is true.'5 Unless validated by its contact with the past, the new can quickly fall into the trap of fashion. This insight lay in the future, but even at this early stage she sensed it.

14 Developing process

Whether or not Bridget believed entirely in the direction taken by the American painters, abstract painting on this scale and in these numbers presented a challenge. The idea of emphasising painting as a thing in itself could not be denied, and while she distrusted the heroic claims made for it, the intention resonated. For the moment, however, she deliberated, weighing the inspiration she had drawn from Matisse, Monet and other European exemplars of modern painting against the position taken by the American school.

While she continued working at J. Walter Thompson, these thoughts were an ongoing preoccupation. This was a time when in London the latest artistic developments were increasingly debated. Having shaken off the austerity of the immediate post-war period, the country's mood was changing. An appetite for the new was developing. Alongside the Whitechapel Gallery, one of the other main spaces for the presentation and discussion of 'modern art', as well as the ideas and values associated with contemporary culture, was the Institute of Contemporary Arts. Founded in 1947, the ICA was located initially in Oxford Street and three years later moved to Dover Street, Piccadilly. At that location, the Director was Dorothy Morland, assisted by the critics Reyner Banham and his successor Lawrence Alloway. During the 1950s the expanded premises became the site for a stream of important exhibitions, which covered an impressive range of modern tendencies. As well as early shows dedicated to European masters such as Picasso, Max Ernst and Klee, the work of influential British artists also found a platform. Exhibitions devoted to Victor Pasmore and Eduardo Paolozzi in 1954 and 1956 were followed in 1957 by a survey of recent British abstract art.

Bridget was aware of these developments without being directly acquainted with any of the individuals associated with the London art scene. But this now began to change. In April to May 1959, the ICA mounted *The Developing Process: New Possibilities in Art Teaching*. This exhibition would affect her thinking profoundly. Its origins can be traced to events that had taken place earlier that decade. In 1952 the Independent Group had begun to meet at Dover Street in order to discuss the complex manifestations of contemporary culture and its associations with technology and the mass media. The group included the architects Alison and Peter Smithson, James Stirling and Colin St John Wilson; the artists Magda Cordell, Richard Hamilton, Nigel Henderson, John McHale, Eduardo Paolozzi and William Turnbull; the music producer Frank Cordell and art writers Lawrence Alloway, Reyner Banham and Toni del Renzio. For the next three years the group's meetings spanned art, science, technology and popular culture, the ideas discussed sowing the seeds for what eventually became known as Pop Art. The same debates focused on the future of arts education. This was a topic that *The Developing Process* exhibition addressed and, her interest aroused, Bridget visited the show.

The exhibition provided an opportunity for Victor Pasmore – in collaboration with Richard Hamilton – to present ideas about a new approach to art training based on contemporary theory. Like Hamilton, Pasmore had been associated with the initial discussions that had taken place at the ICA. Building on the ideas developed by Herbert Read, one of the ICA's founders, they had developed further the implications of art education in the context of social change. In his influential book *Education through Art* (1943), Read had argued that 'art should be the basis of education'.[1] Accordingly, in 1953 Pasmore had established a course of studies called 'The Developing Process' at King's College, Durham University, and, assisted by Harry Thubron and Tom Hudson, introduced a summer school at Scarborough run by Leeds College of Art. There they established the principles of what became known as Basic Design, which focused on exercises in form, space and colour. *The Developing Process* exhibition was founded on that approach and at its heart was the concept of organic development. Beginning with a basic linear form – a drawn line

– the organisers showed the potential for growing complex structures from fundamental elements. A line could be expanded into a plane, from there into an intimation of three-dimensional space and, beyond that, into the context of sculpture and architecture. Vital to that momentum was the concept of process, a central principle based on the ethos of growth and the formation of diverse structures from simple forms.

This idea – that something as rudimentary as a line contained within itself seeds that could evolve into sophisticated and subtle arrangements – captured Bridget's attention. It echoed the training she had received from Sam Rabin, to which she remained true. More importantly, it suggested a possible way forward. Coinciding with the exhibition, Hamilton, Pasmore and Hudson organised a discussion at the ICA in which they set out the theoretical model for their ideas. Central to their approach was the need for greater rigour. Countering the romantic idealism of subjective expression, they advocated a more professional mode of activity in which intellect and intuition operated in dialogue and harmony. Underpinned by these rational foundations, art education would serve the needs of a modern society. In evolving that position, Read's ideas were augmented by earlier Bauhaus teaching, which had aimed at an experimental fusion of the arts, design, architecture and education. Hamilton had incorporated this thinking within the course he ran at Newcastle University. It also drew on the approach developed by Pasmore and Hudson with Maurice de Sausmarez in the context of the Society for Education through Art conference (SEA), which had been held in 1956 at Bretton Hall and chaired by Read.

Bridget did not attend the ICA discussion, but was stimulated by the ideas that the exhibition had presented and was keen to pursue them further. An opportunity now arose. Following the exhibition there was to be a summer school held in Suffolk convened by a number of the principal protagonists. She did not see this prospect as providing a solution to the impasse that had stalled her progress for over two years, but she was curious. She may also have hoped that getting involved would address some of the many questions surrounding modern art to which she was seeking answers. Having obtained the necessary application form from

the ICA, she submitted her remittance and secured a place on the week-
long residential course. With its country house accommodation, the
proceedings promised to be salubrious. Pasmore was not present, the main
tutors being Thubron and his wife Elma, Hudson and De Sausmarez.
They were joined by Anton Ehrenzweig, the Viennese psychologist and
art theorist, who came for a day. Norbert Lynton, then teaching at Leeds
under Thubron's direction, was also there for part of the time. The school
was well attended and the other students included Paul Huxley, Alan
Green and John Hoyland, all of whom would later gravitate towards an
abstract mode of expression in their respective careers. The question of
abstraction versus figuration hung in the air. Indeed, as Bridget was well
aware, Pasmore was renowned for having changed direction when in 1948
he abandoned his earlier figurative work in favour of an art of pure form.
That dramatic move had intrigued her. Although Pasmore did not attend
the course, the thinking behind his conversion to abstract art was another
motive for her presence there.

The sessions began with a relatively simple exercise. The students were
invited to collect images that interested them and to arrange them on a
wall. Connections and collisions were encouraged, the resulting relation-
ships drawing on the interaction of conscious and unconscious decisions.
Each individual was then expected to give a talk about their selection
and its organisation. While the source of this activity was to some extent
Surrealist automatism, it exemplified Ehrenzweig's ideas, which empha-
sised the subliminal nature of the working process and its interaction with
the intellect. There were also practical drawing sessions during which
there was an imperative to make images comprising as many marks as
possible. That process underlined the need for great variety in the way
pencils, crayons and other tools were used, and was calculated to develop
expressive 'touch'. Calling on her extensive previous experience, Bridget
found this assignment relatively easy to accomplish. Other tasks were
more challenging. Proceeding beyond the principle of straightforward
depiction, the programme engaged with movement and its pictorial
representation. In the context of Bridget's mature work, in which the
perception of movement is a conspicuous concern, this early involvement

with such issues had a prophetic character. At the other end of the spectrum, there were analytical outdoor activities in which plants were carefully scrutinised, the resulting images being a closely observed record of tonal progressions and chromatic transitions. This, too, seems prescient in view of later developments in Bridget's thinking, not least when her early black-and-white paintings embraced tonal progressions in purely abstract terms. Throughout, Thubron was, in her words, a 'benign presence'. While the students carried out their assignments, their father-like mentor would observe them vaguely from afar while lying under a tree.

The week thus fell into a pattern. Tasks were set each morning, the resulting work would be exhibited, and each session would conclude with a critical response from one of the tutors. These activities were punctuated by lectures on a range of topics. Gradually a presiding theme emerged, with abstraction being held up, interrogated and explored. Underpinning that discussion were the ideas presented in *The Developing Process* exhibition regarding the principle of growing an image, the use of line to convey a sense of movement and weight, the expansion of volumetric form working from the interior outwards, the creation of tonality and the relation of a figure to its surroundings. Bridget had previously encountered some of these concepts and practices in Rabin's classes. She now re-engaged with them afresh, focusing on the idea of organic growth. Most importantly, the notion of developing pictorial autonomy through progressive abstraction was pursued further.

These practical and theoretical issues were compelling and valuable, but Bridget was also seeking answers to deeper questions relating to the historical development of modern art that she, in common with others who had attended art school, felt at a loss to explain. Growing familiarity with particular artists, movements and ideas was enormously stimulating, but without a sense of the underlying chronological structure these manifestations remained unaccountable, strangely isolated and perplexing. There was a shared need to understand what had happened prior to the recent war: how Fauvism, Cubism, Surrealism, Constructivism and modernism's other myriad manifestations related to each other. The central question was how those developments, which led to the present,

fitted together. For Bridget and others of her generation, these were pressing matters.

During the summer school's proceedings, she gravitated towards one of the tutors in particular. Maurice de Sausmarez was an enthusiastic teacher and took a close interest in her work. She responded to his evident admiration for her efforts and to the illuminating insights he brought to bear. As she quickly grasped, these drew on a detailed knowledge of art history, not least relating to the development of European modern art. This was precisely the comprehensive overview she had been seeking, and in their ensuing conversations about Matisse, Bonnard and the other artists she admired, she sensed his understanding and, most importantly, his affinity with artistic practice. De Sausmarez was a painter in his own right whose subjects included portraits, still lifes and landscapes. A member of the London Group and the New English Art Club, he had exhibited widely. He was also deeply involved in art education. In 1947 he became Head of the School of Drawing and Painting at Leeds College of Art, and in 1950 he had accepted an invitation to establish and lead a new Department of Fine Art at Leeds University. At the time of their meeting he had recently been appointed Head of Fine Art at Hornsey College of Art, a position he held until 1962. In this older man – he was then 44 – Riley saw a sympathetic spirit and a potential mentor. Their meeting was the prelude to an intense if relatively short-lived relationship, and one that would exercise a decisive influence on her future direction.

Reflecting an admiration for Post-Impressionism, De Sausmarez's own paintings were rooted in close observation, a lively feeling for colour and broad but incisive brushwork. However, that sympathy for French modernism coexisted with a strong interest in more recent avant-garde developments. The teaching he espoused drew on Bauhaus principles. It also had connections with the kind of liberal art education that had been developed in the USA at Black Mountain College, North Carolina, in the early 1930s, as well as at Ulm School of Design, founded in Germany in 1953. All these institutions were forward-thinking and emphasised the importance of aesthetics in the context of education and

social change. The ideas that De Sausmarez embraced, and which gathered momentum in Britain during the 1950s, can be seen as part of a wider, international movement towards a more progressive outlook. The sources of that experimental ethos were the diverse movements that defined the development of European art in the first half of the twentieth century. From Impressionism onwards, a progressive abstraction underpinned the modernist agenda and propelled it to new modes of expression. Within the context of art education, Basic Design focused on essential pictorial elements of colour, line, texture and form, and transformed art education in Britain from the 1950s onwards. In De Sausmarez, Bridget found an intellect well versed in that narrative and alert to its continuing implications for art at that present moment and into the future. In the absence of authoritative books on the subject, she recognised a mind replete with the information she sought.

When the week came to a close, De Sausmarez drove Bridget back to Foulis Terrace. They were accompanied by Alan Green. The vehicle in which they travelled was, she noted, a Volkswagen Type 2 (Bus), a model introduced in 1950 and, in Britain, a relatively rare presence on the road. During the journey a wide-ranging conversation about early modernism continued. John Rewald's magisterial book *The History of Impressionism* (1946) came up for discussion and there were also exchanges about diverse subjects, from Matisse to Constructivism. Bridget's eagerness to make sense of these different trends was tangible; equally, her companion's capacity to help was plain. Bridget spoke about the work she was attempting and the difficulties experienced. De Sausmarez referred to the research on which he was then engaged. This was connected with three lectures on Futurist painting that he was due to give at the Royal College of Art the following year. To his evident surprise, Bridget responded to that subject with profound interest. De Sausmarez later recalled, 'I did not realise at the outset, nor perhaps did she, how much our discussions and arguments, analyses and criticisms might help to clarify some of her own fundamental problems.'[2] As this statement suggests, it was a meeting of minds. By the time they reached their destination, it was agreed that he would return at a later date to view her work.

Writing in 1970, De Sausmarez provided a detailed account of their subsequent meeting:

My first visit to Bridget Riley's studio, which was then in a terrace house off Fulham Road, was in the summer of 1959. In that large first-floor room with its two long windows overlooking gardens, there was proof enough of the desperate struggle she was having to find some firm ground for the development of her work, following an enforced break of nearly three years. The fact that she had fairly recently had some work included in a mixed exhibition at the Wildenstein Gallery could not disguise the nature of her dilemma. Around the walls stood some largish canvases much influenced by late Matisse, and on the easel, one of a group more recently finished, a rich still life showing love and understanding of Bonnard. In folios was a mixture of strong incisive drawings from the nude, the outcome of her veneration for Ingres, some studies in oil-crayon dense in colour, linked with her prevailing interest in Bonnard, and landscape drawings mainly of Lincolnshire, where her parents then lived, the colour delicately indicated in pastel flecks or dots, superimposed to obtain mixtures in the manner of Signac, premonitory of later optical developments. None of these influences, explored with a mounting sense of desperation, was to prove wholly irrelevant to her later work, although the way forward was at that time entirely unknown and unpredictable.[3]

As this description suggests, Bridget's studio was indeed the scene of an ongoing battle.

Since leaving the RCA, during the intervening period she had been imitating the work of those artists she admired in order to understand their thought processes. As she was well aware, that effort had led to stalemate. She showed her visitor the Matisse-inspired interior she had painted during the period of her estrangement from the college, as well as a number of other paintings in a similar vein, including the attempted copy of Bonnard. There were also various drawings of the studio and

175

some landscape studies. The unifying characteristic of this body of work was its exploration of the principle of abstraction: a constant probing of observation allied to the will to create a pictorial equivalent that stood on its own terms. While these works were successful to an extent, she remained unsure about how to proceed. How was she to invest her work with the autonomy – that possession of completeness in itself – whose existence Rabin had intimated? In turning that question onto painting, she had wrestled alone with this conundrum. Her study of Matisse had revealed that his colour was not simply decorative but had a mysterious internal coherence. His paintings portrayed their subjects afresh and were imbued with an independent logic and life. But what was the basis of that vision and how could she develop this in her own work? She was stuck.

De Sausmarez was sympathetic to her dilemma and at the same time appreciative of her tangible efforts to resolve it. He was also aware that in terms of exhibiting her work, Bridget was a novice. The painting of a nude she made on her arrival at the RCA had been shown at the *Young Contemporaries* exhibition at the RBA Galleries in 1955. She had also been persuaded by Clifford Frith – against her wishes – to include some work in a group exhibition, *Some Contemporary British Painters*, held at the Wildenstein Galleries in 1958. But this exposure had been limited to student efforts. The paintings and drawings that she showed Maurice had been seen only by her flatmate Sue and members of her family. She was therefore delighted by his response. Far from being dismissive, he looked closely and divined the extent of their struggle – and their ambition. While possessing no ready answers, he expressed an interest in his young friend's ongoing campaign and a desire to follow her progress. It became clear that this would not be his only visit to her studio. Maurice now confided that he was shortly to make a trip to France. Maurice had separated from his wife Kate three years earlier, but they had an 18-year-old daughter, Philippa, who was then staying in Rodez in the south of France and whom he intended to visit. He would be travelling by road in the Volkswagen. En route, there would be an opportunity to stay in Paris and to visit the major art galleries whose collections had a bearing on so many of the questions they had been discussing. He asked Bridget

whether she would like to join him. She was thrilled to be asked and thought this was exactly what she would like to do. She readily accepted.

Having secured the necessary leave from J. Walter Thompson, Bridget now embarked for Paris with Maurice, her first visit to the city that stood at the centre of her artistic world. Their address was suitably bohemian. For several days they stayed at the fabled Hôtel La Louisiane, located at 60 Rue de Seine in the St Germain quarter. Built in 1839, the family-owned hotel was inexpensive, down at heel and situated in the midst of a colourful street market. With a butcher's shop, a cheese shop and a fish-monger's in close proximity, on entering the lobby the unwary guest was assailed by the reek of seafood. Connected by a maze of narrow corridors clad in textured wallpaper, its 80 rooms had nevertheless at various times accommodated a range of illustrious visitors, notably Ernest Hemingway, Jean-Paul Sartre and Simone de Beauvoir. As Bridget discovered, the inhabitants of each room also included a 'plentiful supply of fleas and bedbugs', the dubious custodians of the little iron beds and old mattresses that formed part of the establishment's nocturnal comforts. With its wafer-thin walls, the atmosphere was communal. Alongside these quaint distractions, there were compensations. An enlivening breakfast of coffee and croissants could be had at Paul's, situated a little further along the street at number 77. Most enticing of all, within walking distance lay a host of important artistic landmarks, notably Notre-Dame cathedral; the Jeu de Paume, which then housed the world's greatest collection of Impressionist painting; and, not least, the Musée du Louvre. This stay in Paris was Bridget's initiation into the pantheon of artists she had for so long worshipped from afar, and it now proved to be a revelation.

15 A visual education

One of the first ports of call for Bridget and Maurice was the Jeu de Paume. The riches of Impressionist and Post-Impressionist painting lay at their feet, with masterpieces by Manet, Monet, Renoir, Alfred Sisley, Degas, Camille Pissarro, Cézanne, Van Gogh and Paul Gauguin available in abundance. Many works were familiar to Bridget through reproduction, but here it was possible to study at first hand the physicality of the images, to follow closely the thinking behind their creation as revealed in the application of paint. Manet's *Le déjeuner sur l'herbe* (1863) surprised her in the way it was realised, the pigment held in mysterious relation with the intimation of flesh, foliage, space and light. The situation of the figures, and their connection with the shallow, stacked setting and with each other, was a palpable marvel. Bridget later recalled, 'there was nothing imitative about it'. As she now saw, the painting created its own magical self-contained world, with resemblance transformed by imagination and the sensuality of the artist's touch.

Then she confronted Monet. *Femmes au jardin* (1866–67) was something of a disappointment. While the freshness of this huge canvas was a delight, the relatively constrained character of its brushwork made it less impressive than expected. However, this was an exception. Viewing the artist's later paintings, she proceeded from one extraordinary masterpiece to another, and again it was now possible to trace the evolution of a way of thinking. She observed it all: the broken streaks and touches of colour denoting the flags in *L'hôtel des Roches Noires, Trouville* (1870); the resonant red-green contrasts in *Les coquelicots* (1873); the flickering, stippled surface of *Le pont d'Argenteuil* (1874); the agitated, atmospheric texture of *La Gare Saint-Lazare* (1877); the chromatic diffusion of *La rue*

178

Montorgueil à Paris: fête du 30 juin 1878 (1878); the compelling suggestion of movement in *Femme a l'ombrelle tournée vers la gauche* (1886). Collectively, the character of these remarkable works was immediately felt. The culmination of that experience was Bridget's encounter with Monet's paintings of Rouen cathedral. These were previously unknown to her. Products of the 1890s, when Monet began in earnest working in series, the painter's engagement with the fugitive nature of changing light, shadow and atmosphere revealed itself with an unexpected power. At some deeper level, the idea of investing each painting with an individual colour 'harmony' was absorbed.

Their procession through successive rooms unfolded slowly and steadily, with nothing overlooked and nothing unsavoured. During this time, she was reading John Rewald's book on Impressionism, and that intellectual framework underpinned the experience of the works themselves. The process of looking was conducted carefully, analytically, thoughtfully, and eventually it became exhausting. Punctuating their journey with breaks, the two returned repeatedly to those paintings that had made a particular impression in order to look again, see more, penetrate further. In this way their physical, intellectual and emotional responses cross-fertilised and strengthened. Seen again, Monet grew in stature, the visual experience of the paintings triggering subliminal responses and touching other areas of feeling. In his work, Bridget sensed an essentially celebratory presence, its purely physical components connecting with something that went deeper and which she recognised as being essentially spiritual in nature. The paintings had their own life, and even though that dimension remained mysterious, she sensed it and felt a great empathy. Satiated, from the Jeu de Paume they went on to the Louvre, where this intense visual education expanded. Walking its vast galleries, she became attuned to the thrust of art history emanating from its earliest sources.

At the end of each day, Bridget and Maurice would continue the discussion over dinner. She was eager to learn, and her companion would cross-examine her about what she had seen and read. Bridget welcomed this. Although she remained shy, her confidence had grown. Not at all

intimidated, she expressed her responses and views with conviction. She also shared her current experiences and ambitions. She had been able to hold down her advertising job and had found a role there. George Butler had been quietly supportive and her employer had expanded the range of her responsibilities. Even though it lacked the element of discovery that she sought, her work was not entirely without relevance to her instincts. Working with light-boxes, the drawings she was making at J. Walter Thompson involved abstracting an image from its literal sources. As a result, she had already grasped a great deal in a purely intuitive way. Tangentially, her experience in the advertising agency connected with her deepening grasp of related visual issues in an artistic context. Maurice was sympathetic to her predicament and evidently aware of her ability and potential; she learned very quickly and he was impressed. The two grew together as mentor and pupil. But these discussions and their shared experiences were also mutually enlightening, laying the basis of a close intellectual friendship that would continue.

After their stay in Paris, the two extended their journey southwards, heading towards Rodez. Driving and sometimes camping, the experience expanded as it took in the French landscape. Their route enabled them to take in a visit to the prehistoric caves at Lascaux in the Dordogne region. Having opened to the public in 1948, the caves would be closed in 1963 because of the threat posed by visitors causing damaging levels of humidity. Bridget and Maurice were among those privileged to see the site before it returned to the obscurity from which it had been wrested. Her recent visit to the Louvre had acquainted her with the sources of Western art; at Lascaux she confronted some of the earliest known examples of art itself. Making a long descent in a tiny lift, the visitor sensed cool air issuing from the bowels of the earth: a prelude to entering another world. Describing this affecting and unforgettable experience over 50 years later, Riley recalled the instant, lasting impression made by the subterranean cosmos into which she stepped: 'We were in a big, domed space with the heads of the animals up above, the horses at waist height. The surface was rough-hewn, and there were extraordinary projections and planes which had little to do with what was painted on them – animating the paintings even

more.' Following the walkway around the perimeter of the cave, exploring the different sections and probing its adjacent passages, she encountered the mesmerising evidence of life as it was envisaged almost 20,000 years earlier. Animals, figures and abstract signs teemed across its irregular surfaces, with cattle, birds, bears and humans conveying a feeling of constant motion, which had a profound impact: 'people moving, dancing, walking around and around.' She noted, 'It was a hugely active place – a very powerful thing indeed'. That sense of physical energy – of animation within a closed setting – was one that would surface in her work imminently.

From Lascaux, they proceeded to Rodez, where Maurice met up with his daughter. They then moved on. He was keen to visit the picturesque medieval village of Lautrec, the home of Henri de Toulouse-Lautrec, and during that excursion they stopped at Albi, the French master's birthplace. In addition to visiting Sainte-Cécile cathedral and the Toulouse-Lautrec museum, Bridget found time to make some studies of the city set amid the surrounding landscape. These drawings would form the basis of *Blue Landscape* (1959), her first painting based on observation in the neo-Impressionist style that she adopted later that year. This part of their sojourn in France was in many ways the most idyllic. Travelling around, they took in the ancient region's towns and villages, visited historic buildings and monuments, and enjoyed restful lunches. Bridget had brought drawing materials and much attention was given to finding suitable subjects. Maurice had long since given up drawing, but his young companion's enthusiasm revitalised his interest and he was encouraged to re-engage with it. Having rediscovered drawing in this way, he would maintain the activity from then on, much to Bridget's satisfaction. Jean-Baptiste-Camille Corot was one of his great passions and during the holiday he also produced small paintings in oil on panel. Deep in the radiant context of southern France, together they made studies in situ, following the example of the painters they both admired and had recently observed in Paris. Looking now went hand in hand with drawing and painting, and this shared activity became the source of considerable happiness.

The holiday had provided wonderful experiences and the two had bonded closely, joined by the art they had seen and discussed, the places

they had visited and the sense of mutual enjoyment. It was unfortunate, therefore, that their travels concluded on a discordant note: apart and in some confusion. The idea was that they should end their itinerary by proceeding through Spain on to Lisbon, where Bridget would meet up with Poppy Fletcher, her mother's old music mistress who had remained a good friend, and her son Ian. Finishing the trip in this way would provide an opportunity for Bridget and Maurice to spend time with these acquaintances in Portugal before they all returned to England. However, events now took an unexpected turn. To her surprise and consternation, on their arrival in Lisbon Maurice announced that he had to leave immediately. For motives that are obscure, he left Bridget in the hotel in which they were intending to stay and, effectively, disappeared. She was utterly mystified by his behaviour. Whatever the reason, Bridget was left in the lurch. Her situation was made worse because they had arrived a day later than arranged, and Bridget discovered that Poppy and Ian had already departed. Alone, she found herself with no money, no friends and no plans. Maurice had, it seemed, simply run out on her.

At something of a loss, she sought help. A sympathetic hotel official came to Bridget's aid and directed her to the local embassy. There she was able to make contact with her mother, who was furious. Louise was annoyed with Maurice for having abandoned her daughter, and irritated that her own friends had complicated the situation through apparent impatience. With Bridget lacking any means of financing herself, impromptu arrangements had to be made to enable her to prolong her stay while awaiting the arrival of the funds that would facilitate her return. In the meantime, she drifted around Lisbon, reflecting on her peculiar predicament while doing some drawings of the local architecture. The episode was indeed strange. Why had Maurice left so abruptly? With hindsight, there are different possible explanations. One is that Poppy, who was a powerfully assertive woman, had match-making plans and wanted to introduce her son to Bridget. The prospect of that meeting would not have appealed to Maurice, in which case his sudden exit spoke of a wish to avoid a potentially embarrassing situation. Another reason

could be that Maurice had another rendezvous in mind. While it would be some time before Bridget finally became aware of it, Maurice's relationship with another woman may already have begun.

16 Looking becomes the subject

Despite its chaotic conclusion, the holiday had been a success. Together Bridget and Maurice had experienced a huge range of wonderful art and architecture, and visited major cities, historic towns and ancient sites in three countries. They had also made art in each other's company. A shared interest and delight in looking had been their bond; throughout, the pleasure of conversation had been its confirmation. For Bridget, it had been both a liberation and an education.

She had learned such a lot, and not only in terms of the art-historical perspective she had been seeking. In Maurice's company she had acquired a new grounding in looking, a facility for scrutinising art that proceeded in an enquiring and methodical way. Sam Rabin had taught her to question the object of her gaze, to analyse and evaluate her sensations. In her new companion she encountered an intellectual force – 'a new breed to me' – a mind attuned to perceiving as the foundation for examining, connecting and developing a framework of ideas. In the presence of great works of art she had sought a wider and deeper understanding, and with her mentor's guidance had begun to find it. He had showed her how to go around a gallery filled with paintings and not simply browse. The individual works and the relationships between them were to be approached methodically. She admired Maurice's intelligence and knowledge; she was drawn to these qualities and began to depend on them. In other respects, her companion's allure was less obvious. When Bridget had introduced Maurice to her parents, they were indulgent but unconvinced. Louise questioned her daughter's wisdom in becoming involved with an older married man: balding, much taller than his petite protégée and possessing a slightly stooping manner. In retrospect, Bridget later recalled another,

less compelling, aspect of his bearing. There was something about Maurice that seemed evasive: a facial expression that appeared closed. But for the 28-year-old these were unimportant details. In Maurice she saw only a wealth of experience and wisdom – valuable qualities that were a source of help – and to that she was attracted.

For this reason, the events in Lisbon were put aside and the two drew even closer together. Shortly after their return to London, in autumn 1959 Bridget left Foulis Terrace to move in with Maurice. Most of the work she had made there was entrusted to her parents, who were living in the basement of Royal Crescent while the rest of the property was being renovated. Perhaps doubtful about this development in her daughter's circumstances and its likely duration, for the moment Louise held on to her patterned carpet and one or two items of loaned furniture that had previously graced Foulis Road. Bridget's new base was a large three-room flat on the top floor of a Victorian terrace house in Warwick Road, near Earl's Court. Maurice rented the accommodation and the plan was that they would both use the space as a place to live and also as a studio. The premises were ideal for that purpose. Previously a billiards room, the large central area was windowless but had a skylight that flooded the space with natural light. This became their living area and Maurice's workplace, as well as accommodating the bed. At one end there was an adjacent room, a rectangular space that served as Bridget's studio. A pair of windows overlooked the road. At the other end was a small kitchen. The two now settled into their joint arrangement. Apart from one brief interruption and a subsequent rearrangement, this would be Bridget's London studio until 1967: the place where she would make the first abstract paintings that marked the onset of her mature work.

She now resumed working at J. Walter Thompson and, around the same time, also went back to teaching on a part-time basis. Inspired by the 1959 *Developing Process* exhibition, Bridget's interest in teaching had been rekindled. While visiting the show, she had seen an advertisement posted at the ICA for a teaching job at Loughborough School of the Arts. After her travels she was pleased to find that she had secured an interview. In the ensuing discussion she was able to draw on her summer school experience

and to speak eloquently about the new approaches to teaching that she had encountered. This evidently struck the right note. Having been offered the post, she asked George Butler's permission to work a shorter week at the agency in order that she could divide her time between London and Loughborough. He agreed and from then on she maintained her contact with J. Walter Thompson as a consultant. There is a sense that around this time Bridget fully emerged from the shadow that had fallen across her path three years earlier. She was happy and fulfilled in her relationship with Maurice, her new teaching role was a fresh adventure and, tutored by Maurice, she was learning fast. Her job at Loughborough involved staying overnight for two or three days each week. Maurice would accompany her to the station when she was leaving and would meet her when she arrived back. She found this dual life congenial and her return to education exciting.

Bridget was pleased to find the students at Loughborough receptive and the general teaching atmosphere informed by a sense that there was something fresh and important afoot. Inspired by *The Developing Process* exhibition, she created exercises in which looking and making found a more ambitious fusion. Translating observation into practice, she devised tasks involving drawing combined with a new emphasis on colour. Mixing and relating close chromatic harmonies – especially reds – became a favourite theme. At this early stage she was unfamiliar with the concept of perception as such, but her teaching placed a premium on understanding the interaction of essential pictorial elements. Although inexperienced in teaching art at this level, she was confident in her ability to learn by looking and doing. Even so, help was needed. In developing her ideas she talked to Maurice, whose teaching background and current responsibilities at Hornsey made him a valuable source of suggestions and reassurance. With a mutual participation in teaching their relationship grew stronger, but at the same time she found certain elements of Maurice's approach worrying.

Her teaching method placed a premium on investigation, experiment and evaluation of what had been discovered during the process of looking and making. Discussing this with her mentor, she was surprised that, in

contrast, he appeared satisfied with whatever results were yielded by the activities he initiated. In focusing on elements of basic design – colour, shape and formal composition – he did not probe or assess the outcomes with his students, which she felt was a puzzling omission. It seemed to her that, without examination and analysis, such exercises were intended simply to create something that looked like 'modern art'. Bridget challenged him about this and asked, 'What is it you are doing – a style of some kind?' When there was no answer, she demanded to know, 'Isn't it important to you that they understand?' Again, this produced an evasive response. She was suspicious of this dereliction of purpose. As a responsible teacher she thought it self-evident that the students should comprehend the activity in which they were involved, and what it was that they had found as a result. This thinking connected directly with Rabin's teaching, which remained her touchstone. If not questioned and understood, the product of visual investigation was just, as she had implied, an element of style. Without intellectual rigour, whatever ensued was decorative. There had to be a rationale for the way things looked. For Bridget, this was – and would continue to be – an important principle.

While Rabin's discipline was a mainstay of Bridget's approach to drawing, she was well aware of the inherent dangers of facility. By this point her drawing demonstrated the maturity she had achieved in that activity. But with ability can come an unquestioning reliance, and beyond that an encroaching superficiality lurks. For Bridget, the need therefore to go past drawing and engage with the complexities and problems of painting was more pressing than ever. This did not imply abandoning the lessons she had learnt from Rabin; indeed, building on that knowledge was essential. But in going forward, it would be necessary to put aside drawing as a self-contained activity. It would entail a sacrifice: the first of many others that would be entailed subsequently. This realisation lay behind the significant step that she now took.

In late autumn 1959 Bridget embarked on making a copy of Georges Seurat's painting *Le Pont de Courbevoie* (1886–87). This initiative came out of her protracted attempts to understand Impressionist painting through the drawings and studies she had made at Molecey and Foulis

Terrace. She had also tried to derive guidance in the role of colour from copying Bonnard, an endeavour that had proved fruitless. In turning to Seurat she was attracted principally by the French master's methodical approach. With Bonnard, it had been impossible to follow his train of thought. By contrast, Seurat's system of juxtaposing dots of contrasted colour was rooted in empirically verifiable means. In his own way, the French master had attempted to analyse Impressionist painting, to fathom the mysterious relationship of colour, light and pigment with which Monet, Pissarro and others had engaged and which their work manifested. From that enquiry arose the possibility of reinvention and renewal: 'to start anew what they have done', in Seurat's own words. That endeavour chimed with Bridget's present needs and her previous efforts to understand the painters she so admired. His methodical approach was also entirely sympathetic to her instincts. Seurat's examination of these matters placed perception on an explicit footing: one that held out the prospect of revelation and, hopefully, emulation. By engaging directly with the creation of Seurat's celebrated painting – and, in effect, with his thought processes – he could be the teacher she lacked.

As we have seen, Bridget's interest in Seurat's work was long-standing. During the period of her estrangement from the RCA, when she had derived much solace from the room of Impressionist paintings at the National Gallery, Seurat's magisterial composition *Bathers at Asnières* (1884) had affected her profoundly. In that radiant painting she saw the evidence of his will to understand what Monet had achieved in his own, earlier, inimitable way. Seurat had subjected the older painter's work to careful scrutiny, analysing a technique that captured the fleeting effects of light and atmosphere. But whereas Monet's method of painting was carried out *en plein air*, the younger man pursued his investigation in a studio setting. In place of the fugitive moment and direct sensory engagement, Seurat turned his attention to perception itself, focusing on organising a coherent structure for the perceptual process. As a result, transitory visual experiences were given a framework and an architecture, the mutable contained within stillness. The ensuing fabric of Seurat's vision was, as she saw, a surface on which tonal variation, colour, light,

volume, space and depth are precisely constructed, providing rich visual delights. The impression made by *Bathers at Asnières* stayed with her, while remaining essentially mysterious and elusive. Buoyed by her recent visit to Paris, she now returned to Seurat's exploration of Impressionism with the aim of retracing the particular path – '*ma méthode*' – that he had taken.

She did not, however, copy the painting in the National Gallery. In the meantime, another of Seurat's creations had excited her attention, namely *Le Pont de Courbevoie* in the Courtauld Gallery, at that time situated in Woburn Square, Bloomsbury. In discussion with Maurice, the later painting was felt to be the artist's most exemplary achievement. But in preparing to make a copy, she took a leaf from Seurat's book and resolved to carry out her analysis within the confines of the studio. In common with her predecessor, there was a sense that learning is best conducted in private and she decided to use a reproduction. As well as being a practical expedient, the strategy of working indirectly – of not copying the painting itself – had further significance. The separation and distance afforded by using a photographic image – with its inherent colour imperfections – demonstrates that Bridget's concern was not simply to re-create what already existed, but lay rather with the process itself. Her aim was not to replicate Seurat's painting, but, instead, the means of creating it.

For that reason, there are essential differences as well as close similarities between the original painting and Bridget's version. Indeed, the latter is more accurately regarded less as a copy and more as her personal response to the earlier painter's example. The issue of size involved an immediate departure. She began by working from a small image reproduced as a colour plate in a copy of R.H. Wilenski's book on Seurat, published by Faber and Faber in 1949. The canvas that she selected was larger than the original, although similar in the relative proportions of height to width. In other respects there were precedents that she wished to follow. Her preliminary study revealed that Seurat had prepared the ground of his painting with yellow ochre – a departure from the Impressionists' technique of using a white canvas – and she followed his lead. Seurat had then organised his composition by filling in broad areas of

189

colour using a cross-hatched method of application. These planes provided a base for the top layer of tiny dots of pigment whose colour combinations, when mixed optically, are calculated perceptually: that is to say, in terms of the vibrant, illuminated subjective impressions they are intended to produce. The small scale of Seurat's Pointillist method maximised the visual fusion of the different chromatic touches. As Bridget now realised, the interaction of these separate elements is responsible for generating myriad experiences of tonal variation, colour relationship and, above all, internally generated light. Indeed, the relationship of colour and light stands at the centre of Seurat's method, hence his use of the term 'chromo-luminarisme'.

Working on a larger scale, Bridget used a bigger brush to produce each individual point of colour. This enabled her to analyse Seurat's optical combinations in a detailed way, breaking down perceived tones and ambient hues into their constituent parts. Over a period of four to five days she gradually developed the visual fabric of her own painting. Examining each passage of the original, she moved across the expanse of the river, threaded along the jetty and tested its reflections, and then traversed the open space leading to the pale silhouette of the bridge beyond. Repeating Seurat's pictorial journey was, she recalled later, 'a joy to do'. More than that, the process of studying the master's method was enormously instructive and revealing. She traced the radiance within the original to its source in colour, and in replicating that relationship she internalised it. She also absorbed the fundamental principle that underpins Seurat's Pointillism, namely the dynamic connection between discrete elements and their overall organisation.

The most profound lesson was perhaps the way in which Seurat's method led to abstraction. By deconstructing *Le Pont de Courbevoie* into its constituent, fundamental parts, she became aware of something unexpected and surprising. There were areas of the painting that had shed their responsibility for literal description of the observed subject and instead assumed an autonomous, purely pictorial role. Some passages were unidentifiable in terms of description. In that respect there were echoes of her earlier teaching with Rabin, in which the abstracted

190

rendering of tone created the imperative to produce an image that cohered in itself. Seurat's painting was not abstract, but had acquired a self-contained character that made sense on its own internal terms. The examples of Rabin and Seurat were essentially different: one rooted in drawing, the other in painting. In a crucial way, however, their respective approaches were indivisible. The autonomy achieved by a process of abstraction was vitally important because, in an apparent paradox, while standing on its own terms the re-created image revealed the subject anew. The existence of an independent, equivalent object renewed the attention and engagement of the viewer. This was a vital insight.

In other ways, by assimilating Seurat's method Bridget also divined its shortcomings. While fascinated by theory, the master's own method was essentially empirical and intuitive. He proceeded experimentally, trying out different combinations and assessing their effect. Accordingly, she recognised that alongside the wonders achieved by Seurat there were inconsistencies. Certain passages called for pictorial solutions – for example the addition of enlivening points of complementary colour – that were puzzlingly absent. In those instances in which she sensed a lack, she took the liberty of inserting chromatic additions. For example, the foreground of her response includes lively points of red paint that are not present in the earlier painting. She was also aware of the constraints of Seurat's method. His investigation inevitably addressed those visual experiences that can be examined and encoded pictorially. In relation to other, more ephemeral areas of visual experience, notably those impressions that exist at the edges of conscious recognition, Pointillism showed its limitations. The rigour of Seurat's search for verifiable certainty meant that other, unrecognised aspects of consciousness – its peripheries – remained out of reach. His success in presenting these mysteries had an inherent probity. As Bridget later observed in her essay 'Seurat as Mentor', 'Comprehension is not everything; the unaccountable has a place in our lives, particularly in that of an artist.'[1] While that observation came much later, the existence of that uncharted area – the *unaccountable* – had been noted, and also identified as a site for further exploration.

Bridget's study of Seurat was overwhelmingly valuable. It was, as she

later described it, 'a true master class' in understanding a painter's engage-
ment with fundamental pictorial issues. She respected the extraordinary
distance he had travelled in probing the boundaries of expression, and
also the undeniable stature of his accomplishment. Seurat's crowning
achievement is, as she had experienced at first hand, that of transforming
the subject of pictorial enquiry. He had gone beyond the observed motif
and instead had engaged with the process of looking itself. In terms of
Bridget's future work, this was an inspiration and a luminous point of
reference. Also, at the foundation of the entire episode, she had absorbed
an important ethos. This was that, while any system has its limitations
and may even inhibit the scope of what can be expressed, a methodical,
structured approach is essential. In 'Seurat as Mentor' she observed,
'From Seurat I took the *example* of method rather than the method itself.'[2]
The primacy of disciplined exploration would be the key tenet of her
thinking and one to which she would remain always true. For the
moment, however, the practical application of Seurat's precepts became
her next step.

17 Italy

Bridget learned a great deal from the process of copying Georges Seurat. She had focused on the interaction of colours, the relation of hue and tone, and the appearance of light in colour. All were vital elements in understanding the chromatic nature and behaviour of painting. The organisation of larger pictorial structures from discrete elements, and the fundamental importance of a methodical approach were – as she now grasped – guiding principles for its practice. The autonomy resulting from abstraction had also received crucial affirmation, confirming the idea of a painting as a thing that exists on its own terms.

Most importantly, Seurat had taught her to look closely into the minutiae of painting: to appreciate the precision in the chromatic mixtures he employed. Whereas her preceding fascination with Matisse had yielded admiration but bewilderment at his use of colour for its own sake, her study of Seurat produced a new understanding of different hues moulded according to the demands of perception. She had witnessed the deployment of solar orange, green and crimson, his use of pale blue contrasted with yellow, the softening effect of an adjacent pink, the emergence of pearly greys. In Seurat's hands, colour supported the plasticity of painting: an optical *mélange* yielding intimations of space and distance as well as an inherent physical presence. Collectively, these were revelations that seemed to offer the entry into painting that she had been seeking. Through Seurat, she began to find her way.

As her immersion in Seurat's thinking deepened, so did her desire for scientific verification. But, as Maurice de Sausmarez was to record some years later in a vivid account of Bridget's situation in late 1959, that avenue was not yet open:

She was anxious to make contact again with the sources of his theories: Charles Blanc, Chevreul and Charles Henry. However, there were no English translations of Henry, Chevreul last appeared in English in 1872 and Blanc in an English version of 1879. All would have reinforced her creative thinking and would have given her the renewal of confidence she so badly needed, but William Innes Homer's informative book *Seurat and the science of painting* did not appear until four years later. She was now installed in a top-floor studio in Earls Court where, for a time, the walls were covered in fragments of colour theory, an enlarged commercially produced three-colour half-tone of some apples with colour dots the size of cherries, and, in the kitchen, a big reproduction of Seurat's *La grande jatte*.[1]

In the absence of a theoretical underpinning for Seurat's method, there was nothing else for it but to strike out on her own, and to apply the understanding she had acquired to her own subject matter. This realisation was the context for *Blue Landscape* (1959), her first painting using Pointillist principles.

This tall landscape was based on the drawings she had made at Albi during her recent journey through France with Maurice. In what would be a characteristic way of working, she had made three drawings in situ: a line drawing, a tonal study and a final image recording her colour notes. Utilising the methods now at her disposal, the small line drawing was enlarged onto a large canvas. Then, using the other references, the composition was blocked out in planes of tone and local colour. With Seurat very much in mind, these areas were subjected to scrupulous colour analysis, the description of buildings and landscape arising from a patient accretion of discrete chromatic touches. As the final image reveals, this process proceeded from – but almost independent of – the observed motif. Building on the Seurat transcription, *Blue Landscape* demonstrates a quality previously unseen in Bridget's work. From the interaction of small brush marks of colour, there arises a truly plastic surface in which description and independent chromatic activity are held in suspension. As is the case in Seurat's art, in certain passages the painting surrenders

its depictive significance and operates purely in terms of units of colour, contrasted and harmonised. As a whole, the image is unified by a blue atmosphere arising from the interaction of its various parts. In that respect *Blue Landscape* marks the crossing of a threshold.

In one way it can be seen as a straightforward pictorial exercise utilising the knowledge she had acquired from her study of Seurat: it is her version of *Le Pont de Courbevoie*. In another way, Bridget had made a significant advance. She had created a painting that more fully asserts an independent identity, and this would be a continuing preoccupation. Emboldened perhaps by this encouraging outcome, around the same time she completed *Lincolnshire Landscape* (1959), her second fully independent painting using a Pointillist method. This was based on drawings made at Molecey, and in some respects it is an even more resolved work than its predecessor. This further homage to Seurat depicts farm buildings seen at a distance and an illuminated field in the foreground, but it goes far beyond mere tribute. Its solid massing of forms, exploded chromatic touches, and interplay of cool and warm tones, display a precocious authority and a growing assurance.

In the meantime, Bridget and Maurice pursued their respective preoccupations while living together at Warwick Road and their relationship continued to evolve. With Maurice's encouragement, Bridget's knowledge of art had deepened and her work had progressed. This was a source of satisfaction to her older companion and he fed and nurtured her ongoing fascination with Seurat. As her work developed and her experience of teaching had grown, she had gained in confidence. They had differed about certain aspects of teaching, but this had not yet become a serious bone of contention. Bridget continued to admire her mentor's undoubted intellect and, as well as enjoying his conversation, took a keen interest in his research. By now Maurice was planning his forthcoming lectures on Futurism in detail and as part of that preparation was intending to visit the large group exhibition being held in Venice between June and October 1960. Mostra Storica del Futurismo formed part of the 30th Venice Biennale and would present a detailed overview of the movement's development. He also wanted to see the extensive Futurist collection held

at the Galleria d'Arte Moderna in Milan. It was agreed that they would
go to Italy together, once again travelling in the Volkswagen. Their trip
that summer eventually expanded to take in excursions to Pisa, Ravenna,
Arezzo, Padua, Siena and Rome. It would form a golden opportunity for
Bridget to develop her artistic education. At the same time, the experience
would open cracks in their relationship that even now were beginning
to appear.

Having made the long journey to Italy by road, their itinerary took
them on a circuitous route. They began in Milan, where, as planned, the
Galleria d'Arte Moderna provided an immersion in Futurist painting and
also in the collection's pre-eminent holdings of nineteenth- and twentieth-
century Italian art. Their next stop was Pisa, where the dramatic inter-
action of black-and-white shapes, as evidenced in the city's churches and
palaces, made a deep impression. They then criss-crossed their way south-
wards, eventually proceeding as far as Rome before turning back in order
to head towards Venice. En route they encountered a succession of cele-
brated sites whose architectural and artistic treasures were an inspiration.
They saw Piero della Francesca's celebrated fresco cycle in the Basilica
di San Francesco in Arezzo. Encouraged by that experience, they also
made a visit to Monterchi in search of one of Piero's greatest works, the
Madonna del Parto (c.1460). Now housed in the local museum, at that
time the fresco was situated over the high altar of the cemetery chapel,
a small building that replaced the original site, which was destroyed by an
earthquake in 1785. Together they tracked down the local keyholder and
were admitted to the intimate place of worship. Said to have been painted
in just seven days, Piero's affecting image of the pregnant Virgin made
an unforgettable impression. The rich mosaics contained in Ravenna's
chapels and basilicas were similarly moving. Such experiences were both
uplifting and exhausting. The travellers rejoiced in these shared treasures
and yet, as had been the case towards the end of their previous trip
together, there were also occasional moments of tension. As if over-
stimulated by the intensity of their journey's discoveries and revelations,
there were times when animated conversation ceased, to be replaced by
an inexplicable silence.

A growing strain became evident when Maurice insisted on visiting Cortona to meet Gino Severini. This leading figure within the Futurist movement was then 77 years old. Bridget was greatly apprehensive about meeting the distinguished painter whose works she had recently viewed in Milan. The idea of disturbing him in his studio mortified her and she tried to convince Maurice that turning up would be an intrusion. Her companion, however, was not to be dissuaded. Following earlier correspondence with the elderly painter's wife, he was determined to make the contact. Extracting a commitment had not been easy and for Bridget this was a further sign that their arrival would not be welcome. Despite her misgivings, they arrived at Severini's studio at the appointed time. After protracted knocking on the studio door, there was no reply. Bridget took this as confirmation that her instincts were correct. Nevertheless, Maurice would have none of it, reasoning that, as it was lunchtime, Severini was out and would probably soon return. He resolved to wait and they withdrew to the local square. There they spent some considerable time sitting on a stone bench, watched by a group of locals. It seemed a long, desultory afternoon. When finally they retraced their steps, a woman called out from a window above the studio to tell them that no one was at home. Much later it came to light that Severini had suffered a heart attack the night before their arrival. However, at that moment Maurice was bitterly disappointed and Bridget drew no satisfaction whatever from concluding that all along she had been right.

The simmering tension between them seemed to boil over as they approached Siena. They stopped the Volkswagen at the side of a road that overlooked the city and observed the distant buildings situated within a vast plain. It was mid-afternoon and the heat intense. Bridget got out of the vehicle and took in the scene. A huge haze spread across the entire field of vision. She later recorded her impressions: 'It was an immense arid expanse shimmering in the heat. The sheer volume of light seemed to shatter everything in sight. I wanted to make a painting showing the disintegration of this landscape under the fierce sun. A thunderstorm was approaching and had already obliterated the horizon.'[2] With that imminent prospect in mind, she immediately set about making her usual three

on-the-spot sketches. Conscious of the approaching black clouds, she worked quickly and there was just enough time to complete the work before the deluge arrived. Rejoining Maurice, they sat together and waited while the full force of the storm broke around them, buffeting the vehicle. The rain hammered on its roof with a deafening roar, its violence somehow connected with unspoken feelings. It was, as she observed in an interview conducted with Maurice in 1967, 'a powerful visual and emotional experience'.[3]

Moving on to Venice, eventually they arrived at the city immortalised by Canaletto, and parked the Volkswagen at Piazzale Roma. Little time was spent adjusting to the change of topography and pace. Threading their way through the historic network of canals, bridges and palazzi, they went directly to an exhibition of art dedicated to the apotheosis of speed. Writing ten years later, Maurice gave a vivid account of the impression made by the art they encountered in the Giardini:

> The central galleries were devoted to a comprehensive showing of Futurism, 143 major works having been assembled. Perhaps the deepest impression was made by the work of Balla, in particular such works as *Girl Running on a Balcony*, *Dynamic penetration of an automobile* (the decisive thrusting structuring and its pervasive black/white astringency may have unconsciously been partly formative of the group of dramatic new works that Riley was to produce on her return to England) and *The iridescent interpenetration*, which was recalled to memory eight years later in the solution of a problem.[4]

As this account suggests, the exhibition provided a wide-ranging and ambitious platform on which to survey Futurism's preoccupations with speed, machinery and violent contrast. All the major artists associated with the movement were represented, not least Umberto Boccioni, Carlo Carrà, Severini and – as Maurice noted for special mention – Giacomo Balla. In Balla's work especially, Bridget recognised that the elusive sensations of motion and light were effectively evoked, but not by straightforward description. Rather than attempting a pictorial illusion or

illustration of these experiences, the artist had used equivalent visual means. In *Girl Running on a Balcony* (1912), the impression of a figure in motion is conveyed by multiple, repeated images of the girl's body occupying different points in space. The eye skips along this rhythmical progression of similar shapes and, as it does so, the optical progression generates the sensation of movement. Similarly, in *Iridescent Compenetration No. 2* (1912), the appearance of light is not based on literal resemblance. Instead, Balla uses an arrangement of abstract shapes – in this case, interpenetrating lines – in which the contrasts between different colours excite an optical impression of iridescence.

For Bridget, the principle that movement and light were experienced through analogous pictorial means, rather than by the imitation of appearance, was well made. That insight is fundamental to the entire body of her mature art, in which light, movement and colour are evoked not by illustration but by the equivalent interplay of abstract elements. Beyond that early realisation, she was thrilled to see that this means of generating such experiences was a continuation of Seurat's approach. Earlier Futurist paintings, notably by Boccioni, employed a Divisionist technique to break down the pictorial field into arrangements of stippled colour. Balla's later work moves beyond a Pointillist technique, but – like Seurat – continues to build an image from discrete, contrasted elements. One thing acts upon another, in an almost layered way, to produce an overall optical sensation. Balla's use of contrasted black-and-white shapes, and the dynamic presence of abutting edges, were a surprising development beyond Seurat's employment of monochrome in, for example, the studies for *Bathers at Asnières* (1884). Bridget was familiar with those drawings and fascinated by the French master's exploration of the relation of limb and background. In *Seated Boy with Straw Hat* (1883–84), the backlit contour of the boy's arched spine has a mesmerising stillness. Balla took that argument further, as if Seurat's pictorial language had migrated into an agenda of movement. In *Abstract Speed* (1913) a succession of edges evokes the feeling of movement. This seemed to her an astonishing advance.

Something else affected Bridget deeply in her response to Futurist painting. Encountering Boccioni's powerful series *The Farewells* (1911),

she contemplated the emotional message of *Those who go* and its counter-part *Those who stay*. In these magisterial paintings, the impression of motion has an expressive purpose and is connected with the experiences of those leaving and those being left behind. Recalling the family events that had so powerfully influenced her upbringing during the war, these images resonated intensely. Boccioni had commented, 'Reality is not to be found in the object, but in the transfiguration of the object as it becomes identified with the subject.'[5] Although unaware of Boccioni's words, in an entirely surprising way Bridget recognised that transfigured pictorial expression was not only a vehicle for optical experience. Through the creation of visual sensation, it had the capacity to express the deepest feelings. This insight, too, has relevance for her later work, in which seeing and emotion are inseparable.

Towards the end of the survey the movement's later manifestations, produced after the First World War, also featured and Bridget found these less compelling. Even so, as a whole the Futurist exhibition was profoundly impressive. But their stay in Venice was not given over entirely to Futurism. Around this time, they also visited Padua, to see the fresco cycle in the Arena Chapel. Giotto's masterly fusion of human gesture, resplendent colour and vivid narrative flow were a moving counterbalance to the dynamic excitement of Balla and Boccioni. Within Venice itself, there was also time for more relaxed sightseeing and the two followed the familiar tourist route, taking in the Basilica di San Marco, the Palazzo Ducale, Santa Maria della Salute and numerous other landmarks. In common with countless other earlier visitors, they explored the city's labyrinthine layout, with the canals, calle and campi revealing their timeless magic. There were excursions by vaporetti and, punctuated by stops in Venice's ubiquitous cafés and restaurants, moments simply to gaze. It was during one such pause in their itinerary that a surprising and memorable occurrence took place.

Taking a respite from the day's summer heat, the two stopped at a café and lingered at their table. Idling in this way, Bridget was greatly taken by the tessellated pattern of black-and-white floor tiles that lay around them. With its abutting squares the rigid geometry of the design caught her eye

and she surveyed the arrangement with a half-conscious pleasure. Then, as sometimes happens, without warning the sky quickly became overcast and a torrential downpour ensued. With growing fascination, she watched as the exposed floor pattern was fractured by the beating rain. Consumed by spreading pools of water, the chequerboard design gradually dissolved, the lines and squares dancing in chaotic movement. Transfixed, she observed a firm structure as it became convulsed and then finally transformed into its opposite: a pliable, plastic surface that undulated and writhed. Within minutes the mirage had run its course. The sky cleared and, with the return of intense sunlight, the ground dried and the linear structure reappeared. Insignificant in itself, the spectacle had existed only briefly. Yet at some deeper level this optical event made a lasting impression. In *Movement in Squares* (1961), the work that would herald Bridget's maturity as an artist, the viewer experiences a similar perception of movement and instability arising from a geometric arrangement.

When the trip came to an end they returned to Warwick Road and, in the confinement of the studio, Bridget focused on the objective she had formed outside Siena. She wanted to make a painting that would evoke the spectacle she had witnessed: a shimmering landscape whose appearance disintegrated under the impression of relentless heat. Standing out with peculiar vividness, the experience called for expression as a painting, but, as she recognised, straightforward depiction was almost certainly inadequate to convey the particular intensity of the moment. In the transcript of a later conversation with Maurice, she observed:

> The heat off that plain was quite incredible. It shattered any possibility of a topographical rendering of it. Because of the heat and the colour reverberations, to be faithful to that experience it was only possible to 'fire it off' again in colour relationships of optically vibrant units of colour. It wouldn't have mattered if those had been black and black, or green and green – the facts of local colour were quite unimportant. The important thing was to get an equivalent sensation on the canvas.[6]

As that comment implies, the experience carried a significance that transcended the simple facts of appearance.

Her aim was, as she later observed, 'to generate a sparkling, crackling sensation'. The painting on which she now worked took further the language she had derived from Seurat. Working from the in-situ drawings, she recreated the original visual experience. Having made a scaled-up drawing on canvas, she began painting, building up a surface using discrete brush marks, each a vehicle for a different chromatic sensation. Now, however, she drew on her recent experience of Futurism and developed further the structural organisation of the image's individual elements. Eventually the painting reached a conclusion and she surveyed her work. She noted the carefully constructed field of dots with its firm underpinning: a disciplined arrangement of broader masses, from which the overall composition derives. The result is an abstracted equivalent of the original observed vista, a visual statement that has a self-contained pictorial identity. In the same conversation with Maurice she explained, 'it is a question of substitution. As Cézanne said, painting is a parallel to Nature and the expressive quality comes through the structural means, through honouring both.'[7]

She had attempted to create an analogous experience in paint, and she was pleased with the result. *Pink Landscape* (1960) is a visually compelling and highly disciplined pageant of colour. Even so, Bridget was in some ways dissatisfied. Although initially happy to have taken this important step forward, she also grew to feel disappointed with the work. Despite its evident strengths, this Pointillist essay – although arresting – began to reveal certain shortcomings. Its exploration of chromatic interaction was an undoubted advance, but, as she ruefully became aware, she had not succeeded in fully conveying the optically intense, shimmering sensation she had sought. The visual vivacity that she had experienced, and felt to be necessary in painting, was absent. The present, living quality of sight that had captured her attention had, in spite of her efforts, proved elusive. That realisation now provoked a crisis that would involve both her work and her relationship with Maurice.

18 Into black

The summer of 1960 gave way to autumn and despondency. The more that Bridget considered *Pink Landscape*, the greater her dissatisfaction. The original impression was not simply that of a haze of heat. On that highly charged afternoon, it had seemed the baking ground of the Sienese landscape was overlaid by veils of diffracted light, whose movements enveloped the entire spectacle. The resulting effect was one of disintegration. That experience had been enormously powerful and she ruefully concluded that the painting had not succeeded in capturing it. Recollecting that disappointment some 55 years later, she observed, 'I had been hoping that this is what the painting would convey and it didn't.' Her gloom deepened as she reflected, 'What *have* I been doing?' She now doubted her ability. She had first responded to nature during her childhood in Cornwall. Subsequently, the desire to represent her visual experiences had grown and become a preoccupation. In her recent work she had begun to sense an ability to engage meaningfully with those experiences. Looking back at her progress to date, her entire trajectory now seemed a delusion.

Her darkening mood was deepened by growing ambivalence in her feelings towards Maurice. She discussed with him the frustration she felt about her work and the apparent impasse she was confronting. To her dismay, her friend was unmoved and in no doubt that she should stick with Seurat's example. Sweeping aside her misgivings, he admired the Pointillist paintings that he felt she had achieved with his guidance, and advised her to carry on in the same vein. This was not what Bridget wanted to hear. Rather than helping her find a way to the root of her pictorial problems, he seemed content with a stylistic solution that

removed the need to probe any further. Maurice's evident pride in his protégée also began to be an irritation to Bridget, not least in the context of their social life. Around the time that she was feeling the greatest uncertainty about the future of her painting, Maurice took Bridget along to a gathering at the home of the philosopher Richard Wollheim, who would later achieve great distinction for his work on the psychology of art and aesthetics. At the time of their meeting Wollheim was 37 and had recently been appointed Reader in Philosophy at University College, London.

His companion on this occasion was Mary Day Lanier, a beautiful young American woman whom he had recently met and who would later become his second wife. Also present was Françoise Cachin, the art historian and granddaughter of the celebrated painter Paul Signac, together with her husband. Bridget revered Signac as one the pioneers of Pointillism and knew him to have been closely connected with Seurat. Even so, she found the situation deeply uncomfortable. Art figured prominently in the conversation and Wollheim was avuncular. Moreover, his French guests were interested to hear about Bridget's deep immersion in Seurat's work. However, as the evening unfolded, its underlying dynamics became apparent. Wollheim was evidently very proud of his new girlfriend, and it became clear that this was being mirrored by Maurice, also separated from his first wife, who displayed an equal pleasure in *his* young protégée. This was an alarming perception, not least because it suggested that Maurice's idea of their relationship differed from her own, which, in essence, was founded on intellectual attraction. The moment seemed to encapsulate a growing difference in their expectations.

Alongside these personal developments, Bridget continued to teach three days each week at Loughborough, and for a while she extended that activity by giving additional occasional classes at Hornsey. As Head of Fine Art, Maurice invited her to join in the extracurricular tutorials he had set up at Alexandra Palace. Wishing to develop the Basic Design course he had established at Hornsey, he had secured a large open space in the nearby sprawling Victorian building. Backed by the first Coldstream Report, which appeared later that year, the principles of Basic Design

advocated by Maurice would be applied more widely to art education in Britain. In Alexandra Palace, he was able both to expand his classes and to operate with greater independence. He attracted like-minded teachers to this operation, among them the young painters John Hoyland and Allen Jones, both of whom would make a significant mark in their respective careers. He also gathered around him a large student attendance, drawn by the forward-looking and slightly heady atmosphere emanating from this alternative outpost.

Perceived as Maurice's girlfriend, Bridget was accepted by this group, but again she quickly found the situation unsympathetic. She sensed that, despite her friend's aims and ambitions, the students were neither intrigued by nor understood the ideas on offer. Faced with exploratory exercises in the relation of circles and squares, they reacted with bemusement and eventually with ebbing interest. It was evident that, without the benefit of reasoned discussion and comprehension, the students' loyalties were straying elsewhere. Their sketchbooks filled up with portraits of each other and observations of their surroundings. In the absence of understanding, the formal aspects of Basic Design could seem dry and even confusing. Bridget felt that Maurice's approach was going against the grain and this added to her earlier disquiet about her mentor's methods. Writing in 1964 in his book *Basic Design: The Dynamics of Visual Form*, De Sausmarez underlined the premium that he placed on 'personal experiment and free enquiry'.[1] Bridget shared that ethos, but remained committed to analysis, evaluation and a method rooted in discipline. This was a point on which they disagreed and she made it clear that she felt unable to teach in that uncritical situation. In any case, as she was already teaching at Loughborough it was difficult to take on an additional commitment. Her involvement with Hornsey did not develop.

Around this time there occurred a significant development that did much to provoke an increase in tension between Bridget and Maurice. Defying her friend's advice and, it seems, in despair at finding a way forward, she put aside her involvement with Seurat. Instead, working on paper, she began making small studies in black and white. These explorations were radically different in character from the three Pointillist

landscapes she had recently completed. Using a ruler, she carefully divided the image area into compartmentalised squares, which were subdivided into smaller similar shapes and rectangles. Having established a geometric structure, she then imposed several circles of various sizes onto that framework. Finally, the resulting linear armature was filled in, using black-and-white gouache to create contrasting and abutting areas.

These images were directly influenced by the Futurist paintings she had seen. Giacomo Balla in particular was her model, and works such as *Abstract Speed* (1913), with its interlocking and overlaid circles, a specific inspiration. At a further remove, echoes of Seurat can be detected in these studies' focus on the creation of a scintillating pictorial field from individual, related components. Her study of Seurat's *Bathers at Asnières* (1884) also fed her thinking in other ways. In that earlier painting, the shape formed by the boy's arched back, silhouetted against the backdrop of water, had been a visual delight – and one that she now celebrated in her exploration of repeated circles. While these comparisons are true, in other ways they are misleading, for they imply imitation. In fact, the significance of these studies lies in precisely the opposite direction. In the absence of any preconceived image, their source is pure pictorial fact. They derive entirely from simple shapes, developed methodically and intuitively. In that respect, these works represent a complete break with her earlier approach.

Based on the black-and-white gouaches, the result was *Veil* (1960), her first hard-edged black-and-white painting, the forerunner of a new way of working characterised by absolute clarity, total purity of form and, in terms of its making, an objective, disciplined empiricism. Nothing is obscured or withheld, its means of construction being completely open. Yet, as this remarkable prototype for Bridget's mature work makes clear, from that uncomplicated, verifiable structure there emerges, in visual terms, a wealth of riches. The relation of simple, contrasted elements, involving edge, shape and proportion, produces a complex field that is activated by the viewer's gaze. As the eye traverses the surface of the painting, it must negotiate transitions between a multitude of interlocking elements. The circle at the centre seems veiled by larger shapes that look

like they are superimposed in front of it. When attention is concentrated
on the centre of the painting, the peripheries appear to buckle. The result
is a total image that in places gives the impression of shimmering and
shifting. Having turned from her long-standing observation of the world
to an unprecedented and unpremeditated exploration of her basic
materials, she discovered her quarry in an unsuspected place.

Maurice was not pleased. This is somewhat surprising, given the
importance he attached to personal experiment and enquiry. But he
seems to have regarded these developments in his friend's work as an
aberration, a dereliction almost of the ability she had shown – and which
he claimed to have encouraged – in her paintings based on Seurat. There
is a sense that, in the context of their relationship, the French master's
work took on an almost symbolic character. By moving beyond the work
of an artist that had cemented their relationship, Bridget was asserting
an independent identity. Conversely, by upholding Seurat, Maurice sought
to retain the authority he had wielded at the outset of their relationship
when his role as mentor was in the ascendant. He was equivocal about
Veil and continued to argue that she should stick with Pointillism. Bridget
found his attitude patronising. But the fracture that now opened up may
also have proceeded from another – hitherto unacknowledged – source.
At some point, an acquaintance who knew them both said to Bridget,
'Haven't you heard about Maurice?' She was then made aware of a situ-
ation that, it seems, she was almost the last in her circle to know about.
Her friend was involved with another woman.

Throughout the time she had known him, Maurice had maintained
contact with his daughter Philippa, who was living at Leaside Avenue
in Muswell Hill, north London, a couple of miles away from Hornsey
College of Art. Bridget did not involve herself in that part of Maurice's
life, but was aware that, following the separation from his wife, relations
between father and daughter were strained. Accordingly, she accepted the
need for her friend to spend time away from Warwick Avenue, presumably
to be with Philippa. As it later emerged, at some point Maurice met Jane
Boswell, a woman with whom he formed a close bond and in 1963 would
marry. In the meantime, however, the veil that had obscured this aspect of

his relationship with Bridget was now swept aside, and the revelation produced a furious and immediate response. Boarding a bus, she headed to north London and tracked Maurice to Alexandra Palace, where she confronted him directly. During the scene that ensued, Bridget vented her frustration and fury. Berating Maurice for the situation that he had created and had failed to face, her hurt was compounded by the thought that 'You didn't have to be quite so devious.'

She then headed to Royal Crescent where her parents were appraised of the news. Her mother Louise was appalled, admitted that she 'had never liked that man anyway' and made it clear that she failed to see what had attracted Bridget to him in the first place. This, however, was precisely the source of the anger that now consumed her daughter. As Bridget acknowledged, theirs was not a real relationship at all. Maurice was her intellectual companion, a mentor from whom she had learned a great deal and who continued to be a valuable ally. She now saw that she had been wrong. At a crucial point when she felt herself to be progressing, the ground had been cut away beneath her. While reluctant to confess to an element of jealousy, this was a deep betrayal and she seethed. Bridget's parents were anxious at this turn of events and urged her to remain with them. As returning to live at Warwick Avenue was out of the question, she complied. However, even in these circumstances eventually her thoughts turned to work, and after a few days she went back to the studio at Warwick Avenue. There she discovered that Maurice had already given the space to somebody else, namely their mutual acquaintance Alan Green. Infuriated by that further disloyalty she nevertheless retained sufficient presence of mind to insist that her materials and equipment be moved to her new base. Maurice was surprised by the request and said he had not thought she would need anything. This was the final straw. Maurice's response seemed to provide confirmation that he had simply failed to grasp the importance that Bridget attached to her work. From that moment, the relationship effectively fell apart.

Working at her parents' home, Bridget attempted to express the blind rage that set in. Much to Louise's distress, the young painter whose progress she had nurtured, and in whom she had invested so much hope

and confidence, set about making a painting that conveyed her darkest and most disturbed thoughts. She turned to black Ripolin paint, a commercial brand that – as she knew from Maurice – had been employed by Picasso. Using a sheet of glass as a palette, she mixed up a generous quantity. This she applied to a modest-sized support, approximately a metre square. Resorting to gestural, tachiste-inspired brush marks, she attacked the surface, covering it in large, energetic swathes. It seems that there may have been several such attempts, each aiming to banish a feeling of inarticulate ferocity. Even so, her use of black was loaded with meaning. With *Veil* – a painting discounted by Maurice – she had restricted her means to black and white. Now her insistence on this one colour alone was a deliberate further transgression, and in her own mind a way of saying, 'There were absolutes … one could not pretend that black was white.' Given the discipline that was central to Bridget's way of working, this abandonment of control and immersion in negation were shocking. The exorcism went on for a couple of days.

When it ended, she confronted the evidence of the expulsion. Whether there was only one black painting or several is not clear, but either way the conclusion was inescapable. Having retreated towards the tachiste experiments made previously during the summer school, this re-engagement with expressionist gestural painting rang hollow. Abstract and black, the work she had created expressed nothing. It had been some kind of renunciation, but beyond that little else. She had reached another impasse, and once again there was the accompanying, deadening sense of failure. Reflecting, she searched the ruins of her activity for some fragments of comfort. With hindsight she recalled that, at that moment, it seemed as if 'everything went out of the window'. Gradually, however, there was a reawakening sense that perhaps something could be learned, even if only an acquaintance with the problems associated with this kind of approach. Black was not itself inexpressive, but on its own it had a deadness that not even frenetic energy could resuscitate. She recalled *Veil* and pondered that, had the interruption resulting from the breakup with Maurice not occurred, she would have continued in that vein. In that earlier painting, contrast had been a central, redeeming feature. This, she

realised, was entirely absent from her recent efforts, but it could be retrieved.

First, however, she needed a proper studio. She had been furious with Maurice for giving away Warwick Road, but now speculated that perhaps he had thought that she would not have wanted to work there without him. With a stirring of confidence, she realised that the opposite was true. The flat they had shared contained an excellent space for painting – her first real studio – and she resolved to regain it. She contacted Maurice and, having explained her wishes, was mollified when he offered to surrender the rental to her name alone. Some weeks after the retreat to Royal Crescent, Warwick Road was restored to her. Initially it was a struggle to go there. Inevitably it was associated in her mind with her relationship with Maurice and a feeling of loneliness was difficult to shake off. Also, Louise was very much against her returning there. However, Bridget was motivated by the conviction that there was something to build on, and if she persisted something positive would eventually emerge. At the beginning, Louise kept a bed for her daughter at Royal Crescent. Solitude was an unfamiliar experience and quite a hurdle. For that reason, in early 1961 Bridget began using Warwick Road as a studio rather than a place to live. She moved her painting area from the end room to the main top-lit space and was able to spread out. At nights she went back to Royal Crescent. Having re-established herself in this way, there was now a sense of 'where to go from here?'

While the recent reversal was still very real, there was also the intimation of a solution to the problem she had encountered. The black painting had been a step out of character, and even if it had been executed more carefully that would not have made any difference. To make the work speak it was necessary to articulate the image: to divide it up. As had been the case with *Veil*, this meant separating it into parts. With that thought in mind, she recommended by making a board. This choice of rigid support was deliberate, partly inspired by the Futurist paintings she had seen, but also to some extent a practical solution to the approach being contemplated. This inflexible surface was placed face up, directly on the floor. She then drew a line straight across, approximately a third

of the way in, separating the pictorial field into two unequal rectangular parts. This was the division she required, but in itself it was inadequate. Seeking greater contrast, she now thought of adding a curve, but what sort would most effectively animate the line? She would have to find out. Nearby she knocked a nail into the floor and to this she attached a length of string with a pencil secured at its end. She drew the pencil in an arcing movement across the board, exploring various alternative curves by moving the board until she was satisfied with the result. She finally settled on a circular segment that sits unevenly within the square, being higher on one side than the other. Having created an asymmetrical curve, she reinforced the contrast by painting in the divisions: black above and below the lines, white in between. This operation was performed as evenly as possible using Plaka, a water-based emulsion that dries to a matt, velvety finish. The finished painting has a flat, uninflected surface that is the exact opposite of its gestural predecessor, so that the opposition is concentrated entirely on the relation of these simple shapes.

The artist now contemplated her work. Divided up in this way, there was a feeling of weight above the curve. This large area presses down towards the black rectangle at the bottom. The curve and the horizon come as close as they possibly can without actually touching, creating a fleeting point of unrealised contact. The visual tension that results from the relation of these two shapes is responsible for the painting's compelling character: a sustained denial – a frustration of desire almost – as the viewer yearns for the edges to meet. That state of suspension is heightened by the impression of shapes that in themselves appear massive, yet whose relationship seems ineffably delicate. A further optical twist is provided by a sense that the white area is being compressed by these converging forces. Bridget surveyed the painting and recognised a sensation she had not expected: a kiss. As its primary motif, this became the painting's title. In common with *Veil*, Bridget had not sought a particular outcome. But by employing simple shapes, *Kiss* (1961) again makes a cogent visual and fully expressive statement. Being entirely abstract, that intimation of feeling is complete in itself.

Central to that experience is the principle of pure sight. Sam Rabin's

teaching had emphasised the importance of preserving an original impression, that moment when the mind instinctively grasps the visual essence of the thing it beholds. The process of subsequent drawing became the endeavour both to sustain and to give form to that unique instant of insight. The Impressionists, too, had sought in their work to make visible the optical experience that precedes conscious apprehension. In both cases, the artist begins with the things themselves, and from that imperative arises the ethos of pictorial autonomy. Eschewing illustration, the aspiration is to create a painting as a thing in itself: independent, self-sufficient and able to explain itself on its own terms. The artist sees the unexpected in ordinary sight, and the way he or she expresses that essential impression reflects their character, their perspicacity and their endurance. *Kiss* touches these important issues of perception and art. Produced from fundamental elements that are animated by relation and contrast, the painting was a triumphant affirmation of the potential of this abstract way of working. As Bridget later observed, 'I was very pleased when it, so to speak, winked. It spoke back to me. It was the beginning of a response to the formal motif.' Henceforward, her painting would have this new starting point.

19 Movement in Squares

With the creation of *Kiss* (1961), Bridget felt that at last she was on the right path, and in retrospect she recalled that it was 'a great moment'. The painting was a surprise, but she accepted it. Although unexpected, in some ways she felt prepared for its revelations. At Molecey there had been times that seemed connected with this experience of sudden insight, when familiar sights – darkening clouds, figures silhouetted in candlelight – took on a previously unknown significance. In that earlier phase, certain shapes, their relationships and the play of light across a surface would sometimes take on a new, striking aspect and be somehow charged in ways that were not entirely explicable. It seemed that nature revealed its under-lying motive forces in glimpses. Such instances were fleeting but when they appeared there had been a sense of recognition, an intimation of something undisclosed, beneath the surface of things. These occurrences had been encountered in everyday experience, unbidden and beyond conscious control; and they had also been observed in the work of those artists who continued to exercise a fascination. In Bonnard's paintings there was the evidence of an eye alive to seeing the unfamiliar in ordinary sight. That which is immediately apparent touches a deep-seated, intuitive faculty, and elicits an evanescent response. From the sensations previously provoked by nature and art Bridget derived encouragement – and the will to continue.

The question was, how to proceed? On a purely practical level, much had been gained from reverting to a more self-possessed, objective way of working. The drama of the black painting had yielded nothing beyond the catharsis of frustration. By contrast, *Kiss* provided confirmation that the discipline Bridget had previously acquired through life drawing was

essential. Indeed, the formation of *Kiss* had proceeded as a highly con-
centrated exercise in line drawing; its entire rationale was founded on
the deliberate relationship forged between two lines. But objectivity and
restraint were not in themselves an end, only a means. The problem was
that of how to move beyond the position of extreme reductiveness that
she had embraced. Some days passed in this frame of mind. She visited
the studio by day and returned each evening to sleep at Royal Crescent.
During this time it seemed to her mother that the storm had passed,
but in its wake Bridget now appeared to be just loping about, appar-
ently without direction. She sensed the prospect of immobility and it
worried her.

Whether or not she confided it, Bridget was considering her next
step very carefully. With *Kiss* she had made a crucial advance. Having
solved the problems she had encountered with *Pink Landscape* (1960)
and the black painting, she realised the importance of starting from purely
pictorial elements organised coherently. In reaching that position, the
example of Seurat and Futurism had played a vital, formative role. She
had renounced working from life and had created an abstract image with
its own, independent identity. While on one level this satisfied a long-
standing objective, the difficulty was how to apply an organising principle
that in itself seemed so simple as to prohibit any promise of development.
Kiss moved her, but in some ways it was just a square: inflected by lines,
but still a square. In other respects, she was aware of the considerable
potential wrested from this basic form by such artists as Kazimir Malevich
and Mondrian. In their hands, a four-sided figure had assumed an unlikely
but compelling significance. How had this been achieved? How had a
geometric motif been made to yield such riches? She recognised that her
own choice of this elemental shape had been beneficial. A square had
provided the support for the image, and this primary pictorial decision
had supplied the context for its subsequent progress. Turning this over
in her mind, a solution began to emerge, and eventually she arrived at
a primary, arresting thought. Returning to absolute fundamentals, she
decided 'I will draw a square.'

In forming that conception, she found a purpose. Thus armed, she

returned to the studio and started the task she had set herself. Approaching it in a spirit of enquiry, she began with a question: 'What is a square?' Working on the table positioned in the centre of the top-lit space, she took a small sheet of paper, about 20 cm in height and width, and drew the shape she had selected. Its perfect symmetry returned her gaze: four sides of equal length, four right angles. Having commenced in this way, she repeated the action, paused and drew the same shape a third time. A sequence resulted, but, as was immediately evident, nothing had altered within it. Its regularity persisted. Then came a second question: 'What is the smallest change I can make while retaining its squareness?' In drawing a fourth abutting square, she compressed it slightly, reducing its width. She continued this intervention, progressively narrowing the span of each square until the shape was squeezed to the point of becoming a vertical line. Having reached a terminus, she felt unable to leave the arrangement in this condition. The process was completed by recapitulating the previous stages, gradually returning the square almost to its original state. This horizontal movement was repeated down the sheet, so that the entire square was filled. Without stopping to contemplate the outcome, using gouache she filled in the drawing to create a tessellated field of alternating black-and-white shapes. To her amazement, she found herself looking at the forerunner of an image that stands at the beginning of her mature work: *Movement in Squares* (1961).

As with *Veil* (1960), there was a moment of recognition. She saw that her small change to this simple form had made a huge difference. While all four right angles were retained and its essential character preserved, the passage from one state to another generated an astonishing visual situation. The progression began to shift before her eyes: its geometry melted, reformed and finally disintegrated into persistent movements. An apparently static scenario was invested with unexpected and unpredictable energy. She beheld the spectacle she had produced with wonder and exhilaration and gave a shout of joy. That evening she returned to Royal Crescent, as she later recalled, 'fully triumphant'. The following day, she repeated the process, this time making the drawing bigger. She compressed the shapes further in order to increase the tensions within the arrange-

ment. To her mounting satisfaction, these refinements intensified the optical drama, creating an impression not only of movement but also of immanent light. She pursued these developments and went on to make numerous revisions. These explored alternative scenarios, variously accelerating and slowing down the accretion of sensory information according to the width and size of the squares. Her excitement mounted. Throughout, she was in no doubt that eventually she would paint the evolving composition.

When she was finally satisfied, the next stage was to prepare a board. Working from the studies, the composition was painstakingly transferred from paper to the rigid support, where it was completed again using Plaka to obtain a flat, uninflected surface. The result was a prototype, the initial version of what would become Bridget's most celebrated early painting. Although never exhibited, it survives in reproduction in the catalogue of her first solo exhibition, held at Gallery One in the following year (1962). That plate reveals that the original, smaller version of *Movement in Squares* contains fewer shapes: 22 from left to right. The horizontal compression of the squares is, in comparison to its successor, relatively abrupt. In the second, definitive painting, which is the one she included in the exhibition, the sequence is more graduated: the movement sideways is slower and takes 31 squares. The first three vertical columns have the same width, but are then progressively compacted, reaching a point of irreducible pressure two-thirds of the way across. That position of no return generates the recovery that is attained as the shapes proceed to the opposite side. In that concluding movement they undergo a regular expansion, but without fully regaining the proportions of a square.

With these subsequent refinements Bridget took her visual argument to its inevitable conclusion, as if tuning its phrasing until the precise pitch that she was seeking was achieved. The final painting is dramatic and intense, but also subtle in means. Its structure has an almost architectural firmness and solidity, but part of the fascination exercised by this remarkable work is the way that the artist uses geometry to generate instability, confounding the expectations of those who view it. Certainties are cast to the wind – and repeatedly so. No matter how often the painting is seen,

216

it yields this surprising outcome. Apparent fixedness is seen to disintegrate and reform, and, as the viewer becomes involved in that open-ended visual process, their ever-changing impressions become active elements. As those who experience it at first hand become aware, they are not simply passive observers.

In the nineteenth century, the French painter Maurice Denis memorably observed, 'Remember that a painting – before being a battle horse, a nude woman, or an anecdote of some sort – is essentially a flat surface covered with colours, put together in a certain order.'[1] *Movement in Squares* exposes that dictum in extreme, reductive form. But Bridget's unique achievement is both to have confirmed that artistic principle and then to have transcended it. The painting is self-evidently an arrangement of pictorial elements. But instead of depiction, it uses those constituents to entirely different ends. No longer rooted in creating a resemblance or re-creating a previous visual experience, *Movement in Squares* exists as a primary optical event: *in itself* and in the present. Illustration is replaced by reality. The viewer engages with the painting as they would with other phenomena in nature, sensing a subjective relationship with the changing character of whatever is beheld. Their gaze animates the thing seen, and, with irresistible force, an object of contemplation responds with an astonishing suggestion of inherent life. Whereas Jackson Pollock and other pioneers of expressive abstraction had asserted their *own* experience as the subject of painting, Bridget admits and then emphasises the viewer's sensations and perceptions as the work's defining features. Ego is supplanted by empathy. In that respect, *Movement in Squares* is much more than the sum of its parts. It defines a bold new territory for painting.

Bridget was aware that this was a turning point. The living quality of sight in which she rejoiced had its source in nature, and she had sought – unsuccessfully – to replicate that experience through depiction. It now became accessible through a direct, empirical involvement with basic pictorial elements. The shifting, shimmering quality denied to her in *Pink Landscape* was insistent and overpowering in *Movement in Squares*. But it was through equivalence, rather than resemblance, that she reconnected with the experience that had eluded her. The work of art

existed as a thing in itself, with its own identity. This was an extension of the ground won in *Veil*, and, having momentarily lost her way, she was back on track. She also saw this conquest as a continuation of what she had been trying to find and understand in the work of those modern painters she admired, in which the process of looking was paramount. The path became clear: by transferring her subject matter from observation of the external world to the internal patterns of seeing, she knew how to proceed. Drawing, as ever, would be her beginning, and through drawing she would bring the hand and eye into symbiotic relationship, the fruit of which would be the wonders and pleasures of sight. This principle would sustain her mature work and *Movement in Squares* marks its triumphant first embodiment.

The doubts that had assailed her in the past now dissipated. In their place was an anxiety to seize the moment and not let it go. With that new-found confidence and optimism, she embarked upon a broad exploration of the ground she had won. Around this period, she resumed living at Warwick Road. Being close to her work enabled her to pursue it without interruption. Photographs of numerous studies pinned to her studio wall reveal the intense, wide-ranging and even obsessive nature of the activity that ensued. Moving beyond her first motif, the square, she turned her attention to a plethora of different shapes and basic forms. The vocabulary that would sustain her entire future output began to develop. Circles, discs, ovals, lines, stripes, zigzags and curves all made an appearance and she tested them in turn. By manipulating and organising these elements in various ways, the dynamic structure – the syntax – of a new visual language began to emerge. Repetition, inversion, reversal, expansion and compression all had a part to play. Relying on trial and error, she subjected a bewildering array of formal units to a variety of organising strategies, and, as a result, the enormous potential of this working method gradually became evident. As the weeks and months passed, so many possibilities were uncovered that it was impossible to pursue each in full immediately. Instead, ideas were 'seeded'. Once a prospective line of development had been identified, it was put aside and kept for future use. In this way, while certain works took shape, others formed part of a

growing store to be revisited subsequently.

Throughout this fertile period, Bridget continued to teach at Loughborough and to work as a consultant at J. Walter Thompson. Both these roles provided much-needed sources of income. At the latter, she produced illustrational drawings, an activity supported by her considerable draughtsmanship but one that hardly stretched her. She usually arrived at the Knightsbridge office after the rush hour had subsided, and then stayed late so as to avoid the evening crush. Throughout the day, there was a continuous trolley service, so she seldom went to lunch and there was little reason to leave the building. On the days she attended, she could be seen perched in front of an easel not far from George Butler's office. At intervals, she would be approached by Willy Landels, a charming Italian who supplied her with various jobs. Bridget's diligence was not, however, everything that it appeared. Landels was not alone in noticing that her intense concentration was not always focused on the tasks with which she had been entrusted. Beneath the sheaf of drawings on her easel, there was the evidence of activity of an entirely different kind. When not occupied with designing the packaging for some commercial product, J. Walter Thompson's conscientious consultant was evidently hard at work creating drawings that were populated – it seemed – with indecipherable shapes and patterns. Nevertheless, these eccentricities were indulged. Blind eyes were turned, and Bridget was able to continue with her extracurricular pursuits undisturbed.

One evening in early autumn 1961, as usual Bridget left the office at around 6.30pm. Although she was now living at Warwick Road, she continued to make regular visits to her parents at Royal Crescent for evening meals. This was her intention as she stepped into the street and followed her familiar route, heading towards the American Embassy in Grosvenor Square. Her journey took her along Mount Street, by which time it began raining. A torrential downpour quickly developed and she was forced to take shelter. She found herself standing in a shallow doorway set back from the street, to the right of which was a large plate-glass window, which formed a shop front. This, however, was no conventional shop. Above its entrance, the sign read 'gallery one'. Established in 1953 by the

poet and art dealer Victor Musgrave, Gallery One had formed a repu-
tation for showing work by avant-garde European artists and had hosted
exhibitions by Henri Michaux and Yves Klein for the first time in Britain.
One of a handful of galleries that specialised in showing art spurned by a
predominantly conservative establishment, Gallery One's support for such
artists countered the prevailing fixation with American Abstract Expres-
sionism. The 42-year-old Musgrave took a certain pride in his outsider
status, claiming to be the only art dealer in London not to wear a tie.

The rain persisted and Bridget passed the time by looking into the
unconventional establishment. While dusk had fallen and the gallery
had closed, its illuminated interior suggested that it was still occupied.
Eventually a figure appeared from the back of the shop and approached
her. As the door swung open, a man greeted Bridget with the question,
'Why don't you come in, instead of just peering through the door?'
More relieved to get out of the rain than to view the exhibition that
she had already glimpsed from the street, she complied. The small step
she took would change her life forever.

20 Gallery One

Bridget entered the premises and began looking around, all the time conscious of being observed. As had become second nature due to Maurice's example, she proceeded carefully and examined each work in turn. The artist was unknown to her, and only later did she become aware that the pictures on display were by Scottie Wilson. Self-taught, Wilson had been included in the *Exposition Internationale du Surréalisme* held at Galerie Maeght in Paris in 1947 and had held his first exhibition in London the same year. His highly detailed, freely imaginative style embraced a range of subjects, in which animals, botanical forms, figures and faces jostled for attention. Wilson exemplified Victor Musgrave's enthusiasm for outsider art, but the fantastical and almost naive quality of his imagery left his young visitor unmoved. An uneasy atmosphere developed, as neither spoke. Bridget thought her host was dressed too informally to be the director of the gallery; for his part, he regarded his attentive visitor quizzically, but did not engage her in conversation. Eventually, however, the silence had to be pierced and Musgrave asked her what she was thinking.

Bridget was critical and, warming to her theme, unleashed a lengthy explanation of the reasons for her low estimation of the exhibition. While hardly flattered, Musgrave was undismayed and even intrigued by Bridget's response. Evidently his young visitor was used to looking at art and he asked what she did for a living. Bridget did not immediately admit to being an artist, but Musgrave's relaxed and easy manner broke the ice and the two fell into conversation. The portfolio she was carrying caught her companion's eye and he asked to see its contents. She began pulling out some of the studies on which she had been working at J. Walter

Thompson. Musgrave examined them with growing interest and he enquired, 'How did you come to make these?' Bridget's many conversations with Maurice had equipped her with confidence in talking about her work, and her answer was well-informed and unequivocal. Musgrave listened and then asked, 'Have you got any more like them?' Encouraged by his response, and sounding a small note of pride, she told him that she had a studio near Earl's Court. Engaged by these revelations, the older man said he would like to visit and see her work. Having shared her telephone number, Bridget left the gallery and, somewhat later than anticipated, continued on her way to Royal Crescent.

Musgrave was as good as his word, and soon after their first encounter he showed up at Warwick Road. By this time, Bridget had reorganised her studio, and the impression it conveyed combined intense activity with pared-back elegance. Furniture was sparse and instead the space was given over almost entirely to an aesthetic expedience. The floorboards were painted white and, reflecting the natural light admitted from above, the space was filled with a soft, even illumination. This was augmented by fluorescent tubes suspended from the ceiling. Racks containing boards and sheets of paper had sprung up and the central table was covered with the evidence of work in progress. Also painted white, the walls were home to numerous finished drawings executed in black-and-white gouache. These vibrant, geometric compositions animated the room. The presence of *Kiss* (1961) and *Movement in Squares* (1961) completed the sense of an unconventional, exploratory visual intelligence: the first of these works quiet and understated, the second at full throttle.

Her visitor took all this in and then asked to see what she was working on at that moment. Bridget showed him some studies for a painting, *Escaping Centre* (1962), which was then in development. Musgrave contemplated a sheet of circles arranged in regular formation, comprising three rows of five. In the first circle, at top left, he observed a black dot situated at its centre. In the succeeding circles, a similar dot had been placed in various positions, offset from centre, as if exploring its context. By the end of this sequence the dot had reached the inner perimeter of the circular enclosure. In the final motif, the same tiny form had emerged

beyond the circle, having escaped its confines. By contrast to almost every other work of art in the room, this image is in optical terms unassertive, but its subtle visual argument catches the imagination unawares, its primary elements possessing some unlikely energy of their own. In a peculiar way, the work seemed to encapsulate the process of looking, probing and understanding in which the artist herself was engaged. Musgrave was impressed, if, perhaps, not entirely sure. He confided, 'That's quite interesting. I'll come back in a few months' time.'

Although this first visit was inconclusive, Bridget was galvanised by her visitor's response. As a result, during the interim she applied herself with even greater concentration. By the time that Musgrave returned, her output had increased significantly. Seeing her work again, he confessed that, following their previous meeting, he had been unable to get the strange images he had seen out of his head. Now confronting them once more, and viewing their successors, he made a decision, which was to offer Bridget an exhibition in the following year. A date was set for April 1962, which was not so far off, but the prospect of exposure was all the incentive she needed to produce sufficient work in time. During the succeeding months, in an extraordinary flurry of sustained activity, Bridget augmented *Movement in Squares* with a group of eight additional paintings. These were complemented by a selection of works on paper. In the first of what would be many subsequent allusions to the musical nature of her work, she titled these studies *Preludes*. The line-up was completed by a pair of limited edition prints, which she made with the help of Willy Landels, one of which was based on *Movement in Squares*. With this modest but authoritative body of work, and having just turned 31 years old, Bridget Riley would make her artistic debut.

The opening was a relatively understated affair. Early on in the process, Musgrave had made it clear that he attached little importance to holding private views, which in his opinion served no purpose in generating critical or commercial interest. He also discerned that the latest addition to his artistic stable was a solitary person and unlikely to attract a crowd of any distinction. Whatever took place on the night has receded into the past and few details survive. Jack, Louise and Sally came, and they were

joined by various family friends. It seems doubtful that the art world at large would have turned up to celebrate the work of an unknown, so – as Musgrave had predicted – a throng is improbable. Maurice de Sausmarez was not there, as Bridget and he had gone their separate ways. However, they had remained in contact and he wrote a resonant introduction to the catalogue that was published to accompany the exhibition. His intimate knowledge of the sources of her art was now put to good effect. In going to the very heart of her work, his prescient comments are worth repeating at length:

> Dynamism here is neither the description of movement nor the record of actual movement; it is poetic and arises from the pure relationships of the pictorial elements used. The marks and shapes on the canvas are the essential agents and the sole agents of a primarily visual sensation. The paintings act like electrical discharges of energy making immediate contact with our neural mechanism. Bridget Riley treats what has been termed 'optical illusion' as a 'real' system of dynamics.[1]

The installation occupied three walls: the partition between the main space and Musgrave's back office that faced the visitor as they entered the space, plus the two flanking areas. In one way, the arrangement had a certain elegance. The entire ensemble was unified by an insistent restraint in which black and white dominated. Yet, as Maurice had suggested in his introduction, each of the works displayed was a container of visual energy that the unwary visitor released simply through the act of looking. Collectively, there was the clear evidence of an overriding intellectual focus in which simple abstract shapes were harnessed, pressed into service, teased and deployed into startling compositions. One after another, each painting had its own character and purpose, whether this involved generating disarming sensations of movement or setting off sudden scintillating bolts of light. Perhaps most arresting was the understanding that arose from confronting and engaging with these objects: the vivid realisation that none of the experiences being offered was in any way illusory or a matter of optical trickery. Nor was this ever an exercise in dry scientific theory.

To stand in the space and see Bridget's work for the first time was to encounter a new visual reality, one that comprised purely pictorial elements, but a level of experience as immediate, visceral and alive as the world outside.

Looking closer, the viewer would have discerned that this array, while cohesive, embraced a remarkable range of approaches. Some paintings, notably *Movement in Squares* and *Zig Zag* (1961), took the form of fields of activity. A basic shape – a square or, in the case of the latter, a line – was repeated across the entire surface and inflected, compressed and expanded in order to create zones of tension and release. Such works operated swiftly. The viewer's gaze became quickly caught up in a visual situation that almost immediately sprang into action. Others impart their individual personalities more slowly and quietly. *Displaced Parallels* (1962) is a surprisingly simple arrangement of seven horizontal lines of two different lengths. Its character is disclosed as it becomes evident that these bars are coordinated variously, with subtle permutations in proximity between the longer and shorter elements. The shorter line at the bottom is situated between its adjacent neighbours; its cousins move towards the longer members. The effect is to imply a feeling of rising, a sensation that is connected both with one's own body and with movements in the landscape.

By contrast, some works – notably *Circle with a Loose Centre* (1961) – offer a contained situation rather than a dispersed field. In that painting, the eye enters a configuration of displaced concentric circles. The way that these shapes interrelate – some almost touching, others more widely spaced but never with the same centre – gives rise to the kind of 'neural' response referred to by Maurice. In this case, the eye communicates a sense of centrifugal force. Other paintings combine both kinds of argument, being a 'field', yet one that also accommodates discrete visual events. *Hidden Squares* (1961) is a prime example. There, the entire ground is occupied by just two repeated shapes: a square and a circle. The relation-ships created between these elements suggest ghostly forms, whose presence is sensed rather than described.

If *Movement in Squares* was Riley's *cri de cœur* – her first major

statement of intent – then its counterpart in this, her initial outing, was *Black to White Circles* (1962). The largest work on view, this successor to her tessellated progenitor stands the original painting on its point, the square arrangement forming a diamond. In place of squares, the composition uses circles (being filled, these shapes were more properly described as discs in the work's later, corrected, title). Now, however, the movement across the field is less a question of 'dynamism' than tonality. As it passes through the field of discs from left to right, the eye experiences a journey that operates in terms of tonal intensity: grey attaining a strident blackness then fading again. The tendency to 'grow' one painting from another, feeding upon previous discoveries and putting them to fresh use, would characterise Bridget's mature practice. Here it is observed in early operation. In this astonishing body of new work, there was already the evidence of building on earlier ground and moving into uncharted territory.

The exhibition ran for a month only, but its importance for Bridget's development as an artist cannot be overstated. Of prime significance was the critical response. David Sylvester, who in the 1960s had replaced John Berger as art critic for *The Statesman*, visited and wrote an appreciative and perceptive review. 'At Gallery One there is an unusually good first one-man show', he announced. Astutely, Sylvester identified the main protagonists and based his comments on *Movements in Squares* – 'a sort of chessboard ... at once unnerving and reassuring', and *Black to White Circles*, which he compared to 'holes in a solitaire board'. Having referred to the artist – appropriately – as a 'hard-edge abstractionist', Sylvester's figurative references betray an evident difficulty in describing these paintings on their own, abstract, terms and without recourse to familiar associations. In that respect, Sylvester's comments are a valuable reminder of how unfamiliar this body of work must have seemed. In another respect, Sylvester put his finger on a vital point. He concluded his review with the observation, 'This proposing and disposing of order seems no mere game with optical effects, seems to symbolise, dramatically, an interplay between feelings of composure and anxiety.'[2] The capacity of Bridget's work not only to engage a visual response, but also to evoke and express emotional states had been rightly identified.

Norbert Lynton, who later posted a review in *Art International* in September 1962, situated Bridget Riley within wider contemporary developments in the visual arts, and – significantly – made a well-considered distinction. He began by referring to the avant-garde art movement that emerged in Europe during the mid-1950s for which the rubric 'Op Art' would later be coined. 'Vasarely alone had to stand for all the research into the visual dynamics of form and pattern that has been going on there for some time and some of which got organised into the "Groupe de Recherche d'Art Visuel" (members: Yvaral, who is Vasarely junior, Sobrino, Stein, etc.).' Victor Vasarely, as Lynton intimated, was the figurehead for a kind of abstract art that foregrounded perceptual ambiguity. 'This kind of concern', he noted, 'one expects to find in Paris and perhaps also in Germany, but in spite of British constructivist activities and our "Situation" painters, one thinks of this quasi-scientific art as something outside Britain's range.' As Lynton correctly understood, while superficial comparisons were possible, Bridget's art proceeded according to a different agenda: 'she uses the grammar of black squares, bands and segments with a cool economy that makes her French counterparts ... look fussy and extravagant'. The point about her work was driven home: 'it is not illusionist at all in so far as it is concerned with physical facts of optical stimuli and the sensations of movement and colour they produce'.[3] Abstract and autonomous, the empirical reality of her art had been recognised.

In the meantime, Bridget was delighted that the exhibition was attracting visitors. As Musgrave reassured her, people were coming to see the show. For the first time ever, she had an audience. Gratifyingly, this attention even translated into sales. Sylvester, who was an external purchaser for the Arts Council, bought *Movement in Squares*. The entry of a work into a public collection from a debut exhibition was an important endorsement as well as a huge encouragement. There was even something of a competition to acquire *Horizontal Vibration* (1961). When Sylvester expressed pointed personal interest in this painting, he was perturbed to learn that the work had already been sold. Protesting the support he had shown, he upheld his claim and suggested that his rival be given a replica.

Faced with such a dilemma, Bridget commissioned the execution of one her works – in this case, a copy – from other hands. Having painted everything in her first exhibition herself, she now resorted to the assistance of others. Two letterers from J. Walter Thompson were recruited to make the new painting. From this unexpected predicament came the solution to what had already emerged as a concern. Entrusting the painting of works to assistants would become a practice that Bridget subsequently adopted as an essential practical expedient. It would enable paintings to be carried out to her precise instructions without the enormous personal commitment of time that the physical process of completion requires. On this occasion, however, the work involved duplication – and the version received by Sylvester was not the one he coveted, but the replica he had proposed.

Musgrave was pleased with the response to the exhibition, both critically and commercially, as was the artist. The sale of the largest work, *Black to White Circles*, was especially welcome and provided further confirmation of the show's success, if any was needed. Both felt that she was on her way. With that realisation in mind, Musgrave engaged his protégée with a contract for £500 and the promise of a second show in the following year. This was a triumphant seal of approval and, while for the moment she continued at J. Walter Thompson, a transformation was in progress. For so long Bridget had struggled to find her way artistically and had wrestled with the question of how to support that ambition materially. Winning an audience had been a pipe dream. The future now opened up on all these fronts, and – most importantly – the direction she had taken presented the prospect of unlimited development. She was happy and fulfilled. At the core of that feeling of well-being was the realisation that, in terms of her work, she could look ahead with a single-minded ambition to explore further.

21 New horizons

Changes in Bridget's personal circumstances were also afoot. Following the end of her relationship with Maurice she had worked in isolation. At first this had been difficult, but soon she felt freer and able to devote herself with total commitment to her work. She had come to realise that what she had most loved about her friend had been linked with the art she needed to make. She found that the solitude that she now embraced did not bring loneliness. Instead, being alone was essential in order to discover – through work – what she was feeling. It provided a space and a context for reflection. In that respect, she continued to require the seclusion that her disposition had always demanded. In any case, beyond the studio she had a circle of friends and acquaintances. Her previous teaching experience had connected her with other artists, and around this time she also began occasional teaching at Croydon School of Art, where she maintained contact with Allen Jones and John Hoyland. These relationships went hand in hand with an awareness of the wider art world. Pop Art, Situation and Arte Povera were the visible manifestations of the burgeoning cultural scene that went on around her. London was becoming a vibrant hub of creativity. Further afield, she admired the work of Ellsworth Kelly and, beyond that, the ethos of minimalism then developing in the USA. All these wider developments interested her and she observed them from afar – while remaining essentially focused on her work at Warwick Road. Even so, subsequent events would prove that the journey would not be as solitary as she imagined.

Victor Musgrave told her that she had attracted new admirers. Around this time, a young man appeared on the scene. He had visited her exhibition and was won over by it. Subsequently they met at the ICA. He had

spotted her sitting in the back row at a lecture and, at the end of the event, had struck up a conversation. After meeting on several occasions, a friendship developed, but one that was primarily intellectual. They talked at length about Pollock, and the competing notions of artistic involvement and detachment became an ongoing source of animated discussion. Emboldened by new-found confidence, Bridget argued forcefully for the necessity of objectivity. Georges Braque's dictum that 'The senses deform, the mind forms'[1] is illuminating in relation to the direction that she was taking. But passion and diffidence continued to define her personality: despite the strength of her convictions, she remained in many ways the reserved young woman who had taken her first steps towards art. Her companion was more sophisticated and worldly, and, as had been the case with Maurice, these were attractions. Indeed, it became clear that her young suitor had begun to form a deepening affection that, for him, could proceed in one direction only. But it was not to be. Preoccupied with the priority she accorded her work, his attentions went unrequited and the friendship ended.

This was not, however, the end of what appears to have been Musgrave's instinct for matchmaking. As Bridget's friendship with her dealer developed, his interest in her private life strengthened, and he now told her that another follower had come on the scene. The individual in question was evidently enthusiastic about her work, having visited the exhibition on at least two occasions, and was known to frequent the Queen's Elm pub on Fulham Road, Chelsea. Whether or not Musgrave engineered a rendezvous is unclear, but that he encouraged a meeting is certain. Whatever the arrangement, Bridget made her way to the lively gathering place for artists and writers, an establishment forever associated with the memorable phrase 'a smell of broken glass',[2] which was adopted by its Galway-born landlord Sean Treacy for the title of his memoir. A few steps away from the Chelsea Arts Club, this colourful pub included Laurie Lee among its devoted regulars.[3] The artists Francis Bacon and Elisabeth Frink, and the actors Richard Harris and Julie Christie, also drank there. The context for the meeting that ensued was in many ways the polar opposite to the territory with which Bridget was more familiar. In these

convivial surroundings, she made the acquaintance of Peter Sedgley, who
would be her close companion for the next ten years.

At the time of their first meeting, Peter was working as an architectural
assistant, having previously studied building and architecture at Brixton
School of Building. A year older than Bridget, unlike Maurice this tall
young man was neither an intellectual nor an artist, his open manner
down-to-earth, practical and immediate. Nevertheless, his interest in art
was plain to see, and he talked keenly about his particular affections,
which included the work of Max Ernst. Shortly afterwards, he visited
Bridget at her studio and his first response was characteristically practical.
Taking in the mass of paper and materials occupying the centre of the
room, he observed drily, 'You need a proper table, Bridget'. This was some-
thing he was well equipped to provide and he promised to rectify the
omission. The surface on which Bridget is shown working in the many
photographs taken during the 1960s was designed and built by Sedgley.
As their relationship developed, Bridget sensed that her companion was
eminently capable of helping with her work, not least in terms of the
numerous practical issues relating to drawing and the transfer of studies
to the supports for paintings. These were areas that spoke to Peter's
training and particular abilities. For his part, Bridget's work was a source
of fascination, and although his knowledge of art was as yet rudimentary,
her commitment was an inspiration. Indeed, that contact would prove
enormously valuable. In time, Peter would go on to achieve artistic
distinction in his own right for kinetic work using light as a primary
medium.

Despite a mutual attraction, Bridget was circumspect. Peter's affable
and amusing personality was congenial, and his qualities of loyalty drew
her admiration. He had not served in the war but, having done national
service in the RAF, his patriotic fervour was clear. This struck a chord
to which she could respond. Peter was also no apparatchik, his suspicion
of 'the establishment' evident. This refusal to conform, too, was a bond.
As a result, during the early summer they met with increasing frequency.
Having rebuffed her earlier admirer, she now found herself being carried
along by feelings that were not entirely within her control. As she was well

aware, a full-blown relationship would have implications for her work, and this rang alarm bells. For that reason, she consulted Hector, whose medical practice she continued to visit and whose sage help she valued. His counsel was unequivocal: 'If you don't see him at all for three weeks and have no contact, you will get over this.' Bridget heeded Hector's advice and went to ground for two weeks. During that time, she examined her feelings and confronted the divided loyalties she felt towards her friend and her art. Eventually she reached a decision, which was that she 'did not want to lose the person'.

Having accepted the situation to which she had, in effect, committed herself, Bridget now received an invitation to visit France – but from friends who belonged to her relationship with Maurice. Bill and Pip Calvert had recently bought a place in Croagnes in Provence and wanted Bridget to come and stay. She knew that this delightful hamlet was close to Arles, Saint-Rémy and Montagne Sainte-Victoire: places that had inspired some of the greatest paintings by Van Gogh and Cézanne. Its artistic connections were irresistible. Even so, she hesitated; these friends' association with her own personal past, and the necessity of carrying on with her work, were not easily dismissed. Turning this over, she arrived at an unorthodox compromise, which was that she would go with Peter. She had been trying to interest her new friend in modern art because, while aware that he admired her work, his lack of knowledge of its roots was apparent. In a strange inversion of her relationship with Maurice, it fell to her to be the teacher. Paris had been the ground upon which her previous friendship had been built, and its artistic treasures the turning point in her own artistic education. The same could now be true for her friendship with Peter.

Accordingly, the two set off for Paris. This time, the mode of transport was Peter's Lambretta and the journey through northern France sobering. They found a landscape that bore the scars of the recent war: villages battered, their inhabitants bearing the weight of memories still painfully fresh. In some places, food continued to be scarce. Travelling by scooter, they felt unusually exposed to their surroundings and the stark sensibility engendered by them. Nevertheless, that sensitivity also had its more

appealing aspects. Being mid-summer, the heat was intense and Bridget found an expedient if unorthodox solution to keeping cool. Having dyed her nightdress brown, she wore the transformed garment by day and found the sensation of weightlessness delicious. Eventually they reached the French capital, where they hatched the details of their plan. Having spent time together looking around the very same galleries she had seen with Maurice only three years earlier, the idea was that Peter would stay on for a few days while Bridget went ahead to prepare her hosts for an unexpected extra guest.

The remainder of her journey by train was unforgettably idyllic. Dreamlike in its sensuality, the first part of her long route south involved travelling at night when the warm air from the Mediterranean suffused the experience with a delectable languor. Her destination was Avignon, where, as arranged in advance by telegram, she expected to be greeted by Bill and Pip. She arrived in a state of high excitement, only to find herself standing alone as her fellow passengers dispersed. Undeterred, she walked around for a while, and, when her friends failed to appear, eventually booked into a local hotel. Due to the overpowering heat, she slept with the windows thrown open. This proved to be a bad mistake, for she awoke the following morning having, unawares, been the prey of innumerable mosquitoes. It was not an auspicious welcome. Having taken the precaution of sending a second telegram, she spent the rest of the day exploring the town while awaiting some explanation of the unexpected turn of events.

To her considerable relief, that evening her friends arrived and explained that they had received one message only – the most recent telegram, the first evidently having gone astray – and had come immediately. Bridget was uplifted by this renewed contact and glad to be with the couple whose company she valued greatly. They returned together to their home and settled into what, as yet, remained a slightly lopsided gathering. The following day, Bill and Pip went out on a shopping trip, entrusting the care of their young children – a boy and a girl – to their visitor. Child-care was not an area in which Bridget was particularly experienced and the time passed slowly. At some point in the proceedings, the prospect of

respite appeared when she spied a Citroën 2CV driving up towards the house. An older man got out: an American and, from the evidence of some walking disability, clearly a war veteran. He presented himself as a neighbour and some small talk ensued, the subject of which was the surrounding landscape. He asked whether she had seen anything of the valley. Having just arrived, this pleasure had not yet been experienced, but, as she quickly assented, from where she was standing she could see that it looked 'wonderful'. With that – and a bracing swig from a conveniently to-hand bottle of whisky – the two got into the car and set off.

The vast expanse of the wider valley between Croagnes and Gordes is a place that feeds the senses. During the course of that afternoon drive, Bridget experienced for the first time the delights of a landscape that she would grow to know well and to love. In the distance, a blue line of mountains defines the horizon. Closer to view the flat valley planes create a sense of deep open space. The sky spreads around, flowers and plants grow in sweet and bitter profusion, the earth overgrown with blossoms of all kinds so that colour discharges itself in bewildering array. Passing through historic, sleepy villages they stopped in Roussillon, where Bridget observed the ancient sarcophagi carved directly into rock. During the journey back, a heady fragrance – heavy and at times sour – poured off the hills, adding its own intoxication. When they got back, Bill and Pip were nonplussed, having returned earlier to find that their visitor and childminder had apparently made an escape. Their bewilderment was not assuaged when, shortly afterwards, Peter turned up – unexpected and unannounced. Bridget's sightseeing had unfortunately left little time to prepare the ground as planned, so that the new arrival's appearance was something of surprise.

Having come to terms with these revelations, Bill and Pip good-naturedly ensured that their guests enjoyed themselves. Fortunately, they got on well with Peter and took pleasure in sharing their house and its considerable attractions. The holiday unfolded with one magical delight after another. As Bridget now became aware, she was in a place dominated by brilliant light and mesmerising colour. Wherever she looked, the landscape filled the view 'like an unpainted Cézanne or Van Gogh', each

glorious panorama implying a pictorial response. From the vantage point of the house, 50 kilometres to the north, the blue silhouette of Mont Ventoux was visible. Closer to hand, wherever the eye rested there was something to look at, some new visual feast to be savoured. Having lived there for a year, Bridget's friends were thrilled with the life that they were beginning to lead and, seeking company, were enthusiastic advocates of its splendours.

During breakfasts taken outdoors, sometimes the attention of all would be drawn across the valley to a tumble-down, semi-derelict farm-house a kilometre or so to the south. One morning, the visitors were surprised to be told, 'That's yours Bridget.' She regarded her friends quizzically and replied, '*I* don't want it – what would I do with it?' Her hosts' joke faded, but its underlying, serious intent lingered. As she continued to look, the idea of living in this beautiful landscape began to stir. At some point Peter joined in. Gesturing towards the distant ruin, he added that he could do the place up. Bridget remained doubtful, but curious. The tiny hamlet of Les Bassacs was a short walk away and they went over to have a closer look. On arrival they saw a very old, small farmhouse, part of a cluster of neighbouring buildings, probably built sometime after the Revolution. It stood in its own yard and there was a well in one corner. The property was indeed ramshackle. Having been empty for 40 years or more, walls had fallen down and the roof was missing. Three rooms seemed intact and underneath one of the bedrooms there was a cowshed. A row of little piggeries and a loft for silkworms completed the facilities. Despite the building's dilapidated state, Peter was sure that he could rescue it, and in a peculiar way its dereliction had a surprising appeal. Initially unconvinced, as Bridget explored further she began to see the site differently, her feelings influenced by an entirely unexpected perception.

22 Saint Elmo's fire

The ruinous condition of Les Bassacs struck a surprising chord, reminding Bridget of Trevemedar and a situation that she had confronted in very different circumstances many years previously. That, however, was not her only impression. Standing outside the huddle of decayed buildings, she surveyed her surroundings. Looking across the valley in a south-westerly direction, she could see Les Alpilles in the distance. Some 60 kilometres away, a small range of mountains was clearly visible, resting between the intervening hills. As she well knew, the landscape that she beheld had been immortalised by Van Gogh towards the end of his life in paintings that are among his greatest achievements. She now took in the particular quality of the light and colour and was struck by their intense brilliance. It was entrancing, as was the vivid spectacle that lay all around. Her response to Les Bassacs was therefore not entirely nostalgic. Nor was she necessarily convinced that it could be a location in which she could work. Rather, the deep attraction that she now formed arose from the resonant contact with nature that she foresaw. What she could do with Les Bassacs itself would, however, need further thought.

As it was, the place was uninhabitable, and indeed subsequent enquiries would reveal that Les Bassacs was officially classified as a ruin. Despite this, Bridget was undeterred, and as she retraced her steps with Peter and their friends she continued to turn the idea over. She knew from her experience of Cornwall that a small and even primitive living place did not matter. Of far greater importance was its location. Bill and Pip also made light of the obvious need for refurbishment, pointing out that they had faced a similar challenge with their own place and had managed its restoration successfully. At the outset, their encouragement was to some

extent underpinned by another motive. They wanted Bridget's company, but by advancing the possibility of her becoming their neighbour they had also hoped that creating a nearby base would enable the repair of Bridget's relationship with Maurice, who remained their friend. Peter's arrival was an unexpected development, but they grew to like the new man in Bridget's life and their original scheme receded. However, they were not alone in investing Les Bassacs with a deeper, personal significance. Bridget, too, saw its future in another light.

By now her attraction to Peter had grown, but as the relationship developed she became aware that there were possible complications, not least in terms of its implications for her work. Despite the strength of her feelings for him, the need to be able to commit herself completely to her activity in the studio was a pressing concern. With her second exhibition at Gallery One coming up the following year, she wanted to explore the terrain she had opened up, and she knew that this could only be accomplished by working in isolation. Even at this relatively early stage in her career, she was aware that certain sacrifices were necessary. Living with another person and the imperative she felt to work did not go together. Peter understood this. Indeed, his initial attraction to Bridget was rooted in admiration for her art and he was keen to support her in that. Both recognised that his renovation of Les Bassacs provided a potential solution. It would be a project that he relished and it transpired that while working there he could live with Bill and Pip. This would give Bridget the distance and space she needed to get on with her work, while maintaining the relationship with Peter. In addition, Bridget harboured a further motive that she did not necessarily confide to anyone. Peter was, as she later observed, 'my hero man', but she also worried about his lifestyle and some of the people with whom he associated. One in particular was an alarming companion. Known as Dennis the Menace, his involvement with drink and drugs was an unwelcome temptation. From that company, Les Bassacs would be a providential diversion.

For all these reasons, the 'rubble' that Bridget confronted in Provence contained a fair amount of gold, and after she returned to Warwick Road the idea of acquiring it stayed with her. She made several subsequent visits

and enquired about the price. The building's rateable status as a ruin
meant that it was relatively inexpensive. The recent sales of her work had
generated some funds and she also had the £500 contract money from
Victor Musgrave up front. This, together with the salary she received from
J. Walter Thompson and a legacy of £1,000 from her grandmother, made
the purchase and necessary building work feasible. Indeed, the more
she considered it, the greater her interest became. There were numerous
family precedents for doing up dilapidated properties and from these she
drew the inspiration that led her towards commitment. Having decided to
proceed, she was elated and excited about the future. In that cast of mind,
she commenced an enduring relationship with a place that would be the
site of 'vividly coloured days', and in which, following suitable improve-
ments, she would establish both a living space during holidays and a
studio. After 1967, when Bridget's work embraced colour and increasingly
evoked tinted light, shimmering movement and glowing atmosphere,
Les Bassacs would be a rich source of visual inspiration.

First, however, a long process of refurbishment was needed. Peter
was eager to make a start and, after setting up a base with Bill and Pip, he
bought a two-stroke motorbike complete with sidecar. This enabled him
to travel around and to transport materials needed for the building work.
His commitment was impressive and, benefiting from a regular regime
of sustained effort, improvements were quickly apparent. Throughout,
Bridget and he kept in touch by daily letters and she sent what money
she could, drawing on her earnings from J. Walter Thompson and her
part-time teaching at Croydon, both of which continued until 1964.
As anticipated, when not working at the advertising agency or teaching,
she was now able to devote herself to preparing for her second exhibition,
the date of which had been set for September 1963. Her earnestness
received an unexpected spur when she was selected for inclusion in two
group shows that were scheduled to take place before her Gallery One
exhibition.

The first of these was *Towards Art? The Contribution of the RCA
to the Fine Arts 1952–62*, which was held at the Royal College of Art
from 7 November to 1 December 1962. Bridget showed one painting,

Hidden Squares (1961), an earlier work that had already been seen in her solo exhibition. The exhibition is notable mainly for being the first group exhibition to include one of her mature black-and-white paintings. Of greater significance was the second group show, *1962: One Year of British Art*, which took place at Tooth Gallery, London, from January to February 1963. Selected by the art critic Edward Lucie-Smith, the exhibition set out to provide a view of 'what British art looks like now'. As he pointed out in his catalogue introduction, the focus was on younger, emerging artists whose work 'seemed to contain the seeds for the future'.[1] The ten chosen comprised Frank Auerbach, Peter Blake, David Hockney, Howard Hodgkin, John Hoyland, Patrick Hughes, Gwyther Irwin, John Latham, Peter Phillips and Bridget Riley: representatives of a disparate range of tendencies. Turning his attention to those artists within the selection 'which remain stubbornly turned away from any kind of figurative reference', Lucie-Smith commented that these are 'notable for their severity'. He explained that such works are pervaded by a 'Baroque dynamism', adding that 'Always, there is rhythm and movement. If these pictures are severely classical in one sense, it is a classicism modified by a dislike of the still and the frozen.'[2] While these remarks sit less well with the work of Hoyland, Irwin or Latham, the reference to dynamism echoes Maurice de Sausmarez's analysis of Bridget's work in the catalogue of her first solo exhibition. In particular, this description encapsulates the visual energies generated by *Blaze* (1962) and *Fission* (1962), the two new paintings that Bridget completed in time for this important group show.

Her forthcoming solo exhibition was, however, her priority and the Warwick Street studio became the scene of intense activity. Throughout, Bridget's efforts were directed towards one end: to follow up the insights she had pursued in her work to date. That, of course, was no small undertaking. The first exhibition had presented an impressively cohesive vision that was rooted in the dynamic interaction of simple shapes. But underpinning that way of working were numerous avenues for possible future development. Each of these related but different lines of thought called for attention, and each led to unknown destinations. Exploring them all would, as Bridget knew, be time-consuming, but that realisation did not

239

render the allure of investigation any less compelling or irresistible. As she later commented, 'I was so much in it. I hadn't been there before. I also felt that this was right and was what I should be doing.' The prospect of moving forward was exhilarating.

A wide field had opened up, and at the centre of all this activity was the principle of contrast, which derived from Bridget's study of Seurat. Whatever formal elements she adopted, and however they were disposed, her early paintings' dynamism is generated by the viewer's perception of contrasted shapes and lines, whose modulated relationships create an involuntary visual excitement. The optical friction between those basic elements is maximised by being calibrated in black and white; in turn, that friction produces myriad impressions of instability, shifting movement and iridescence. The overarching principle of contrast confers an essentially unified character upon the work in black and white. For that reason, despite its diversity, certain broad themes are discernible. These themes draw her endeavours into groups of related activity that may be characterised respectively as: paintings in which a field is a primary agent; those defined by a single self-contained image; and those in which both these aspects are combined. These three areas now became her principal points of focus and she moved between each, employing a gradual process of trial and error in a spirit of discovery.

Galvanised by the pressure she felt to be ready in time, the work continued urgently. By September 1963, that exhausting process had run its course and her second solo exhibition comprised an even larger group of works than the first. There were 16 paintings in all, as well as a three-dimensional construction titled *Continuum* (1963) installed in the basement area. The field paintings included *Shift, Around, Straight Curve, Fall* (all 1963) and *Fission* (1962). The first three of these advance a new protagonist: a repeated triangular shape, alternating between black and white, disposed across the entire surface of each painting. In *Shift*, the triangles are locked into formation, and because of progressive changes in the length of their sides, they appear to proceed directionally and to turn around. The white triangles at the top of the image move from left to right, those at the bottom from right to left. In between there is the

apparent 'shift' that gives the work's title.

Shift is an outstanding example of Bridget's new visual language of dynamism in action. As in Seurat's work, the image comprises numerous individual components that the viewer combines optically through the action of looking. As a result, a visual field is generated as the separate units form a unified whole. However, Bridget's paintings progress beyond those of Seurat, for with sustained looking the opposite impression is produced. The field appears first to buckle and then to disintegrate. The eye's efforts to organise a stable image from the information with which it is presented are frustrated. The visual crisis thus precipitated, in which the viewer's gaze veers from one element to another, is the source of her work's most compelling feature: the realisation that an inert object – a painting – contains unexpected sources of energy that are unlocked and activated by perception. That unique spectacle, which the viewer experiences as a fully active agent, creates the subject of the painting, but there is a deeper level of implication. Her work provides tangible evidence that what we see is essentially subjective and arises from our perceptual responses to visual stimuli. In that way, it foregrounds the mysterious relationship that exists between mind and matter: the ineffable connection that builds a bridge between the individual and the world.

As we have seen, Bridget's path to such insights originates in her experience of landscape, informed by recollected moments when sight seems to connect the seer intimately with their surroundings. Such experiences are proof that the connection is visual, but also physical and emotional. The perception of light in nature can shock or soothe the eye, and both these responses produce an associated emotional reaction. The individual *feels* the things they see. In similar vein, her paintings have a visceral as well as a purely optical appeal. That bodily dimension was recognised by critics such as Anton Ehrenzweig. During the preceding summer he visited Warwick Road in order to see the work in progress and was evidently impressed. Having agreed to contribute a text to the catalogue to the show, he described the somatic aspect of her work in the following way:

One can distinguish two contrasting phases in the experience of Bridget Riley's paintings – the first phase can be called cold, hard, aggressive, 'devouring', the second warm, expansive and reassuring. We sometimes speak of 'devouring' something with our eyes. In these paintings the reverse thing happens, the eye is attacked and 'devoured' by the paintings. There is a constant tug-of-war between shifting and crumbling patterns but at a certain point this relentless attack on our lazy viewing habits will peel our eyes into a new crystal-clear sensibility. We have to submit to the attack in the way in which we have to learn to enjoy a cold shower bath. There comes a voluptuous moment when the senses and the whole skin tingle with a sharpened awareness of the body and the world around.[3]

Given her work's physical nature, to which Ehrenzweig rightly drew attention, it is ironic that the ensuing critical response would identify Bridget so closely with Op Art, the implication being that her paintings' appeal is to the eye alone. The association with Op Art is perhaps inevitable given the international context in which her art would shortly be presented, but it is an unfortunate way of viewing her work when it obscures other aspects of her mode of expression. Among these, the experience of occupying a human body has a conspicuous importance, not least in terms of the particular physical sensations that her paintings convey.

In *Shift* and *Around*, for example, the movement implied in these paintings' titles relates specifically to a figure occupying space and changing its position within it. While employing purely abstract pictorial shapes, the lines of direction taken by the triangles in *Shift* suggest a torso turning around, the weight of the shoulders shifting from one side to another. In *Around*, the action and sensation of twisting are evoked. The source of this physical subject matter is her deep immersion as a student in life drawing, a period when looking at the human body and developing an empathetic response became second nature. 'What is the model doing?' Rabin had demanded of his students. *Shift* is Bridget's answer, although no longer expressed in terms of resemblance. The

movement is evoked not in terms of its appearance, but rather through
the associated sensation of shifting that arises from an optical experience.
Shift does not describe movement but, through the viewer's active percep-
tual involvement, conveys the feeling directly. When he saw these works,
Rabin reproached her for abandoning life drawing. Her response was
typically to the point: 'It's the same thing. I'm taking it further – every-
thing you taught me, including the response.'

This exchange with her former teacher is significant for it underlines
how radical these developments in her work would have appeared, even
to Rabin who understood their source. As he saw, Bridget had moved
forward in an entirely surprising way. While she maintained that her work
retained a preoccupation with the human body, the language she was
using related to that subject in terms of *equivalence*. Comprising entirely
abstract elements, her paintings do not imitate the appearance of an
observed subject. Rather, they exist on their own terms, and the feelings
they foster – from shifting and turning to twisting and falling – are
analogous to those that are sensed in another human body. Whereas an
image of the body implies sensation, her work generates sensation directly.

This is powerfully evident in *Fall* and *Fission*, for example, which also
operate in terms of a dynamic visual field, albeit with entirely different
components. *Fall* uses a single simple form: a line. That unit is repeated
across the surface of the painting and, reading the image from top to
bottom, the field is compressed so that it bends and buckles. The ensuing
pressures result in one of Bridget's most 'devouring' images, to use
Ehrenzweig's term. The picture plane quickly appears to lose flatness and
stability and, instead, dissolves into a dazzling display of energetic move-
ment and shimmering light. *Fission* is slower, but no less entrancing.
The eye traverses a field of discs that also undergo compression and, even-
tually, a restoration of their circularity. Although more measured in the
way it is paced, that dynamic progression also draws the viewer into a
field of sensation. In both paintings, there is no representation of feeling.
Instead, the viewer's own sensations are an immediate reality.

Ehrenzweig later expanded his catalogue text into a longer essay that
analysed the structuring principles employed by the artist. Published in

Art International in February 1965, 'The Pictorial Space of Bridget Riley' identified seven stages that govern the organisation of her paintings and figure in the viewer's responses. These comprise: 'establishment of unit, intensification of contrast, climax, crisis (split), return, recapitulation, and finally the crucial choice of scale for the execution of the painting.'[4] That cycle was subsequently expressed more concisely by Bridget herself in her essay 'Perception is the Medium', published eight months later in *Art News*. This contained the following account: 'The basis of my paintings is this: that in each of them a particular situation is stated. Certain elements within that situation remain constant. Others precipitate the destruction of themselves by themselves. Recurrently, as a result of the cyclic movement of repose, disturbance and repose, the original statement is re-stated.'[5] That approach is manifest in *Movement in Squares* (1961), her first mature painting, it is explicit in the field paintings that were included in her second exhibition, and it is an ethos that, to a greater or lesser extent, would underpin her mature work in general. At the centre of this thinking is a concern with structuring the visual organisation of her work and expressing corresponding emotional states, using the progression and modulation of individual, contrasted units.

The pattern of repose–disturbance–repose would come to be the basis of her artistic practice. But in evoking certain states of being – notably composure and its disruption – that sequence is deeply rooted in the experience of life. This richly expressive dimension in her work is frequently overlooked, and her emotional as well as her visual life are its sources. In developing the approach, Bridget relied on what she called 'pacing'.[6] Using trial and error in the form of detailed preparatory drawings, a unit such as a square, disc, triangle or line would be put 'through its paces'. Certain relationships and sequences would be tested for their capacity to generate particular optical energies. Eventually, this way of working would be extended beyond those initial shapes to various others, including zigzags and curves. In the meantime, Bridget did not restrict herself to fields of paced activity. She also explored an entirely different structure: the single self-contained image. The second exhibition is notable for its inclusion of six paintings that appear to be very different

from the field paintings: *Uneasy Centre, Interrupted Circle, Broken Circle, Disfigured Circle, Blaze 1* and *Blaze 2* (all 1963). In making her break-through with *Movement in Squares*, she had posed the question 'What is a square?' In the second wave of activity she pursued a similar line of enquiry, this time subjecting a circle to progressive investigation and adaptation.

Seen as a whole the circle paintings may be viewed as variations on a theme. In each, the stated 'particular situation' is that of concentric circles. In *Uneasy Centre*, the smallest of these units is placed off-centre, and by varying the width of each surrounding circle the entire structure is sub-jected to a chain of disturbances. As the eye moves from left to right, it experiences a state of stability, then encounters progressive compression that leads to a visual 'crisis' and eventually attains repose on the opposite side. The related paintings in this group proceed in different ways, but also involve a range of dislocations and distortions in the concentric arrangement. The most violent is *Blaze 2*, in which 'intensification of contrast' is achieved by incorporating dazzling zigzag lines within an off-centre concentric format. Ehrenzweig presumably had this in mind when he referred to a characteristic of her work that surely ranks as one of the most distinctive in modern art: 'As an outer sign of the delicate balance achieved, strangely iridescent disembodied colours, like St Elmo's fires, may begin to play around the centres of maximum tension.'[7]

While these circle-shape images form an apparent contrast with the field paintings, the two approaches are nevertheless intimately connected. Both employ the structuring principle of repose–disturbance–repose to create a dynamic perceptual experience, and both ways of organising the image convey sensations that are not simply optical but also have an asso-ciated physical appeal. The contortions advanced by several of the circle paintings are analogous to those performed by the human body as it twists, turns, bends and stretches. The pressures exerted by their concen-tric arrangement arise from visual contrast, but the same pressures evoke muscles and sinews under duress. For example, in reading *Disfigured Circle* from left to right, the image is progressively compressed, clenches at its centre and then relaxes at the opposite periphery. As would be expected,

the visual and physical events generated by the painting have a concomitant emotional resonance.

The exhibition included a further five paintings in which these seemingly opposed approaches – a field of activity and a self-contained image – are combined. The line-up comprised *Fugitive* (1962), *Ascending and Descending (Hero)*, *Off*, *Dilated Centres* and *Twist* (all 1963). Even within this subgroup, a range of different approaches is evident. *Ascending and Descending (Hero)* is something of a hybrid image: it fills the entire picture plane, but also seems strangely monolithic in shape, suggesting vertical movement. *Dilated Centres* comprises a field of discrete units, but this time in the form of an exploded arrangement that accommodates the viewer's perceived after-images as active elements. Between these extremes, the other three paintings explored the ambiguous relation of field and image. In *Fugitive*, ghostly shapes – 'hidden' images – are buried within the painting's formal progressions.[8] *Twist* employs a field of zigzags shaped to evoke a twisting torso. The final small work, *Off*, deploys chevrons to generate the illusion of the picture plane being pulled upwards and to the right.

In common with Ehrenzweig, David Sylvester also visited Bridget during the preparations for her follow-up exhibition, and he, too, contributed to the catalogue. As his comments make clear, he was convinced that the new paintings confirmed the potential that he had noted in his previous review, describing her work as 'among the finest of its kind being done anywhere'.[9] Previously he had recognised that her painting transcended optical effects and possessed the seeds for a richly expressive interplay involving sensation and emotion. That view now seemed entirely vindicated. He noted that, whereas the earlier paintings had evoked landscapes, in the new work 'there is neither the diffuseness nor the distance of landscapes'. His conclusion was that 'The disturbance of regularity seems somehow more strenuous, more physical, than in the earlier works'.[10] Indeed, the capacity of Bridget's work to involve the viewer physically, as well as optically, is the defining feature of the direction she had taken. That aspect is nowhere more evident than in the exhibition's surprising coda. *Continuum* was displayed in a separate downstairs room.

In some ways this remarkable three-dimensional construction was, as she later acknowledged, the star of the show, but it represented a path that even she would hesitate to take.

23 Acclaim

Creating a site that the viewer occupies visually is a central concern of Bridget Riley's black-and-white paintings. Whether presented as a field of activity or in the form of a self-contained image, her early paintings draw the gaze of the viewer, whose ensuing perceptual involvement is immersive. As a result, the observer inhabits the virtual space of the painting. The same imperative remains true of her subsequent work and, while using other strategies, it continues to the present. In 1963, however, she considered whether it was possible to engage the spectator even more completely. She saw that the paintings exist at a remove, separated by an intervening space; however 'devouring' their relationship with the viewer, the work of art is something external. The question was how to dissolve that separation, so that the viewer is actually in the painting.

That ambition was prompted partly by seeing Monet's *Water Lilies* at the Musée de l'Orangerie in Paris during her earlier visit with De Sausmarez. Monet's success in producing a field of colour that envelops the viewer had made an indelible impression. In particular, she was struck by the intimate relationship that these large works establish with anyone standing in proximity. With their entire field of vision filled, the spectator ceases to be an onlooker and, instead, becomes an occupant of the world created by the artist. On that earlier occasion in Paris she had absorbed the thrilling insight occasioned by Monet's paintings, and it was one that she now wished to emulate for her second solo exhibition at Gallery One using her own visual language of black and white. Her aim was to extend the perceptual situation proposed in her paintings by making a physical structure that the viewer could physically enter and occupy. In realising that idea, Bridget turned to her companion Peter Sedgley for assistance.

Taking time off from the building project at Les Bassacs, he returned to London and together they devised the three-dimensional construction that would be titled *Continuum* (1963).

The entire structure was approximately 28 feet (8.5 metres) long, six feet and ten inches (2 metres) high and twelve feet (3.5 metres) in diameter. Resembling a large shell, it comprised seven wooden panels that interlocked in a continuous coiled arrangement. While the exterior walls retained a purely functional appearance, the interior was painted in white emulsion, creating a surface for large chevron shapes in black. The viewer entered a sanctum-like inner space through a vertical aperture between the ends of the encircling wall. Standing in that internal area, the occupant was completely surrounded by the interplay of black-and-white shapes; with all external viewpoints removed, the spectacle was both enveloping and highly disorientating. In common with the paintings hanging elsewhere in the exhibition, *Continuum* destabilised the viewer's field of vision. The dynamic action of expanding and contracting chevron shapes produced hallucinatory movements, undulations in space and unpredictable, dazzling discharges of light. But in a further development, while standing inside *Continuum* the viewer could turn around and shift their gaze within an enclosed space. That expanded view powerfully augmented the sensation of being 'devoured'. In effect, virtual space and real space had overlapped and merged. The result was an all-encompassing intensification, generating an experience at once perceptual *and* uncompromisingly physical.

Continuum was a powerful demonstration that Bridget's agenda far exceeded the boundaries of purely optical art. That lesson was not lost on Norbert Lynton, who reviewed the exhibition for *Art International*. In his earlier response to her first show Lynton had made a connection with Victor Vasarely's research into visual dynamics. Now he concentrated on the expressive capacity of her work in terms of bodily experience. He began with a ringing endorsement: 'Quite the most brilliant (in more than one sense of the word) exhibition in London ... is that at Gallery One: Bridget Riley's second one-man show.' Having identified the complementary directions advanced by the field and image paintings, he then continued:

Riley has done the seemingly impossible by tightening her work up still further, excluding the one or two playful pictures that had crept into her first show. And yet these paintings are beguiling. One has to write of them as though they were nothing but scientific diagrams exploiting and illuminating the mechanics of human vision and setting up a kind of domestic conflict between expectations and visual data, but they are more than merely fascinating. They are physically stimu-lating and compelling. More than the eye and the conceptual vision department of the mind are involved: each work is a bodily experience that draws the spectator into a world where vertical and horizontal and gravitational pull are no longer the controlling facts – a world more like that experienced in swimming or perhaps sky diving.[1]

As Lynton's comments confirm, Bridget's aim of using her art to involve the viewer completely went far beyond mere illusion. *Continuum* took her paintings a step further by creating an indefinable space of pure sensation that absorbed the occupant. Photographs of Bridget taken by Ida Kar in the exhibition show the artist standing in what is effectively a world of her own making. The paintings are hanging on walls painted black, the images appearing to float. Beyond, and visible through a doorway, the entrance to *Continuum* can be seen, inviting access to the disorientating arena that Lynton described.

Lynton's review gave the exhibition a valuable international endorse-ment, but it was significant in another way. Extending the views expressed in his first review, it now situated her alongside but also *apart* from Op Art, the artistic context into which, from this time onwards, she would steadily be drawn by other critics. Op Art, as it would become known from 1964 onwards, had its roots in developments that had taken place in France in the mid-1950s. Spearheaded by Vasarely, there was a widening interest in paintings and sculpture that cultivated effects of movement, light and other sensory phenomena. Exhibitions held in Paris and Zagreb in 1955 and 1961 conferred an expanding international visibility on that movement. In his response to her first show, Lynton had not been alone in making links between Bridget and Continental artists concerned with

optical research. Writing in *Arts Review* in May 1962, Michael Shepherd had made a similar connection. He identified her 'as being in the vanguard of a branch of research in contemporary art which is a world-wide concern at the moment: the integration of optical, scientific effects into the language of painting'.[2] By contrast, Lynton's response to the second exhibition cited Bridget's involvement with 'bodily experience', implying an essential difference between her work and the optical art then being produced elsewhere. But that view was by no means widely held. The success of the Gallery One exhibition meant that from this point on her work was regularly included in group shows, and that exposure ensured that she enjoyed a rapidly growing profile. At the same time, however, her work would increasingly be connected with wider tendencies even though such links were tangential or superficial.

The extent to which Bridget was aware of the developments in optical art is debatable. By her own later account, she did not encounter Vasarely's work until 1962 or 1963, when she was invited to the home of a collector who had seen her work at Gallery One. That, of course, does not discount a degree of second-hand awareness from ideas and reports that circulated at the time. But evidence of any first-hand influence by the Hungarian, or other artists connected with Le Mouvement as it was known, upon the direction that she took in 1961 is unsubstantiated. The sources of her work – and its motives – lay elsewhere. Eschewing visual research, Bridget's devotion to developing visual structures in an intuitive and improvised way is a defining characteristic of her approach. By contrast, the Groupe de Recherche d'Art Visuel insisted on rational, systematic, research-based methods, which prioritised optical effects over the expression of emotion. The artists and artistic movements that she has cited as models – notably Seurat and Futurism – belong to a much earlier time frame. The closest contemporary influence that she acknowledged was the phenomenon known as Happenings that came into vogue from the late 1950s. The involvement of spectators in a live event-based situation caught her attention and sympathy and has clear parallels with her own aims. In both ways of working, the principle of dynamic engagement is conspicuous. That said, the theatrical aspect of Happenings stood at a remove to Bridget's

single-minded commitment to painting.

Following the exhibition at Gallery One, Bridget would not have another solo exhibition until 1965, when she showed at the Richard Feigen Gallery in New York. In the meantime, however, the group exhibitions in which she participated, and the attention that these attracted, sustained an ever-increasing reputation. That process had commenced with *Ten Years*, which was held at Gallery One immediately prior to her second solo show. Selected by Victor Musgrave, the exhibition brought together artists whose work had been presented at the gallery in the preceding ten years. The timing was fortuitous, the inclusion of *Ascending and Descending (Hero)* providing a foretaste of her imminent solo exhibition. More significantly, *Ten Years* marked the first time that her work was seen in an international context. The artists from abroad with whom she showed included Yves Klein, Henri Michaux, Rufino Tamayo and Enrico Baj.

That outing was followed by inclusion in the John Moores Liverpool Exhibition to which she submitted *Blaze 3* (1963). The jury included two artists of a very different persuasion – Peter Lanyon and William Coldstream – as well as the curator and art historian Ronald Alley representing the Tate Gallery. She won a non-purchase prize of £100, but there was more to come. The year 1963 concluded with a piece in *The Times*, which announced that 'Miss Bridget Riley, whose painting "Fall" was recently bought by the Tate Gallery, has been awarded this year's Critics Prize.'[3] The acquisition of one of her most distinctive early paintings speaks of support from Alley, who was acutely aware of the need to build the Tate's holdings of contemporary art. For Bridget, representation in the national collection was an important staging post in a career that was now clearly gathering momentum.

The following year provided confirmation, if any was needed, that Bridget Riley had joined the ranks of the first division of leading British artists. She was included in no fewer than eight group shows, several of which took place overseas. In *Six Young Painters*, an Arts Council exhibition that toured to various venues in the United Kingdom, Bridget's work was placed alongside that of Peter Blake, William Crozier, David Hockney, Dorothy Mead and Euan Uglow. As the accompanying cata-

logue noted, these were artists 'whose names are becoming established
in this country – and indeed abroad'.[4] The selection drew together
exponents of markedly different tendencies. Pop Art, expressive figuration,
observation from life and – courtesy of Bridget – the latest abstract
painting were all represented. Her growing international prominence
was signalled by inclusion in *Nouvelle Tendance*, a large group exhibition
held at the Musée des Arts Décoratifs, Paris. Its title refers to the group
of Continental artists, formed in Paris, whose involvement with kinetic
and Op Art formed common ground. Bridget was the only British
representative in a line-up of 52 artists dominated by men. In November
she was included in *The New Generation: 1964* held at the Whitechapel
Gallery, London. She was one of a group of 12 artists described by its
visionary Director Bryan Robertson as 'conspicuously brilliant and
gifted'.[5] That David Thompson, one of the judges associated with the
exhibition, could justifiably describe the wider context as 'a boom-period
for modern art'[6] evokes a sense of the distinction that Bridget had so
quickly achieved.

Three exhibitions that cemented Bridget's international profile now
came in swift succession. The first of these, *Painting and Sculpture of a
Decade 1954–1964*, was organised by the Calouste Gulbenkian Foundation
and held at the Tate Gallery, London, from April to June 1964. As its title
suggests, the exhibition surveyed the artistic developments that had
occurred in the preceding ten years through a stellar line-up of over 50
leading figures from around the world. For Bridget's work to be shown
alongside that of such senior luminaries as Picasso, Joan Miró and Barnett
Newman was an extraordinary advance given that her work had been
unknown only two years previously. This remarkable year of achievement
concluded with her inclusion in *Contemporary British Painting and Sculp-
ture*, held at the Albright-Knox Art Gallery, Buffalo, from October to
November, and *Motion and Movement*, an exhibition of kinetic painting
and sculpture mounted at the Contemporary Arts Center, Cincinnati,
Ohio, from November to December. With these exhibitions, her reputa-
tion now had a foothold in America. They were important steps in a heady
ascent that would lead to celebrity status on both sides of the Atlantic.

Bridget Riley's achievement of international prominence came with her inclusion in *The Responsive Eye*, which opened at the Museum of Modern Art, New York, in January 1965.[7] Curated by William C. Seitz, this ambitious exhibition comprised 123 works by artists from 15 countries. Seitz's original intention, as stated in the accompanying catalogue, was to chart the development of paintings with a 'primarily visual emphasis',[8] from Impressionism to the present. However, as he conceded, the recent proliferation of art with an 'optical' basis made a historical survey impossible, and he chose instead to concentrate on contemporary art that he characterised as having a 'perceptual' character. That conceptual framework was a loose one. It emphasised the subjective nature of seeing, which, as Seitz rightly pointed out, was bound up with thinking, feeling and remembering. This was something of a catch-all, and as he acknowledged, even with a narrower chronological focus, the scope of the resulting survey was diverse. It embraced various tendencies, ranging from kinetic art to hard-edge abstraction, with artists as radically different in character as Kenneth Noland and Agnes Martin. The selection is notable not least for including Peter Sedgley, who was by now also developing an independent artistic profile.

Despite the porous nature of Seitz's selection, one unifying characteristic was that the works were all abstract, his argument being that any form of representation deflects from 'the purely perceptual effect of lines, areas and colors.'[9] That rationale conferred a seeming unity on what in reality was a heterogeneous body of work by artists practising in many different ways. In that respect, the exhibition would draw its critical detractors. Even so, the show was a huge popular success and, despite its expansive outlook, it would be viewed as a manifesto for a new phenomenon: Op Art. The visibility of the new style, which attracted a wide audience through an ever-attentive American media, was helped by Seitz himself, who contributed an article to *Vogue* magazine. While that kind of publicity galvanised public interest, it also had the effect of alienating sections of the art establishment, particularly certain critics, curators and academics who recoiled from the taint of populism surrounding the exhibition.

Aside from the media storm that it provoked, *The Responsive Eye*
was controversial in other, more enduring ways. Its abiding significance is
to have firmly established Op Art as an important artistic manifestation.
At the same time, the movement – such as it was – would suffer from
the perception of fashion-driven success. When the exhibition opened,
Bridget found herself very much the focus of these different kinds of
attention. Two of her paintings were included in the show, namely
Current and *Hesitate* (both 1964). Of huge consequence to her ensuing
reputation was the organisers' decision to reproduce *Current*, which
MoMA had recently acquired, on the cover of the catalogue. Seitz also
singled out her work in his catalogue essay, which set out various themes
within the overarching concept of perceptual abstraction. He noted that
in *Current*, 'The eyes seem to be bombarded with pure energy'.[10] Arguably
less helpful was Seitz's bracketing of her work with that of Vasarely, both
artists being cited as exponents of black-and-white optical painting.
The recognition thus accorded to Bridget was a powerful endorsement,
but by identifying her so conspicuously with the stylistic aspects of Op
Art it was also misleading.

This, however, did not detract from her elevation to stardom. In
addition to the enormous popular interest generated by the media, she
was lionised by other artists in the exhibition, notably Josef Albers and
Ad Reinhardt. Significantly, that wide acclaim translated into commercial
success. All 16 paintings in Bridget's solo exhibition at the Richard Feigen
Gallery, which opened a week later, sold in advance. Those collectors who
were disappointed when the availability of works was exhausted imme-
diately registered on a waiting list. Critically and financially, her position
seemed secure. Almost immediately, though, there was a backlash.

In the April edition of *Art News*, its editor Thomas B. Hess filed a
stinging review of *The Responsive Eye* exhibition. Describing it as a
'mishmash', Hess criticised Seitz for lumping together disparate kinds of
painting and sculpture beneath the banner of Op Art, citing its purported
connections as 'cosmetic'. Hess then turned on Bridget in satirical vein.
'At the press-opening', he wrote, 'it was noticed that one black-and-white
Op panel by Bridget Riley had been dirtied in transit. The artist happened

to drop by, and she volunteered to make repairs. I came across her cheerfully scouring the surface with Ajax, "The Foaming Cleanser". Hess's tone was light-hearted, but the implication was clear. Whether or not the label Op Art could be applied to Bridget's work, it had stuck. Worse still, it was obvious that in Hess's view Op Art was pure surface without substance: 'the Op audience passively participated, conditioned into giving up critical faculties'.[11]

A more considered and, for that reason, potentially more damaging review appeared in the June 1965 issue of *Art International*. Penned by Rosalind Krauss, then a regular contributor to the magazine, her article 'Afterthoughts on "Op"' took aim at the exhibition and the claims made for Op Art, and it singled out Bridget's work for particular criticism. In Krauss's view, the exhibition's covert ambition 'to chronicle "Op Art" as a new stylistic phenomenon' was undermined by an approach that was 'journalistic as opposed to the serious'. Seitz's investigation of Op Art was, she claimed, limited by a preoccupation solely with the 'possibilities of retinal excitement'. Although couched in different terms, Krauss's article echoed Hess's criticisms. The same line of attack was clear: Op Art lacked a firm conceptual base.

Developing her case, Krauss dismissed the 'Op picture', as she called it, as no more than old-fashioned *trompe l'œil* painting, which induces 'the idea that behind the picture plane lie three-dimensional objects'. That is to say, Op Art, like any figurative representation, tricks the eye with illusionism. Bridget's paintings were cited as an example of the kind of conventional deception that 'aimed at evoking actual textures where the canvas is in reality flat'.[12] Krauss's argument is flawed because it elides two essentially different artistic phenomena. The painted image of an object that is apparently situated behind the picture plane is not the same as the perceptual experience produced by Bridget's painting, which has its own independent reality and occurs in front of – not behind – the picture plane. Whatever its merits, the article typified the hostility that the exhibition aroused in certain quarters. Even so, the seriousness with which Krauss discussed the exhibition was – however unintentional – a signifi-

cant bonus. A critical debate had been sparked and Bridget Riley had
been singled out as one of the principal protagonists.

The responses of Hess and Krauss appeared in print following
Bridget's return to London. If she was to be dismayed by that subsequent
critical disparagement, she was appalled by an unexpected development
in an entirely different context that occurred even before she left New
York. Excited by the media coverage that the exhibition received, Op Art
quickly became a fashion craze. Its 'look' suddenly dominated clothes and
commercial design, with shop windows the platform for the new move-
ment's sensational appeal. Bridget's work in particular suffered from this
blatant appropriation. Stripped from their obvious artistic source, imi-
tation dazzle patterns were re-presented as pure style. Without recourse
to the protection of copyright, she was at the mercy of plagiarism and saw
this as a depressing conclusion to what had begun as a triumph. At the
precise moment of achieving recognition, the view of her work seemed
distorted by misrepresentation. Contemplating the trivialisation of her
work by the designers of dresses and handbags, she looked to the future
with a heavy heart. 'It will take at least twenty years', she thought, 'before
anyone looks at my paintings seriously again.'[13]

Fortunately, that view would in time be proved wrong. Despite the
negative reviews from some American critics and also what Bridget
described as 'an explosion of commercialism',[14] interest in her art both
continued and flourished. On 19 April 1965, just five days short of her
34th birthday, *The Times* reported: 'Miss Bridget Riley has just returned
from America, where few English artists can have been so well received.
Her one-man show at the Richard Feigen Gallery, New York, sold out, her
works are reproduced on the covers of all the important art magazines,
and she has the distinction of featuring in three exhibitions at the same
time.'[15] As this piece suggests, in addition to the exhibitions at the
Museum of Modern Art and Richard Feigen Gallery, she was included in
another major touring exhibition, *London: The New Scene*, which was
seen at seven venues in America and Canada between February 1965
and March 1966. In that context, Bridget Riley was presented as one of

a number of leading British artists manifesting 'Young London's dialogue with the world'.[16] In only three years since her first solo exhibition, she had achieved a global platform for her work. It was a position that she would now occupy and one she would never relinquish.

NOTES

PREFACE

1 George D. Painter, *Marcel Proust: A Biography*, Volume 1, Chatto and Windus, London, 1959, p.xi.

ANCESTRAL LANDSCAPE

1 Unless otherwise indicated, the source for statements attributed to Riley is the author's unpublished notes of interviews with the artist held between September 2014 and March 2016.
2 The source for this statement and others attributed to deceased family relatives is as above.
3 *The New York Herald*, 6 August 1903, p.3.
4 A complete file of documents relating to the lawsuit brought by Edison against former employees James W. Gladstone and Eben G. Dodge, who established the Battery Supplies Co. to compete with the Edison Manufacturing Co. in the sale of primary batteries, is held at Rutgers University, New Jersey: The Thomas Edison Papers, Case Files: Thomas A. Edison and Edison Manufacturing Company v. James W. Gladstone and Eben G. Dodge [QB004].
5 James William's symptoms may also have been due to exposure to X-rays, on which he worked with Edison, in which case it is unfortunate that he did not heed the report in the *New York Herald* that was printed immediately above the article about his lawsuit with his former employer (see note 3 above). This noted that 'Mr. Edison is not the only person to suffer from the mysterious powers of the Rontgen rays. Two physicians in the radiograph department of the London Hospital have fallen victims to its baneful influence ... The first symptom of X-ray poisoning is a troublesome

inflammation of the hands, accompanied by swellings resembling chilblains, depression of spirits and insomnia.'
6 This document and other family records, including birth certificates, school reports, letters and photographs, are held in the artist's archive.

A VERY VERY PERSON

1 Around this time Bridget was diagnosed as suffering from mastoiditis, a painful ear infection. This was successfully cured by an operation, but the necessary period of convalescence led to absences from school.

UNEARTHLY BEAUTY

1 Bridget Riley, 'The Pleasures of Sight' [1984], in Robert Kudielka (ed.), *The Eye's Mind: Bridget Riley Collected Writings 1965–2009*, Thames and Hudson, London, 1999, reprinted 2009, p.32.
2 *Ibid.*, p.33.
3 *Ibid.*, p.32.

GREAT PROMISE

1 The pliers are still in Bridget Riley's possession and remain in use.

THE FLEDGLING

1 Transcript held in the National Gallery Archive, London of a talk given about the concerts by Kenneth Clark on the BBC on 24 October 1939.
2 *Ibid.*

TO GOLDSMITHS

1 Bridget Riley, 'From Life', in Paul Moorhouse and Bridget Riley, *Bridget*

Riley: From Life, National Portrait
Gallery, London, 2010, p.7.
2 *Ibid.*, p.9.

LOOKING AND DRAWING

1 Bridget Riley, 'From Life', in Paul
Moorhouse and Bridget Riley, *Bridget
Riley: From Life*, National Portrait
Gallery, London, 2010, p.9.
2 Alfred James Munnings, *The Finish*,
Museum Press, London, 1952, p.145.
He published the speech, preceded by
an apologia, in his book *An Artist's Life*,
Museum Press, London, 1950.

THE BARGAIN NOT KEPT

1 Bridget Riley, 'Student at the Royal
College of Art, 1952–55' [1988], in Robert
Kudielka (ed.), *The Eye's Mind: Bridget
Riley, Collected Writings 1965–2009*,
Thames and Hudson, London, 1999,
reprinted 2009, p.37.
2 *Ibid.*

PARADISE AND DISASTER

1 Sally Riley, interviewed by the author,
11 June 2015.
2 *Ibid.*

CRISIS

1 Holger Cahill, *Modern Art in the United
States: A Selection from the Collections
of the Museum of Modern Art New York*,
exhibition catalogue, Tate Gallery,
London, 1956, p.24.

RECOVERY

1 Transcript of an interview with Lee
Krasner conducted by Dorothy Seckler
on 2 November 1964 for the Archives of

American Art, Smithsonian Institute.
Krasner recalled: 'When I brought
Hofmann up to meet Pollock and see his
work which was before we moved here,
Hofmann's reaction was – one of the
questions he asked Jackson was, do you
work from nature? There were no
still-lifes around or models around and
Jackson's answer was, "I am nature." And
Hofmann's reply was, "Ah, but if you
work by heart, you will repeat yourself."
To which Jackson did not reply at all.'
2 Alfred H. Barr, Introduction, *The New
American Painting*, exhibition catalogue,
Tate Gallery, London, 1959, p.9.
3 *Ibid.*, p.11.
4 *Ibid.*
5 Igor Stravinsky, *Poetics of Music in the
Form of Six Lessons*, Harvard University
Press, Cambridge, Massachusetts, and
London, 1942, p.57.

DEVELOPING PROCESS

1 Herbert Read, *Education through Art*,
Faber and Faber, London, 1943, p.1.
2 Maurice de Sausmarez, 'The
Development of Bridget Riley's Work
1959–65', in *Bridget Riley*, Studio Vista,
London, 1970, p.26.
3 *Ibid.*

LOOKING BECOMES THE SUBJECT

1 Bridget Riley, 'Seurat as Mentor' [2007],
in Robert Kudielka (ed.), *The Eye's Mind:
Bridget Riley, Collected Writings
1965–2009*, Thames and Hudson,
London, 1999, reprinted 2009, p.73.
2 *Ibid.*, p.66.

ITALY

1 Maurice de Sausmarez, 'The Develop-
ment of Bridget Riley's Work 1959–65',
in *Bridget Riley*, Studio Vista, London,
1970, p.27.

2 Bridget Riley, 'Seurat as Mentor' [2007], in Robert Kudielka (ed.), *The Eye's Mind: Bridget Riley, Collected Writings 1965–2009*, Thames and Hudson, London, 1999, reprinted 2009, pp.65–66.
3 Bridget Riley, 'In Conversation with Maurice de Sausmarez', in Robert Kudielka (ed.), *The Eye's Mind: Bridget Riley Collected Writings 1965–2009*, Thames and Hudson, London, 1999, reprinted 2009, p.74.
4 De Sausmarez, *op. cit.*, p.27.
5 Umberto Boccioni, *Pittura Scultura Futuriste Milan*, Edizioni Futuriste di 'Poesia', 1914, p.198.
6 Riley, 'In Conversation with Maurice de Sausmarez', *op. cit.*, p.74.
7 *Ibid.*, p.75.

INTO BLACK

1 Maurice de Sausmarez, *Basic Design: The Dynamics of Visual Form*, Studio Vista, London, 1964, p.9.

MOVEMENT IN SQUARES

1 From Maurice Denis, 'Definition of Neo-Traditionalism', originally published in *Art and Critique*, Paris, 23 and 30 August 1890; included in Maurice Denis, *Théories; 1890–1910*, 4th edition, Rouart et Waterlin, Paris, 1920, pp.1–13.

GALLERY ONE

1 Maurice de Sausmarez, 'Introduction', in *Bridget Riley*, exhibition catalogue, Gallery One, London, April–May 1962, n.p.
2 David Sylvester, *New Statesman*, 25 May 1962.
3 Norbert Lynton, 'London Letter, Bridget Riley', *Art International*, Lugano, vol.6, no.7, September 1962, p.47.

NEW HORIZONS

1 From Georges Braque, 'Thoughts and Reflections on Art', originally published in *Nord-Sud*, Pierre Reverdy, Paris, December 1917, reprinted in Herschel B. Chipp, *Theories of Modern Art*, University of California Press, Berkeley and Los Angeles, 1968, p.260.
2 Sean Treacy, *A Smell of Broken Glass*, Tom Stacy Publishing, London, 1973.
3 Laurie Lee coined the title for Treacy's book.

SAINT ELMO'S FIRE

1 Edward Lucie-Smith, 'Introduction', in *1962: One Year of British Art, Selected by Edward Lucie-Smith*, exhibition catalogue, Arthur Tooth & Sons Ltd, London, January–February 1963, [p.2].
2 *Ibid.*, [p.3].
3 Anton Ehrenzweig, [untitled], in *Bridget Riley*, exhibition catalogue, Gallery One, London, September 1963, n.p.
4 Anton Ehrenzweig, 'The Pictorial Space of Bridget Riley', *Art International*, Lugano, vol.9, no.1, February 1965, pp.20–24.
5 Bridget Riley, 'Perception is the Medium', *Art News*, vol.64, no.6, October 1965, pp.32–33, cont. p.66.
6 This concept is discussed in Maurice de Sausmarez, 'In Conversation with Bridget Riley', in *Bridget Riley*, Studio Vista, London, 1970, pp.57–58.
7 Ehrenzweig, in *Bridget Riley*, 1963, *op. cit.*, n.p.
8 See Bridget Riley, 'Seurat as Mentor' [2007], in Robert Kudielka (ed.), *The Eye's Mind: Bridget Riley, Collected Writings 1965–2009*, Thames and Hudson, London, 1999, reprinted 2009, p.68.
9 David Sylvester, [untitled], in *Bridget Riley*, 1963, *op. cit.*, n.p.
10 *Ibid.*

ACCLAIM

1 Norbert Lynton, 'London Letter, Riley', *Art International*, Lugano, vol.7, no.8, October 1963, p.84.
2 Michael Shepherd, 'Bridget Riley', *Arts Review*, vol.14, no.8, 5–19 May 1962, p.19.
3 'Critics Prize for Bridget Riley', *The Times*, 14 December 1963.
4 'Foreword', in *Six Young Painters*, exhibition catalogue, Arts Council, January–June 1964.
5 Bryan Robertson, 'Preface', in *The New Generation: 1964*, exhibition catalogue, Whitechapel Gallery, London, March–May 1964, p.5.
6 David Thompson, 'Introduction', *ibid.*, p.7.
7 The exhibition subsequently toured to four other American venues: City Art Museum of St Louis; Seattle Art Museum; Pasadena Art Museum; Baltimore Museum of Art.
8 William C. Seitz, 'Acknowledgements', in *The Responsive Eye*, exhibition catalogue, Museum of Modern Art, New York, 1965.
9 William C. Seitz, 'Introduction', *ibid.*, p.7.
10 *Ibid.*, p.31.
11 Thomas B. Hess, 'You Can Hang It in the Hall', *Art News*, vol.64, no.2, April 1965, pp.41–43.
12 Rosalind Krauss, 'Afterthoughts on "Op"', *Art International*, Lugano, vol.9, no.5, June 1965, pp.75–76.
13 Quoted in Robert Kudielka, 'Biographical Notes', in Paul Moorhouse (ed.), *Bridget Riley*, exhibition catalogue, Tate, 2003, p.222.
14 From Bridget Riley's essay 'Perception is the Medium', which was published in *Art News*, vol.64, no.6, October 1965, pp.32–33, cont. p.66, as a riposte to the controversy surrounding *The Responsive Eye* exhibition.
15 'Miss Bridget Riley and Optical Art', *The Times*, 19 April 1965.
16 Martin Friedman, 'Introduction', in *London: The New Scene*, exhibition catalogue, Walker Art Center, Minneapolis, in association with the Calouste Gulbenkian Foundation and The British Council, 1965, p.50. The exhibition toured to venues in Washington, Boston, Seattle, Vancouver, Toronto and Ottawa.

Page numbers in *italic* refer to the
illustrations

p.129, above: postcard, collection of the author
p.129, below: Courtesy of Boston High School
p.130, above: © Adam Burton/Alamy Stock Photo
p.130, below: © Michael Dutton/Alamy Stock Photo
p.131: © The Francis Frith Collection
pp.132–33: © Philip Sharp/Alamy Stock Photo
p.134, above: © David Cattanach/Alamy Stock Photo
p.134, below: Courtesy of the Old St Stephenite's Society (OSSS)
p.135: © Pictorial Press Ltd/Alamy Stock Photo
pp.136–37: Courtesy of Cheltenham Ladies' College
p.138: Courtesy of the History of Advertising Trust
p.139: Courtesy of Penguin Books
p.140: Courtesy of The Mills Archive Trust
p.141: © The John Deakin Archive/ Bridgeman Images
pp.142–43: Courtesy of Tate
pp.144–45: © Whitechapel Gallery, Whitechapel Gallery Archive
p.146: © Heritage Image Partnership Ltd/ Alamy Stock Photo
p.147: Courtesy of Jane de Sausmarez
p.148: © The John Deakin Archive/ Bridgeman Images
p.149: © National Portrait Gallery
pp.150–51: © Tony Evans/Timelapse Library Ltd./Hulton Archive/Getty Images
pp.152–55: © National Portrait Gallery
pp.156–57: © BBC Photo Library
pp.158–59: Digital Image © 2004, The Museum of Modern Art, New York/ Scala, Florence
p.160: Courtesy of The Museum of Modern Art, New York

Published in 2019 by Ridinghouse
46 Lexington Street
London WIF OLP
United Kingdom
ridinghouse.co.uk

Distributed in the UK and Europe by
Cornerhouse Publications
c/o Home
2 Tony Wilson Place
Manchester MI5 4FN
United Kingdom
cornerhousepublications.org

Distributed in the rest of the world by
ARTBOOK | D.A.P.
75 Broad Street, Suite 630
New York 10004
artbook.com

British Library Cataloguing-in-
Publication Data
A full catalogue record of this book is
available from the British Library.

ISBN 978 1 909932 50 0

Edited by Sophie Kullmann

Designed by Mark Thomson
Set in Garamond Premier (Robert
Slimbach) and Söhne (Kris Sowersby)

Printed in Estonia by Tallinna
Raamatutrükikoja OÜ

Ridinghouse